MAKING ART CONCRETE

The Getty Conservation Institute and the Getty Research Institute | Los Angeles

MAKING ART CONCRETE
WORKS FROM ARGENTINA AND BRAZIL IN THE COLECCIÓN PATRICIA PHELPS DE CISNEROS

Pia Gottschaller and Aleca Le Blanc
Edited by Pia Gottschaller, Aleca Le Blanc, Zanna Gilbert, Tom Learner, and Andrew Perchuk

The Getty Research Institute Publications Program
Thomas W. Gaehtgens, *Director, Getty Research Institute*
Gail Feigenbaum, *Associate Director*

Laura Santiago and Janelle Gatchalian, *Manuscript Editors*
Catherine Lorenz, *Designer*
Michelle Woo Deemer, *Production Coordinator*

Published by the Getty Conservation Institute and the Getty Research Institute, Los Angeles
Getty Publications
1200 Getty Center Drive, Suite 500
Los Angeles, California 90049-1682
www.getty.edu/publications

Distributed in the United States and Canada by the University of Chicago Press
Distributed outside the United States and Canada by Yale University Press, London

Printed in China
Type composed in Muller and Whitney.

This volume is published on the occasion of Pacific Standard Time: LA/LA, an initiative of
the Getty with arts institutions across Southern California, and accompanies the exhibition
Making Art Concrete: Works from Argentina and Brazil in the Colección Patricia Phelps de Cisneros,
held at the J. Paul Getty Museum from 16 September 2017 through 11 February 2018.

The exhibition was co-organized by the Getty Conservation Institute and the Getty Research
Institute and has been made possible by the Colección Patricia Phelps de Cisneros.

Library of Congress Cataloging-in-Publication Data

Names: Gottschaller, Pia, author. | Le Blanc, Aleca, 1972- author. | Gilbert,
Zanna, 1980- editor. | Learner, Tom, editor. | Perchuk, Andrew, editor. |
Pacific Standard Time: LA/LA (Project) | Getty Research Institute, host
institution, issuing body, organizer. | Colección Patricia Phelps de
Cisneros, sponsoring body. | Getty Conservation Institute, organizer.
Title: Making art concrete : works from Argentina and Brazil in the
Colección Patricia Phelps de Cisneros / Pia Gottschaller, Aleca Le Blanc
; edited by Pia Gottschaller, Aleca Le Blanc, Zanna Gilbert, Tom Learner,
and Andrew Perchuk.
Description: Los Angeles : Getty Conservation Institute and the Getty
Research Institute, Los Angeles, [2017] | "This volume is published on the
occasion of Pacific Standard Time: LA/LA, an initiative of the Getty with
arts institutions across Southern California, and accompanies the
exhibition Making Art Concrete: Works from Argentina and Brazil in the
Colección Patricia Phelps de Cisneros, held at the J. Paul Getty Museum
from 16 September 2017 through 11 February 2018. The exhibition was
co-organized by the Getty Conservation Institute and the Getty Research
Institute, and has been made possible by the Colección Patricia Phelps de
Cisneros."—ECIP galley. | Includes bibliographical references and index.
Identifiers: LCCN 2017003024 | ISBN 9781606065297 (hardcover)
Subjects: LCSH: Concrete art—Argentina—Exhibitions. | Concrete
art—Brazil—Exhibitions. | Colección Patricia Phelps de
Cisneros—Exhibitions. | Art—Private collections—Exhibitions.
Classification: LCC N6494.C635 M35 2017 | DDC 709.04/056—dc23
LC record available at https://lccn.loc.gov/2017003024

Presenting Sponsors

The Getty

Bank of America

FRONT COVER: Willys de Castro (Brazilian, 1926–88), *Objeto ativo (cubo vermelho/branco)*
(Active object [red/white cube]), 1962. See p. 90, pl. 15A.
BACK COVER: Willys de Castro (Brazilian, 1926–88), *Objeto ativo (cubo vermelho/branco)*
(Active object [red/white cube]), 1962. See p. 90, pl. 15B.
FRONTISPIECE: Alfredo Hlito (Argentine, 1923–93), *Ritmos cromáticos II* (Chromatic rhythms II)
(detail), 1947. See p. 97, pl. 18.

CONTENTS

FOREWORD

First introduced in Paris by the Dutch artist Theo van Doesburg in 1930, concrete art was a kind of geometric painting that insisted on creating "concrete" forms that would make no reference to exterior reality. In the postwar period, concrete art became a truly international movement, with practitioners in Europe, in the United States, and across Latin America. The works of art presented in the exhibition *Making Art Concrete: Works from Argentina and Brazil in the Colección Patricia Phelps de Cisneros* are a testament to the originality and diversity of these artistic experiments. They tell a story of artists striving for a visual language with which to connote modernity in the postwar scenario of rapid industrialization and modernization in Argentina and Brazil.

This exhibition was possible only because of the generosity of the Colección Patricia Phelps de Cisneros. The Colección Cisneros is one of the world's greatest collections of modern art and the world's most important collection of geometric art from Argentina and Brazil. In 2001, as director of the Harvard Art Museums, I had the pleasure of working with the Colección to present the exhibition *Geometric Abstraction: Latin American Art from the Patricia Phelps de Cisneros Collection.* More than fifteen years later, I am thrilled to revisit these extraordinary works of art and to be introduced to so many others.

The Colección loaned the Getty forty-seven works for a period of three years. This allowed our conservators and curators time to study the works carefully, using the facilities available at the Getty Conservation Institute (GCI) and the Getty Research Institute (GRI). The work of my colleagues is part of an ambitious and unparalleled collaborative and cross-national research project with partners in Argentina and Brazil: TAREA—Instituto de Investigaciones sobre el Patrimonio Cultural, Universidad Nacional de San Martín, Buenos Aires; and LACICOR, Universidade Federal de Minas Gerais, Brazil, as well as the Museum of Fine Arts, Houston (MFAH). Technical experts on the teams have pursued unprecedented research into the materials and processes adopted by the artists and have worked in tandem with art historians to consider these choices in relation to the social, historical, and economic issues of the period.

The GCI's Modern and Contemporary Art Research Initiative was launched in 2007 to explore the many and varied conservation needs of modern and contemporary art. The GRI's resources have likewise proved invaluable to the project, and historical material on view in the exhibition was provided by the Research Institute's immensely rich Special Collections. Through the GRI, we have also had the opportunity to invite a diverse group of scholars, curators, conservators, and other specialists to share their expertise with us in workshops and other forums. *Making Art Concrete* displays some of the findings of this comprehensive study.

Making Art Concrete hopes to shed light on the contributions artists from Argentina and Brazil have made to modern and contemporary art, and to consider their unique contributions to the history of art. The exhibition is part of Pacific Standard Time: LA/LA, a far-reaching and ambitious exploration of Latin American and Latino art in dialogue with Los Angeles. Supported by grants from the Getty Foundation, Pacific Standard Time: LA/LA takes place from September 2017 through January 2018 at more than seventy cultural institutions across Southern California, from Los Angeles to Palm Springs, and from San Diego to Santa Barbara. Pacific Standard Time is an initiative of the Getty. The presenting sponsor is Bank of America.

For her commitment to original research, her generosity in lending such an important part of her collection to the Getty for this exhibition, and her trust in us, we are honored to dedicate this exhibition catalog to Patricia Phelps de Cisneros.

James Cuno
President and CEO, the J. Paul Getty Trust

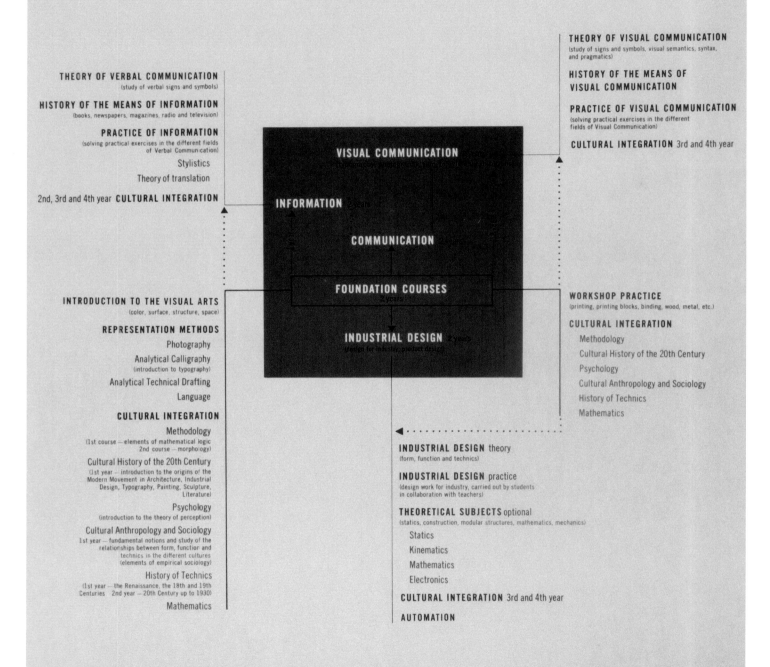

THEORY OF VERBAL COMMUNICATION
(study of verbal signs and symbols)

HISTORY OF THE MEANS OF INFORMATION
(books, newspapers, magazines, radio and television)

PRACTICE OF INFORMATION
(solving practical exercises in the different fields
of Verbal Communication)

Stylistics

Theory of translation

2nd, 3rd and 4th year **CULTURAL INTEGRATION**

INTRODUCTION TO THE VISUAL ARTS
(color, surface, structure, space)

REPRESENTATION METHODS

Photography

Analytical Calligraphy
(introduction to typography)

Analytical Technical Drafting

Language

CULTURAL INTEGRATION

Methodology
(1st course — elements of mathematical logic
2nd course — morphology)

Cultural History of the 20th Century
(1st year — introduction to the origins of the
Modern Movement in Architecture, Industrial
Design, Typography, Painting, Sculpture,
Literature)

Psychology
(introduction to the theory of perception)

Cultural Anthropology and Sociology
1st year — fundamental notions and study of the
relationships between form, function and
technics in the different cultures
(elements of empirical sociology)

History of Technics
(1st year — the Renaissance, the 18th and 19th
Centuries 2nd year — 20th Century up to 1930)

Mathematics

THEORY OF VISUAL COMMUNICATION
(study of signs and symbols, visual semantics, syntax,
and pragmatics)

HISTORY OF THE MEANS OF
VISUAL COMMUNICATION

PRACTICE OF VISUAL COMMUNICATION
(solving practical exercises in the different
fields of Visual Communication)

CULTURAL INTEGRATION 3rd and 4th year

VISUAL COMMUNICATION

INFORMATION 2 years

COMMUNICATION

FOUNDATION COURSES
2 years

INDUSTRIAL DESIGN 2 years
(design for industry, product design)

WORKSHOP PRACTICE
(printing, printing blocks, binding, wood, metal, etc.)

CULTURAL INTEGRATION

Methodology

Cultural History of the 20th Century

Psychology

Cultural Anthropology and Sociology

History of Technics

Mathematics

INDUSTRIAL DESIGN theory
(form, function and technics)

INDUSTRIAL DESIGN practice
(design work for industry, carried out by students
in collaboration with teachers)

THEORETICAL SUBJECTS optional
(statics, construction, modular structures, mathematics, mechanics)

Statics

Kinematics

Mathematics

Electronics

CULTURAL INTEGRATION 3rd and 4th year

AUTOMATION

THE MATERIAL OF FORM
HOW CONCRETE ARTISTS RESPONDED TO THE SECOND INDUSTRIAL REVOLUTION IN LATIN AMERICA

Aleca Le Blanc

In 1956, Tomás Maldonado, the recently appointed interim rector of the Hochschule für Gestaltung (College of Design), in Ulm, Germany, came to Rio de Janeiro for an extended stay.[1] He was there primarily to install and inaugurate an exhibition in the capital at the Museu de Arte Moderna do Rio de Janeiro (MAM Rio)—his second exhibition there (fig. 1)—but he also used the experience to travel the environs and better familiarize himself with Brazil's changing cultural landscape: he visited new museums, met critics and intellectuals, and became acquainted with a group of young avant-garde artists who referred to themselves as Grupo Frente.[2] In fact, Maldonado made the 130-kilometer trip with MAM Rio's director, Niomar Moniz Sodré Bittencourt, to the nearby industrial town of Volta Redonda for the vernissage of their exhibition installed at the Companhia Siderúrgica Nacional (CSN), Brazil's national steelworks factory.[3] Although the documentation on this exhibition is scant and it is impossible to know which works were shown and how they were displayed, the fact that a national public-works company hosted an exhibition of contemporary art made by vanguard artists who were just beginning to establish their reputations is by no means commonplace.[4] This seemingly minor event is illustrative of how the visual arts in Latin America—artists as well as institutions—engaged with the rapid industrial development in the region's principal cities during the postwar period.

In the broadest sense, studies of aesthetic modernisms and the historical avant-garde have explored the ways in which artists, architects, and designers responded to the vast technological changes that took place in Europe and the United States during the nineteenth and twentieth centuries. These makers frequently tethered the radical new formal languages to very specific political and historical contexts.[5] As society began to move away from agricultural traditions in favor of an urbanized and industrial way of living, artists in cities such as Detroit, Dessau, Moscow, and Paris began reacting to these changes with a host of new visual forms and structures.[6] Sometimes celebratory, oftentimes critical, many of the visual languages that emerged came to constitute an evolving avant-garde.

OPPOSITE | Diagram of the curriculum of the Escola Técnica da Criação, printed in fundraising brochure for the Museu de Arte Moderna do Rio de Janeiro's Camininha Internacional de Socios, November 1957, p. [14]. Museu de Arte Moderna do Rio de Janeiro.

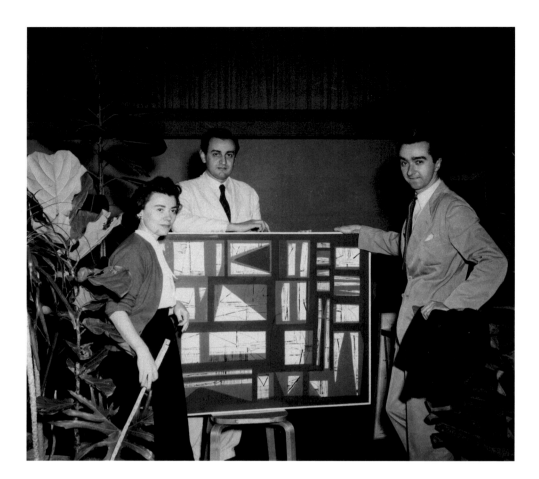

The development and expansion of industrialization in Latin America is significantly different from the way it unfolded in the North Atlantic. Although cities such as Rio de Janeiro, São Paulo, and Buenos Aires experienced many of the same phenomena that cities in Europe and the United States had experienced before—industrialization, technological innovation, increased communication, and rapid urbanization—the chronologies of these processes followed a different course and sequence than their North Atlantic counterparts. As in the United States and Europe, these changes to the fundamental ways people lived their quotidian lives in Latin America registered deeply in their visual cultures. Yet, many artists working in Brazil and Argentina were already well versed in the visual languages of the earlier European vanguards when their own nations entered the throes of wide-scale industrialization initiatives in the 1940s and 1950s. These artists could adeptly deploy the signifiers of previous avant-gardes that had emanated in decidedly different historical contexts; the manipulation of one-point perspective as in Pablo Picasso's analytical cubism from Paris in the early 1910s, the restraint of the primary colors as in Piet Mondrian's de Stijl painting from Holland in the early 1920s, and technological investigation with photographic materials as in László Moholy-Nagy's experiments at the Bauhaus in the mid-1920s are just some examples. This ostensible

FIG. 1 | (From left) **Niomar Moniz Sodré Bittencourt, Tomás Maldonado, and Miguel Ocampo during the installation of the exhibition *Grupo de artistas modernos Argentinos* at the Museu de Arte Moderna do Rio de Janeiro in 1953.** Maldonado exhibited at this museum again in 1956. Museu de Arte Moderna do Rio de Janeiro.

anachronism—the deployment of modernist visual languages before the wide-scale modernization of the region, or as anthropologist Néstor García Canclini described it, "an exuberant modernism with deficient modernization"—is fundamental to the subsequent configurations of art and technology in various Latin American contexts.[7] The works discussed in this essay, and on display in this exhibition, are examples of these reordered chronologies. Indeed, Latin American modernisms at midcentury are representative of broader international trends in which artists, architects, and designers were searching for aesthetic forms and strategies to reconcile prewar legacies with the vast new social, political, and cultural conditions that characterized the postwar experience. By examining Latin American vanguards in relation to received histories of modernism, it is possible to make an important intervention into dominant narratives and undermine the artificial division commonly drawn between work produced in the decades before and after World War II.[8] Moreover, these artists, and the work they made, prove there is historical and intellectual continuity across the twentieth century, not to mention across the Atlantic Ocean. These chronological and geographical connections are some of the key reasons this period in Latin American visual culture is so compelling. Young artists working in the cosmopolitan centers of the Southern Cone region were experiencing a major societal and economic paradigm shift, but it was one with which they were already familiar, even if from a distance. In their lifetimes, they had pined for commodities manufactured and imported from abroad while simultaneously witnessing the tragedy of technological warfare during World War II, both outcomes of industrialization in Europe and the United States. For many, the destruction of nations and people represented the very real dystopian consequences of runaway technology—and consequently, in the Southern Cone the perception of industrialization was already prejudiced. Therefore, in a conscious effort to avoid repeating the ghastly acts of World War II and protect the future of their nations, presidents such as Brazil's Getúlio Vargas (1930–45; 1951–54) and Argentina's Juan Perón (1946–55) began initiating what they considered major industrial programs geared toward positive forms of modernization (such as automobiles), rather than negative (such as weaponry). Artists were quick to engage with the effort and took active roles in shaping its direction as architects, designers, and educators. Most of the objects included in the discussion that follows reflect an enduring optimism about the possibilities of industry; indeed, given the benefit of hindsight, there was a pervasive enthusiasm in Brazil and Argentina based on the assumption that their growing domestic industrial sector would lift their nations out of underdevelopment and ultimately improve quotidian life for all.[9]

In this exhibition of selected artworks from the Colección Patricia Phelps de Cisneros, we have focused on the cities of Buenos Aires, São Paulo, and Rio de Janeiro, and on works made between the 1940s and the early 1960s.[10] Of course, there are many other cities in Latin America that could have been included to explore this theme of industrialism, visual arts, and new materials, but we chose to concentrate on these three due to their somewhat parallel histories in the twentieth century. Brazil and Argentina experienced similar immigration patterns, with large populations arriving from Europe

in waves during the first half of the century; as well as comparable political histories, with each country undergoing periods of intense dictatorships as well as populism and democracy.[11] The history of modern art in each of these cities was also similar, with important avant-garde movements in the 1920s, the rise of social realism in the 1930s and 1940s, the establishment of museums of modern art in the 1940s and 1950s, and then a turn to radical conceptual practices during the 1960s and 1970s.[12] But what is most important to our project is that all three cities had groups of artists that were dedicated to concrete art during the period in question.

Concrete art is a style of abstraction divorced from any observable reality and partially based on mathematic principles, typically resulting in compositions of geometric shapes. Originally an outgrowth of European constructivism, concrete art was founded on one of the key tenets of the historical avant-garde: the desire to produce images and objects that merged art with life and industry. The term was first coined in a 1930 manifesto written by Theo van Doesburg in Paris, decades before the movement's widespread postwar revival in many cities across the West, including among groups of artists working in Zurich and Milan, as well as Buenos Aires, São Paulo, and Rio de Janeiro.[13] Although the reasons concrete art was taken up by artists in each city are undeniably quite unique, a fundamental motivation that unites all of them and helps to explain why the style had such wide appeal is its supposed rejection of subject matter. By eliminating representations of discernible real-world symbols—archetypical folk heroes, cityscapes, battle scenes, and such—the artists presumed that their geometric works were politically and culturally neutral, and therefore accessible to any viewer regardless of education and cultural background. For these artists, the viewer needn't have any specific historical knowledge, nor even be literate; in theory, all one needed to experience these works was the ability to see. Of course, the very desire to eschew national specificity is already political, and this aspiration is ultimately part of what tethers these artists to the time and place in which they worked.

The concrete artists working in Buenos Aires, São Paulo, and Rio de Janeiro came from very diverse backgrounds: some were from prominent families with wealth and social standing, others were part of an emerging middle class, and still others were European immigrants themselves.[14] Nearly all of the artists under consideration here traveled to Europe at one point or another, many with the help of prize money, and it wasn't uncommon for artists from different parts of Latin America to meet for the first time abroad. There were also those who ultimately left the Southern Cone, eventually establishing residences in cities such as Paris, New York, and Milan.[15] What ties these artists together is that they were affiliated with concrete art while they lived in Argentina and Brazil and, as a result, made significant contributions to postwar visual culture.

However, the aim of my essay is not to argue whether these artists were beholden to nationalist or universalist ambitions—although these works have frequently been interpreted in both ways—nor is it to reinforce a teleological narrative of originality within the avant-garde, keeping track of who did what first. Both of these art historical approaches can

very quickly become interpretive traps, limiting the possibilities for potentially rich comparisons. Instead, this study draws a new perimeter around these artworks and attempts to understand how and why artists living in the cosmopolitan centers of Brazil and Argentina during the late 1940s and 1950s interrogated the possibilities and limits of concrete art, frequently arriving at similar conclusions, even with few channels of communication.[16] This is a study not of influence but rather of coinciding aspirations and synchronicity.

To write this new narrative, one must give equal consideration to the historical and physical properties of these works. In other words, the social and political context in which they were realized is of paramount importance to the interpretation of these objects, as are the formal decisions these artists made when executing their paintings— their chromatic choices as well as the mathematical or design decisions that produced the final compositions. However, this two-pronged approach is frequently where interpretation concludes; other aspects of each composition's form are rarely, if ever, examined with the same scrutiny. I contend that when interpreting the object, one must also ask questions about which support material, such as canvas or board, was selected; how that material was manipulated prior to its painting, primed or left bare; which tool—spray gun or brush—was used to apply the paint to the surface; and finally, how that finished object was installed on the wall, taking into account not just the front but also the sides and back of the work.[17] In fact, the deliberate and specific material and technical choices made by artists are inextricably linked to the social and political underpinnings that led artists to explore and expand concrete art.

Although some may see these choices as incidental considerations, they are in fact fundamental to the integrity of the final object and further underscore the artist's subjectivity in the art-making process. If one is to consider the object's design in aggregate, then we must study not just the disembodied composition on the surface but also the three-dimensional object that sustains the composition, indeed the materials that concretized the forms. The material and formal decisions made by these young artists are indices of the time and place in which these works were realized. Therefore, I propose a different interpretive lens—what I call holistic formalism—that amplifies the frequently relied-upon interpretive model of formalism. Holistic formalism calls attention to the shape and size of an object, its surface quality, and the particularities of framing and installation; it also addresses each of these factors with historical specificity, thereby revealing what makes each of these objects culturally and materially distinct from concrete art objects realized elsewhere. Despite what some artists and critics might have hoped, these works are neither politically neutral nor culturally universal.

Redesigning Education

In 1956, when Maldonado was visiting Rio de Janeiro, concrete art had already been adopted in all three cities in question. In fact, Maldonado himself was a concrete artist who had helped to establish the movement in Buenos Aires more than a decade earlier. As previously mentioned, by 1956 he was the newly appointed interim rector at the

Hochschule für Gestaltung, in Ulm, Germany, where he taught design and theory.[18] The Ulm School, as it is more commonly known, was an academy that had just been inaugurated in 1955. It was established with the intention of continuing the pedagogical work of the Bauhaus, which ceased operations in 1933 under Nazi pressure. Ulm's curriculum was largely modeled after the earlier institution's program when it operated in Berlin in its final years, focusing on design with aspirations to merge art with life and industry for the modern citizen.[19] The Ulm School served as a model to others and seemed to propose an optimistic path forward in an increasingly industrialized postwar period.[20] So important was the concept behind the Ulm School that Moniz Sodré, MAM Rio's director, invited Maldonado to install an exhibition at the museum dedicated to the school even though it had been in operation for only a single year. The role of aesthetic education was a cornerstone of MAM Rio's mission from the time it opened in 1952, and even though the museum was still in its infancy, Moniz Sodré was determined to establish a smaller version of the German design school within her museum (see p. viii). Maldonado was also in the city because Moniz Sodré had invited him to help design curriculum for that academy, the Escola Técnica da Criação (Technical School of Creation).[21]

During these years, it was widely believed by many, including this new generation of artists, that education was one of the most important tools to safeguard against repeating the atrocities of World War II.[22] Broadly, education would enlighten citizens, imbuing them with reason and a newfound sense of humanity—and, more specifically, with a visual appreciation for their modern world, informing their relationship with industry and its potentials. In addition, for those in the art world, education would promote aesthetic appreciation. It was precisely for these reasons that many of the newly founded museums in Rio de Janeiro and São Paulo aspired to offer classes for their patrons, young to old, from their first days of operation. Even before Moniz Sodré initiated the Escola Técnica da Criação at MAM Rio, she hired the artist Ivan Serpa to teach painting classes for children and teens, beginning in 1952. Young artists such as Hélio Oiticica and Aluísio Carvão both attended Serpa's Ateliê Livre, where they befriended other concrete artists. Lina Bò Bardi established the Instituto de Arte Contemporânea (IAC; 1951–53) at the Museu de Arte de São Paulo (MASP) to develop the applied arts in Brazil, with the objective of making quotidian objects aesthetically pleasing. Some of the artists affiliated with the concrete movement in São Paulo, including Antonio Maluf, Alexandre Wollner, and Mauricio Nogueira Lima, attended courses in graphic arts at the IAC and went on to become some of the most esteemed designers in Brazil (fig. 2).[23]

In Buenos Aires, the situation was different. There, new ideas about modern life and design were circulated principally through *Nueva Visión: Revista de cultura visual,* founded by Maldonado and in publication from 1951 until 1957 (fig. 3). Maldonado had been advocating for a strengthened connection between art and industry since before the founding of *Nueva Visión,* and he put his theories and position into practice in his classes at the Ulm School as part of a new phase of lecturers who promoted a closer relationship between design and science.

FIG. 2 | **Brochure for the Instituto de Arte Contemporânea at the Museu de Arte de São Paulo, 1951–53.** Collection of the Library and Documentation Center of MASP.

While in Rio, Maldonado lobbied specifically for the importance of education in a public talk he delivered at MAM Rio titled "A educação em face da Segunda Revolução Industrial" (Education in the face of the Second Industrial Revolution). He began with a dire prediction: "It is not an exaggeration to say that the future of our industrial civilization relies upon the success or failure of educational reforms made in the short term," and went on to discuss how vital this was for the advancement of humankind.[24] To further emphasize his point, he put it into political terms, describing how education had entered the arms race and become a strategic tool marshaled by the new world powers—the United States and the Soviet Union—to create advantage during the steady expansion of the Cold War.[25] In short, to Maldonado's eyes the potential for catastrophe was already in place unless there was a rapid and widespread implementation of art and design curricula that would help orient people toward positive ends rather than self-destruction. Perhaps, then, it is not surprising that many of the artists represented in this book studied design in one capacity or another—it became a common vocational program for young people during these years—and ultimately established their professional careers in the field. Design in graphics, products, textiles, garments, furniture, and lighting are just some of the ways in which these concrete artists made their living.[26]

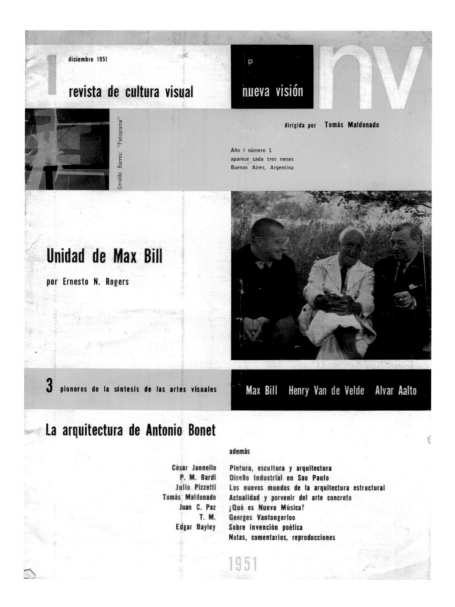

Visualizing Industry

Visual artists working in these design fields would have been accustomed to the mechanical reproduction of their patterns and prototypes, as well as to their inability to control how their creations circulated in the public sphere. However, the artists did not see these industrial consequences and the anonymity of their ideas negatively. Instead, they embraced the principles of serially produced designs and incorporated the concept of repetition in their artistic practice as yet another way to visualize the industrial process.[27] In some instances, intentional or not, serial repetition was a by-product of their group installations, and in others, such as in paintings by Geraldo de Barros and Hermelindo Fiaminghi, it was used as a compositional schema, creating patterns by repeating the same geometric shapes and colors. Many concrete artists took advantage of symmetry,

FIG. 3 | **Cover of *Nueva Visión*, no. 1 (Buenos Aires, December 1951), designed by Alfredo Hlito.**
Buenos Aires, Private collection.

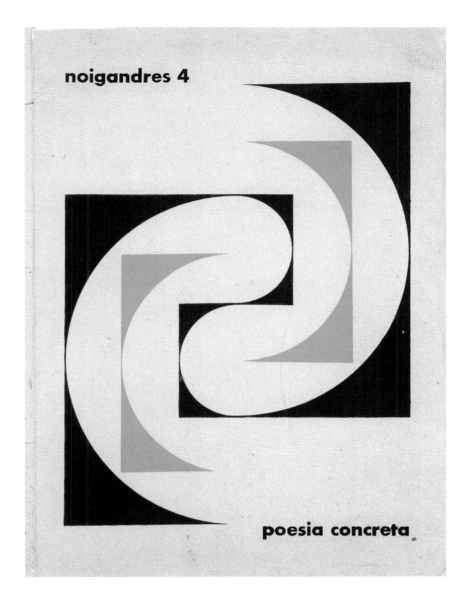

noigandres 4

poesia concreta

doubling or mirroring the forms in their paintings. Fiaminghi utilized these strategies in his graphic design as well as in handmade paintings (fig. 4). He often assigned titles to his works that referenced their serial nature. *Alternado* 2 (1957), for example, suggests that a value is repeatedly alternating in the composition, while *Seccionado no. 1* (1958) hints that a value has been dissected in equal parts or sections (see pls. 16, 17).

Geraldo de Barros is one figure who, as a painter of concrete art, a photographer, and a designer, liberally applied concepts, tools, and materials from one arena to another. De Barros came of age in São Paulo in the late 1940s and was one of the first young artists working in Brazil to produce visual art that responded to the new phase of industrialization. His painting *Função diagonal,* from 1952, is an early response to the changing times and also connects to the other media in which he was working, both visually and

materially (see pl. 11). For example, restricting himself to the same reduced palette as his experimental and abstract black-and-white photography, at first glance the relatively modest painting (2 × 2 feet) seems to consist of alternating black and white squares that in turn overlap one another as they tilt and decrease in size. In fact, on closer inspection, one can see that the work was painted white and then black shapes were painted on top to create a pattern of nine white triangles repeated, in three descending proportions, arranged around a single white lozenge just slightly askew from the very center of the composition. The illusion of space within the painting is also paradoxical; the configuration of these shapes seems to dissolve foreground and background into a flat plane, despite the fact that the same configuration suggests that the squares are receding toward a vanishing point in the very middle. The title indicates that this painting is the graphic representation of a mathematical function, or, in Portuguese, *função,* which by definition relates one set of values to a second set that was methodically processed identically, like products coming off of a conveyor belt—in this case, presumably governed by the diagonal line, or *diagonal.* The surface betrays little evidence of the artist's hand and has the smooth finish of industrially produced and coated compressed board, resembling a manufactured product like Formica. De Barros painted with alkyd, the technical term for house paint, on compressed hardboard, in order to achieve this flat and uniform surface. The sharp straight edges within the composition appear to have been executed by laying down tape, an inference that can be made based on the sharp and raised nature of the edge itself, as well as the type of imperfections of the line seen only on closer inspection. These are not due to a shaky hand holding a brush newly loaded with paint; these small irregularities are a common phenomenon when using tape, wherein small amounts of paint often bleed under the tape before it is removed.

Hermelindo Fiaminghi, a friend and colleague of de Barros's, similarly made use of the industrial paradigm in his artistic practice. Like de Barros, Fiaminghi was also a graphic designer, and he was already working as a prominent lithographer when he began making his geometrically abstract paintings in 1953. Fiaminghi, too, applied alkyd paints to prefabricated hardboard; however, instead of aiming for the perfectly smooth finish of *Função diagonal,* Fiaminghi called attention to the surface of the painting by creating geometric patterns that fluctuated between matte and gloss finishes. In *Seccionado no. 1,* which looks like a series of squares and circles superimposed on one another—again similar in concept to *Função diagonal,* although to very different effect—Fiaminghi juxtaposed zones of glossy orange on the left half and glossy red on the right, both butting up against a very matte, almost chalky, salmon pink (see pl. 17a). What makes this work exceptionally interesting is that rather than work on the smooth side of the hardboard, typically favored by artists who wanted a quasi-industrial finish, Fiaminghi painted on the textured side, which bore the physical trace of the board's production and thus left a slightly coarse, uneven surface (see pl. 17b). One possible reason for doing this was to take advantage of the textured surface and exacerbate the differences in gloss levels between the two paints being used, allowing the salmon pink zones to be dull and lusterless and heightening the shininess of

the orange passages. Fiaminghi also glued a small box to the back of the board, using the box as his hanging device, so that the painted panel projects from the wall and seems to float in space (see pls. 17c, 17d). He even made the extra effort to paint the sides and back that are visible behind the panel, blurring the line between painting and sculpture.

To further distance the object from any personal or sentimental content, many artists from this generation—including both de Barros and Fiaminghi—also neutralized their names into symbols or signed their work only on the back. De Barros's use of industrial paint and tape was unorthodox, and he marked the surface of *Função diagonal* in yet another unconventional manner. Instead of signing the work, he scratched the lowercase letters *g* and *b* and a small circle into the black field in the lower right corner, thereby incising a symbol that incorporated his initials in lowercase script, circumscribed within a circle (see pl. 11c).[28] With this etched monogram, de Barros replaced the traditional signature, something typically written effortlessly as a mark of both individuality and authentication, with a symbol that was carefully scratched out using a sharp utensil or stylus for engraving (a technique he commonly applied to his negatives before he printed the photographs) and a design template to make perfect circles, likely on hand in his studio. De Barros used this mark on other objects, too: sometimes it appeared as a professional logo for his work in mass communication and furniture design, as well as on artworks, in much the same way that most industrially produced commercial products bear the logo of their manufacturer. Fiaminghi went so far as to paint his name in a stylized lowercase sans-serif script on the reverse side of his boards, executed with the precision of a schoolteacher's penmanship (see pls. 16c, 17d).

An obvious consequence of undermining one's signature, either by obscuring it on the back or by depersonalizing it with a logo, is that it becomes harder for the viewer to identify the artist when the work is on the wall. This is further accentuated in paintings of geometric abstraction, since these paintings were never intended to reflect an individual's intuition or personal feelings, nor to refer to objects in the real world, making it difficult to recognize an individual's style. Rather, these paintings were impersonal premeditated diagrams that engaged and challenged the viewer's relationship to space; the artist's identity became nothing more than a subordinated detail. Certainly, it can be a challenge to tell the works apart sometimes, even for the experienced viewer. This authorial ambiguity resonated with the political views of many in these groups. Because so many of the artists in São Paulo, and in Buenos Aires before them, ascribed to socialist if not communist values, they believed that collective talent superseded the sum of their individual contributions, so that when the artists installed their works they preferred to be associated with the group, such as Grupo Ruptura in São Paulo and Grupo Madí in Buenos Aires, rather than identified as solo artists.

A principal way these painters visualized this collective sensibility was in the scheme they followed when hanging their works together. Grupo Madí rejected the traditional row of paintings hung one by one and instead arranged artists' works as a cluster on the wall, with some works above, some below, and others off to each side, all with the

intention of not privileging a single work of art. In São Paulo, both de Barros and Fiaminghi frequently painted on same-size panels—compressed board approximately two feet square projecting a few inches from the wall—as did the others in Grupo Ruptura. As a result, when the artists hung their work together—in their case, one next to another in a row on the wall—the serial repetition of these shallow square panels created visual cohesion and uniformity between the individual works, again making it difficult to differentiate one artist from another. Furthermore, without a signature on the front of the work, the identities of the individual artists were practically obscured. The nullification of identities was further reinforced by the fact that many of these artists engaged in a purely geometric visual language—indeed, it is still challenging to attribute a work to an artist without inspecting the textual clues on the back of it. For example, the early paintings by Juan Melé and Raúl Lozza, who worked together in Buenos Aires, are difficult to distinguish on form and composition alone. That artists were eager to work collectively and thus mitigate their own reputations was a significant departure from anything conventional.

Although it would seem contrary to socialist values, this embrace of serial repetition was also reinforced by the newly commoditized cultures in which the artists were living. As the means of production increased in Argentina and Brazil, so did domestically produced commodities such as radios, televisions, and other appliances, which began to circulate with more frequency, filling store shelves as well as living rooms. Because many of these domestically produced objects were increasingly available to and affordable for the growing middle class, there was a democratizing effect, which would have appealed to the artists' sense of populism. These circumstances—representing a major economic shift for people living in Argentina and Brazil—seeped into the consciousness of artists and designers.

Without a doubt these artist-designers understood that designers had devised all of these new products, as well as the logos and packaging, for the modern citizen. Designers typically remained anonymous to the consumer, though; instead, these items were better known by their brand names and the logos that were stamped on them. In fact, one could argue that negating one's signature on a work of art was not dissimilar from doing so with one's graphic or industrial designs.[29] This growing awareness of brand names registers in the materials that artists, especially artists in Brazil, were adopting. With a keen eye toward their ascending commodity culture, many of the artists indicated which brand of board they had used, rather than simply referring to it as a panel. The backs of many works display the proprietary names, such as Eucatex or Duratex, although it is quite possible that the artists used them as generic signifiers (see pls. 14d, 23d). In the case of Brazil, these brands began to be domestically produced and commercially available only in the early 1950s. Thanks to increased demand for inexpensive materials by the industrial sector, the alkyds and hardboard panels with which artists were painting were far more widely available and affordable than traditional oil paint and cotton canvas. Thus, by indicating the brand names on the works themselves, these artists openly acknowledged the importance of the industrial materials and the role they played in the creative process.

FIG. 5 | **Raúl Lozza (Argentine, 1911–2008). Sketch of *Invención no. 150* (Invention no. 150), 1948, gouache and graphite with collage of cut paper on board, 15.7 × 22.4 cm.** Buenos Aires, Archivo Raúl Naón.

To achieve these results, many concrete artists adopted methodical working processes, reminiscent of the research and development phase a manufactured product undergoes: these artists often worked in series, systematically tested various compositional solutions, and created multiple modified renderings of similar visual and compositional challenges. The adaptation of these industry-inspired procedures also implies that the very idea of artistic research had changed. Whereas one or two decades prior, the artist studied history and literature in order to connect their visual artworks to established narratives, in the postwar period the concrete artist tried to emulate a more detached and dispassionate process by creating and testing prototypes. For example, many of the titles of the works in this show include numbers, insinuating that they resulted from a serial process. The titles for the individual paintings suggest one iteration within a much longer sequence. Juan Melé, who was active in Buenos Aires in the 1940s, often numbered the titles of his works from this period; *Marco recortado no. 2* (1946) and *Planos concretos no. 35* (1948) are just two examples (see pls. 28, 29).

Melé's friend and colleague Raúl Lozza archived a sketch of each composition, leaving visible the geometric diagram that determined the final composition. He also created meticulously detailed inventories of the paint colors and mixtures he used for each element in his artworks (fig. 5).[30] By systematically cataloging the process of his research,

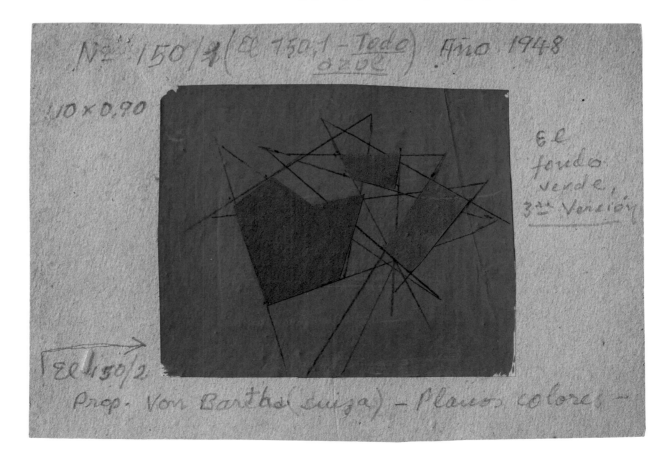

Lozza kept track of his formulas and mixtures for different color values as if he were working in a laboratory. Even in a relatively minimal work like *Relieve no. 30* (1946), the title suggests that there could have been at least twenty-nine other iterations that came before (see pl. 25). This work consists of four small, irregularly shaped geometric monochromes, in green, ochre, and two different shades of red. They are joined in a fixed configuration by a heavy metal wire painted black that is attached to small wooden blocks on the backs of the panels. Once hung on the wall, this arrangement of hardware is just enough to project the paintings off the wall so that they hover just in front of it. Lozza seems to have been searching for a way to generate a composition that incorporates both the hanging device and the wall into a work with multiple freestanding elements. In *Relieve no. 30,* he uses the heavy black wire to arrest these four hand-size monochromes into fixed positions, thus retaining control of the elements' relationships to one another. One can find examples throughout Lozza's career of the solutions he attempted as a way to regulate how the smaller monochromes were installed, such as mounting the individual elements onto a larger monochromatic board and fixing both their configuration and the color of the background. Eventually, Lozza jettisoned the painted backboard and decided that the entire wall should be painted a color of his choosing. By revealing so many aspects of his procedures in notes, writings, and inventories, Lozza's archives reinforce the fact that he, like many of the concrete artists, was as interested and invested in the research process as in the final product.[31]

Wrestling Conventions

Judith Lauand, a concrete artist who worked in São Paulo during the 1950s, also made use of seriality. Like others, her titles are frequently numbered, suggesting a sequential progression or potential relationship from one composition to the next. Two works in this exhibition, *Concreto 36* and *Concreto 37,* both from 1956 and both painted on plywood of similar dimensions, certainly suggest that there is a conceptual connection between the final products, as well as with the presumed thirty-five pieces that came before (see pls. 21, 22).[32] Like Fiaminghi and Lozza, Lauand rarely framed her boards and instead developed a specific hanging device so that the face of the work would project from the wall (see pl. 23d). Many of her works have small wooden boxes attached to the back, so that when installed, the painted surface appears to float in space, unhinged from conventional hanging devices (see pls. 21b, 22b, 22c, 23b–23d).[33] They are executed with similar palettes, and one can see that the compositional elements are at least partially determined by mechanical tools such as protractors and compasses, particularly in *Concreto 36,* where the vermilion angle in the lower region continues to expand by regular intervals (see pl. 21). However, despite her novel hanging devices and mathematically derived compositions—indications that Lauand strived to create a specific visual experience in accordance with the tenets of concrete art—she signed and dated her works with paint along the lower edge of the composition (see pls. 21, 22, 23, 24). With that small scrawl punctuating the lower edge, Lauand essentially negates any illusion that her works are divorced from lived reality.

Lauand was not the only concrete artist to undermine her own aesthetic objectives with something like a signature. All of the artists I have discussed thus far were wading into contested territories as they rejected some of the most traditional devices of fine art painting: oil, canvas, and frame, not to mention figurative content as well as the artist's signature in a lower corner. Indeed, they were anxious to push the boundaries and create work that was in conversation with industry, through serial reproduction, an emphasis on the research process, a selection of novel materials, and the anonymity of the artist. Yet, despite a repudiation of convention on the part of many concrete artists, theirs was a constant mediation between tradition and vanguard, as well as local and international.[34] Lauand's works from this period are an excellent example of this Janus-faced negotiation, simultaneously looking to the future and the past.[35] Although the historiographical record implies otherwise, the artists affiliated with concrete art in Buenos Aires, São Paulo, and Rio de Janeiro were still emerging and relatively unknown in their respective cosmopolitan contexts; they were working under the hegemony of artists like Antonio Berni in Buenos Aires and Cândido Portinari in Rio, who had dominated the 1930s and 1940s in their respective cities with heroic portraits of the proletariat and who were still considered by most in their countries to be the artistic masters of the period.

Like Lauand, Fiaminghi mediated the past and the future in his works. As previously described, he often painted his name on the back of the board in an extremely neat and stylized lowercase script. However, with *Alternado 2,* he signed the front of the work, albeit in a curious way: he signed it twice, in two different corners, oriented in different directions, though now only one is visible, under infrared light (see pl. 16a).[36] Signatures traditionally run horizontally on the painted surface, implicitly orienting the direction of the work. Yet, in the case of *Alternado 2,* the signature that remains visible runs along the upper right edge of the painting, vertically. According to convention, the composition should be rotated so that the signature falls to the lower right corner. But the back of this painting includes a bold black arrow, presumably signaling the direction it is to be hung and shifting that signature back to the upper right (see pl. 16c). This ambiguous orientation is further complicated by the use of the square format, which makes it neither landscape nor portrait, and since the painted subject does not refer to the world of objects around us, it is not easy to determine in which direction the geometric pattern should hang, nor if the artist even had a single orientation in mind.

The issue of the frame is one of the fundamental conventions that artists in Buenos Aires, São Paulo, and Rio de Janeiro took up in their quest for a new industrialized vanguard. In fact, in *Arturo,* the first publication issued by the artists in Buenos Aires, Rhod Rothfuss wrote "El marco: Un problema de plástica actual," which became a seminal text for his cohort in the 1940s.[37] Rothfuss argues that the work of art could not be contained in or confined to an arbitrary rectangular frame. Instead, the composition itself should determine the final shape, for which artists could custom-build a support around the composition's perimeter or on the back. Many of Rothfuss's peers in Buenos Aires adopted this mandate, and almost immediately the works started to reflect a new

openness. Take Juan Melé's painting *Marco recortado no. 2,* for instance. In this work, Melé constructed a geometric composition, but one that was executed as if an exercise in skewed one-point perspective, where the vanishing point lay somewhere below and off the painted surface (see pl. 28). The final shape of the panel takes on the contours of a cast shadow falling across a grid, resulting in angular notches jutting out from three sides, thus making a rectangular frame impossible.

Typically, frames help to create the illusion that one is looking through a window onto the world—however, if one has no desire to depict the observable world, then the device is rendered entirely dispensable. With the omission of the frame, artists expanded their ideas about what was possible on the painted surface. They began to address other elements of their compositions, frequently wrapping the forms past the margins and onto the sides, as we have already seen in Fiaminghi's work (see pl. 17c). This small gesture produces a dramatic effect by calling attention to the fact that these are physical things, underscoring the reality that no painting is only a disembodied two-dimensional composition—rather, all are three-dimensional objects, usually with at least six sides, that are then affixed to the wall.

Willys de Castro, a graphic designer and visual artist working in São Paulo, not only rejected the rectangular frame in his mature work but also created objects that were impossible to contain, simultaneously painting and sculpture, questioning the arbitrary distinction between these traditional categories. Somewhat surprisingly, like Maldonado, he worked with relatively traditional materials—oil paint, canvas, and board— but it was how he manipulated and combined them that prevented any of his works from fitting easily into a preordained category. In a work such as *Objeto ativo (amarelo)* (1959–60), de Castro methodically glued canvas to one side of a hardboard panel, fold- ing it meticulously around the edges and mitering the corners on the back so that all of the fabric lay perfectly flat. Then he painted the face of it yellow, creating what by most accounts would appear to be a monochrome, except for two small visual clues that sug- gest there is something more to the composition (see pl. 14). At the middle of the far right edge of the painting appears a very small dark blue square, and along the left edge is a dark blue strip with a yellow notch in the middle, the same size as the square opposite (see pl. 14b). It is as if that square has somehow escaped and migrated across the canvas. These small clues issue an invitation to the viewer to come closer and look more carefully. Only then does one realize that the composition actually wraps around the sides of the panel, which is only half a centimeter in depth, revealing similar zones and squares of yellow and blue along the very thin edges (see pls. 14a, 14c). Because de Castro attached pieces of wood to the back of the panel in order to create a very shallow rectangular box, the work projects off the wall, but only by an inch.

This *Objeto ativo (amarelo)* epitomizes the concept of the nonobject, developed and theorized by poet and critic Ferreira Gullar. In his landmark essay, "Teoria do não-objeto" ("Theory of the Non-Object"), published in the Sunday supplement of the *Jornal do Brasil* in December 1959, Gullar contends that many of the art objects being produced in Brazil

under the newly formed rubric of neo-concretism are not exclusively painting or sculpture but instead a new type of entity, the nonobject.[38] To illustrate this concept, Gullar relies on contemporary works by Lygia Clark, a concrete artist practicing in Rio de Janeiro during the 1950s. Works like her *Casulo no. 2* (1959) typify the nonobject: it is neither a painted sculpture nor a sculpted painting, but a geometric object representing an evanescent organic phenomenon, the cocoon (see pl. 8). Clark negotiated these seemingly irreconcilable dichotomies—the geometric and the organic, the industrial and the handmade, the painted and the sculpted—throughout her career, proving that not everything can be so easily categorized. Of course, Clark was also responding to the industrial climate in Rio, and her work exemplifies the issues discussed thus far about how artists of this generation in these three cities reacted to this radically new societal paradigm. In *Casulo no. 2,* Clark worked exclusively with industrial materials, nitrocellulose paint and sheet metal, and likely had the work produced by a fabricator in a metal shop, following her specifications about dimensions, cuts, and folds.[39] She exchanged the traditional paintbrush for the spray gun in the application of black and white on this object, which is painted not just on the front, sides, and back but also inside the cavities created by the folds (see pl. 8a). Furthermore, *Casulo no. 2* typifies the concept of seriality, as it belongs to an extensive series of other similarly titled works, where each is slightly modified from the next. Lastly, the object refuses framing of any kind because the quadrilateral is tilted into a lozenge, making it effectively impossible to associate the composition with landscape or portraiture, as is commonly done with the rectangular format.

This essay began by describing an impassioned lecture Maldonado delivered in Rio de Janeiro in 1956, in which he argued for the importance of education during this new industrial period. But he was not the only concrete artist espousing this position. Clark traveled to Belo Horizonte the same year to speak to students at the Escola Nacional de Arquitetura (National School of Architecture). In her comments, Clark praised their interest in "all forms of research." She encouraged them to continue to think expansively about potential applications of their technical training, even going as far as to associate their structural projects with painting, describing the latter as "an experimental field for the seeking out of new spaces."[40] She pronounced that painters were dealing with issues not so far removed from those of the modern architect. She equated the lines produced in her then current series, *Planos em superfície modulada,* as comparable in function to the doors, windows, and floors that architects draw into their designs (see pl. 7). In this short lecture, Clark makes one of the best and most succinct arguments for the importance of the concrete artist to "the future habitation of man," and the tenor of her words perfectly encapsulates the visionary and idealistic aspirations associated with concrete art.

 Early in her lecture, Clark emphatically states, "I firmly believe in the search for a fusion between 'art and life,'" and then explains why the concrete artist is uniquely situated to enter into collaboration with architects from the earliest stages of planning in order to achieve this synthesis. She describes concrete painting as the result of "a total

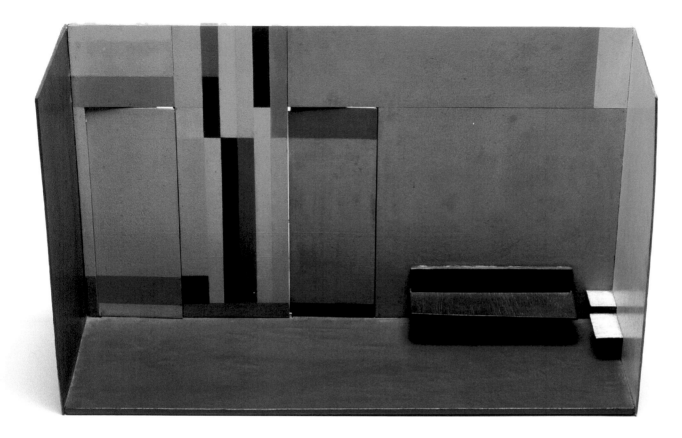

simplification in this manner of expression, a form has become a value in itself, without an expressive content" and continues, "if the Concretes compose with equal spaces and similar forms, there is already the establishing of a relationship between an architectural module and Concrete painting itself. If Concrete art dispenses with the expressive-organic character which has always been the characteristic of an individual work of art, then it should be supposed that it is already situated in an essentially different manner to an individual work of art in itself" (fig. 6). Having established the unrivaled merits of the concrete artist, Clark increases the stakes by declaring that "the most revolutionary thing that will be presented tomorrow, when new techniques and malleable materials are available for the artist and the architect to plan the future habitation of man," would be to enter into an equal partnership by which they will "find new and authentic plastic solutions."

Clark's sentiments echo those of many others who also saw the potential of concrete art to serve as a portal to the future. For the artists and critics of this generation, concrete art was far more than a formal style—it provided the road map to the new materials and techniques that would populate the future. With newfound access to technical education, concrete artists were exposed to new working methodologies and gained critical-thinking skills that ultimately allowed them to reevaluate many of the long-held conventions that governed their approach to fine art. In the modern economy,

FIG. 6 | **Lygia Clark (Brazilian, 1920–88).**
Maquette para interior (Maquette for interior), 1955, wood and automotive paint, 30 × 48 × 14.5 cm.

manual labor was no longer prized; instead, innovation came to be rewarded. This was a monumental paradigm shift for many in the rising middle class in Brazil and Argentina. In their rapid transition from agricultural economies to industrialized ones, these young artists and designers represented the first generation in a new societal order. It is no wonder that they began to experiment with different materials and methods, frequently documenting their attempts to produce a more systematic and less intuitive approach toward visual work. They were no longer the plantation workers engaged in repetitive manual labor. They were now the generators of new ideas and systems, optimistic about their process of research and development, with the imagined ends of making their modern cities appealing and efficient places to live and work. In the capable hands and mind of the concrete artist, the visual cultures of Buenos Aires, São Paulo, and Rio de Janeiro would be aesthetically enlightened, socially harmonious, economically sound, and politically stable.

NOTES

The identification of paint type used in this essay was carried out by Joy Mazurek, assistant scientist at the Getty Conservation Institute, as part of the project's broad technical study. Technical aspects of my essay rely on the work of my colleagues in the GCI.

1. Maldonado was a member of the board of governors, which assumed the control of the school fo lowing Max Bill's resignation in March 1956.

2. The exhibition held in July of 1956 was Grupo Frente's final show. This group consisted primarily of young artists dedicated to concrete art but was a much looser affiliation than other groups, such as those in São Paulo or Buenos Aires. Between 1954 and 1956, some of the artists linked with Grupo Frente included Aluísio Carvão, Lygia Clark, Rubem Ludolf, Hélio Oiticica, Abraham Palatnik, Lygia Pape, and Ivan Serpa, among others. Frederico Morais and Edmundo Jorge, *Ciclo de exposições sobre arte no Rio de Janeiro: 2. Grupo Frente / 1954–1956; 3. I Exposição Nacional De Arte Abstrata, Hotel Quitandinha / 1953* (Rio de Janeiro: Banerj, 1984).

3. In the early 1940s, President Getúlio Vargas selected the city of Volta Redonda as the site of the future national steelworks factory, which opened in 1946, for reasons both symbolic and functional. On the pragmatic side, the site is between São Paulo and Rio de Janeiro, Brazil's major centers of industry and of government, respectively. The federal government began construction on BR116, one of Brazil's busiest and longest highways, in the 1940s. In 1951, the stretch that connected Rio and São Paulo was finally inaugurated. Robert M. Levine, *Father of the Poor?: Vargas and His Era* (Cambridge: Cambridge University Press, 1998).

4. There are only two newspaper clippings describing this show in MAM Rio's archives. According to one, it was the cultural and recreational sector of the CSN that requested the exhibition, which included works by fifteen artists: Eric Baruch, Aluísio Carvão, Lygia Clark, João José da Silva Costa, Vincent Ibberson, Rubem Ludolf, César Oiticica, Hélio Oiticica, Abraham Palatnik, Lygia Pape, Ivan Serpa, Elisa Martins da Silveira, Carlos Val, Décio Vieira, and Franz Weissmann. "1a exposição de arte moderna em V. Redonda," clipping, newspaper unknown, 10 July 1956. From the Centro de documentação, MAM Rio, EXP #29, Grupo Frente, 14/7 a 14/8/56. According to Esther Emilio Carlos, curator of the 1994 Grupo Frente retrospective, works were installed in the corridors and attendees were described as "roaming through the Siderúrgica, looking at the exhibit." Despite its installation in a public building, it is hard to imagine who, exactly, the audience for this show would have been, other than the CSN workers, and if the general public could have easily visited and seen

the works ("que percorreram as dependências da Siderúrgica visitando a exposição"). Esther Emilio Carlos, *Grupo Frente* (Rio de Janeiro: Instituto Brasil-Estado Unidos, 1994), 4.

5 Some exemplary studies include Carol S. Eliel, ed., *L'Esprit nouveau: Purism in Paris, 1918–1925,* exh. cat. (Los Angeles: Los Angeles County Museum of Art, 2001); Serge Guilbaut, *How New York Stole the Idea of Modern Art: Abstract Expressionism, Freedom, and the Cold War* (Chicago: University of Chicago Press, 1983); Christina Kiaer, *Imagine No Possessions: The Socialist Objects of Russian Constructivism* (Cambridge, MA: MIT Press, 2005); and Nancy J. Troy, *Couture Culture: A Study in Modern Art and Fashion* (Cambridge, MA: MIT Press, 2003).

6 Examples include the paintings and photographs of Ford's River Rouge plant in Detroit by Charles Sheeler; the Bauhaus, a school of art and design in Dessau; constructivist artists in Moscow who aided the Russian Revolution; and Purism's embrace of new technologies and materials in Paris.

7 Néstor García Canclini, "Latin American Contradictions: Modernism without Modernization?," in Néstor García Canclini, *Hybrid Cultures: Strategies for Entering and Leaving Modernity,* trans. Christopher L. Chiappari and Silvia L. López (Minneapolis: University of Minnesota Press, 1995), 41. This is not to say that modernization was completely absent in Latin America; in fact, it happened very unevenly throughout the region, and only in the 1940s and 1950s did it accelerate and become more widespread in ways that were commensurate with the phenomenon in the North Atlantic decades earlier. Furthermore, the reference in this essay's title to the second industrial revolution is taken from a talk, "A educação em face da Segunda Revolução Industrial," delivered by Maldonado in 1956 at the Museu de Arte Moderna in Rio de Janeiro, and signals the acknowledgment of the delayed development of Latin America. Canclini's theory of hybrid cultures is one of the most widely read theoretical and interpretive models with respect to twentieth-century cultural exchange in Latin America. See Canclini, "Latin American Contradictions," 41–65.

8 This chronological division is commonly found in surveys of modern art. For example, *Art since 1900* is broken into two volumes, "1900 to 1944" and "1945 to the Present." Consequently, course curricula reflect this divide with classes about modernism covering 1865 through 1944 and postwar art focusing on the rest of the twentieth century as well as the twenty-first. Hal Foster et al., *Art since 1900: Modernism, Antimodernism, Postmodernism,* 2 vols. (New York: Thames & Hudson, 2004).

9 Despite having a generally positive outlook on industry, artists took part in outward acts of disapproval as well. In 1954, on the occasion of the 3° Salão Nacional de Arte Moderna, more than eight hundred artists across Brazil signed a petition condemning the increase in levies on foreign artist materials, put into effect in 1951 in order to support domestic manufacturing. However, the artists found the local materials to be inferior in quality—and, to prove their point, they agreed to exhibit only works executed with black and white materials. Because of this, the salon came to be known as the Salão Preto e Branco. The artists' protest successfully reversed the decision, and taxes on these foreign materials were lowered, although not as much as artists had hoped; in fact, these materials have remained quite expensive. Paolo Herkenhoff and Glória Ferreira, *Salão Preto e Branco: III Salão Nacional de Arte Moderna, 1954: A arte e seus materiais* (Rio de Janeiro: FUNARTE, 1985).

10 The artists who created these artworks are most frequently studied and exhibited in relation to their specific group allegiances and affiliations, including Asociación Arte Concreto-Invención, Grupo Madí, Perceptismo, Grupo Ruptura, Grupo Frente, and Neoconcreto. Instead, I discuss them with respect to the cosmopolitan center where they made their concrete work, which helps to break down the sometimes arbitrary divisions made between nationalities, class, and race. This model was very successfully deployed in the exhibition *The Geometry of Hope.* See Gabriel Pérez-Barreiro, *The Geometry of Hope: Latin American Abstract Art from the Patricia Phelps de Cisneros Collection,* exh. cat. (Austin: Blanton Museum of Art, University of Texas, 2007).

11 Of course, many events and circumstances created disparities between these places. My point is simply that the urban histories of these neighboring countries in the Southern Cone followed parallel paths.

12 There are several authors who discuss this period. See, for example, Rodrigo Alonso, ed., *Sistemas, acciones y procesos, 1965–1975,* exh. cat. (Buenos Aires: PROA, 2011); Cristina Freire and Ana Longoni,

eds., *Conceitualismos do Sul / Sur = Conceptualismos del Sur / Sul* (São Paulo: Annablume, 2009); Andrea Giunta, *Vanguardia, internacionalismo y política: Arte argentino en los años sesenta* (Buenos Aires: Paidós, 2001); Inés Katzenstein, ed., *Listen, Here, Now!: Argentine Art of the 1960s; Writings of the Avant-Garde* (New York: Museum of Modern Art, 2004); Fernanda Lopes, *Área experimental: Lugar, espaço e dimensão do experimental na arte brasileira dos anos 1970* (Rio de Janeiro: Prestígio, 2013); Sérgio B. Martins, *Constructing an Avant-Garde: Art in Brazil, 1949–1979* (Cambridge, MA: MIT Press, 2013); and Elena Shtromberg, *Art Systems: Brazil and the 1970s* (Austin: University of Texas Press, 2016).

13 Two examples of the movement in other cities are Konkrete Kunst in Zurich and Movimento arte concreta (MAC) in Milan. Margit Staber, "Methods, Meanings and Reactions…Some Observations…," in *The Non-Objective World, 1914–1955,* exh. cat. (London: Annely Juda Fine Art, 1973), 3–5; and Luciano Caramel, ed., *MAC: Movimento arte concreta, 1948–1958,* exh. cat. (Florence, Italy: Maschietto & Musolino, 1996).

14 For example, Lygia Clark was born into a wealthy family that owned substantial cattle ranches in the Brazilian state of Minas Gerais. Waldemar Cordeiro emigrated from Italy in 1946 and established a career as a landscape designer. Tomás Maldonado was born in Buenos Aires to a middle-class family and increased his social standing when he married Lidy Prati, who was from a family that considered itself more sophisticated than his.

15 For example, in 1948, Carmelo Arden Quin left Buenos Aires for Paris, where he maintained a residence for the rest of his life. In 1954, Tomás Maldonado also left Buenos Aires, first living in Ulm, Germany, for several years before ultimately settling in Milan.

16 Although artists in these three cities did communicate, especially once museums were established and exhibitions could circulate, my objective is not to chronicle traceable or causal linkages between artists working in each place, which inevitably implies influence based solely on chronological development. For example, Rhod Rothfuss rejected the rectangular frame in Buenos Aires in 1944 ("El marco: Un problema de plástica actual"), and Lygia Clark arrived at a similar conclusion in Rio de Janeiro in 1954 with her *Quebra da moldura* series (see pl. 6).

17 To clarify, I am referring specifically to the humanistic discipline of art history, not the cross-disciplinary field of technical art history. In the latter field, studies exist that bring together the science and history of art. See, for example, Maarten R. van Bommel, Hans Janssen, and Ron Spronk, *Inside Out Victory Boogie Woogie* (Amsterdam: Amsterdam University Press, 2012); Harry Cooper and Ron Spronk, *Mondrian: The Transatlantic Paintings,* exh. cat. (New Haven: Yale University Press, 2001); and Rachel Rivenc, *Made in Los Angeles: Materials, Processes, and the Birth of West Coast Minimalism* (Los Angeles: Getty Conservation Institute, 2016).

18 María Amalia García discusses this in "The Ulm School and the Bauhaus," in *Tomás Maldonado in Conversation with / en conversación con María Amalia García* (New York: Fundación Cisneros, 2013), digital edition.

19 The Bauhaus curriculum underwent a transformation over the course of its thirteen-year existence. It is important to note that the earlier years in Weimar, led by Walter Gropius, were characterized by an attention to craftwork, whereas by the time the academy closed in 1933, under the direction of Ludwig Mies van der Rohe, the curriculum was increasingly focused on industrial innovation.

20 The Ulm School was but one offshoot of the Bauhaus. Others include Black Mountain College in Asheville, North Carolina; the Illinois Institute of Technology, Institute of Design, in Chicago; and the Harvard Graduate School of Design. All three of these schools were started by former Bauhaus professors who emigrated from Germany because of World War II.

21 This technical design school was never formally established, and was more aspirational than actual. See Silvia Fernández, "The Origins of Design Education in Latin America: From the hfg in Ulm to Globalization," *Design Issues* 22, no. 1 (2006): 3–19; and Pedro Luiz Pereira de Souza, *Esdi: Biografia de uma idéia* (Rio de Janeiro: Eduerj, 1996).

22 Many in the West were followers of John Dewey's pedagogical philosophies about progressive education, which became increasingly adopted during this period. Dewey emphasized critical

open-ended thinking, rather than rote memorization; the latter was associated with the mentality of the Nazi regime.

23 Also, starting in 1948 (a year after the museum opened), MASP held a series of exhibitions under the title *Artes industriais* (Industrial arts) and then beginning in 1950 published *Habitat* magazine, which focused on visual culture with a particular emphasis on architecture and design. Adele Nelson, "The Bauhaus in Brazil: Pedagogy and Practice," *ARTMargins* 5, no. 2 (2016): 27–49. doi: 10.1162/ARTM_a_00146.

24 "Pode-se dizer, sem exagerar, que o futuro de nossa civilização industrial dependerá do êxito ou fracasso das reformas que, a curto prazo, terão forçosamente de levar-se a cabo ro domínio do ensino, em geral, e do universitário, em particular." Tomás Maldonado, "A educação em face da Segunda Revolução Industrial," *Revista brasileira de estudos pedagógicos* 40, no. 92 (1963): 20. Unless otherwise noted, all translations are mine.

25 Although some may think of the Cold War as endemic to the late 1950s and 1960s, in fact tensions between the United States and the Soviet Union began just after the end of World War II, as early as 1946, when Winston Churchill described an "iron curtain" descending across Central Europe as Soviet control expanded westward. This speech, which Churchill delivered at Westminster College in Fulton, Missouri, accompanied by President Harry S. Truman, is considered one of the first descriptions of what would commonly be known as the Cold War.

26 For example, in Buenos Aires in 1950, Tomás Maldonado and Alfredo Hlito founded AXIS, widely credited as being the first design and communications firm in Argentina; in São Paulo in 1954, Geraldo de Barros cofounded Unilabor, a firm that designed and manufactured mass-produced furniture; and also in São Paulo that year, Hercules Barsotti and Willys de Castro founded Estudio de Projetos Graficos, dedicated to the design of magazine layouts, books, exhibition graphics, and logos. Thanks to Robert Kett for bringing these details to my attention. Furniture firms are discussed in Ana Elena Mallet, "Social Utopia and Modern Design in Latin America," in *Moderno: Design for Living in Brazil, Mexico, and Venezuela, 1940–1978,* ed. Gabriela Rangel and Jorge F. Rivas Pérez, exh. cat. (New York: Americas Society, 2015), 47–61.

27 Lynn Zelevansky discusses the issue of seriality in her essay "Beyond Geometry: Objects, Systems, Concepts," in *Beyond Geometry: Experiments in Form, 1940s–70s,* ed. Lynn Zelevansky, exh. cat. (Cambridge, MA: MIT Press, 2004), 9–33.

28 In a similar fashion, Carmelo Arden Quin, who was active in Buenos Aires in the mid-1940s and in Paris after that, labeled many of his works by turning the initials of his last name, the letters A and Q, into a small black triangle and a circle next to each other.

29 Rafael Cardoso, *O design brasileiro antes do design: Aspectos da história gráfica, 1870–1960* (São Paulo: Cosac Naify, 2005).

30 In the case of Lozza's larger paintings, the sketch as well as the color legend often appears on the back of the painting.

31 My appreciation to both Pino Monkes, conservator at the Museo de Arte Moderno in Buenos Aires, and Raúl Naón, a collector of Lozza's archives, for the time and knowledge they shared. Pino Monkes, discussion with the author, Buenos Aires, 2 July 2015; and Raúl Naón, discussion with the author, Buenos Aires, 29 June 2015.

32 Humberto Farías de Carvalho, a conservator who conducted an interview with Lauand in August 2015, said that her numbering system did not correspond to convention and that she did not attribute numbers to the titles in a faithful order, which makes her adoption of numbers that are outside of a system all the more interesting. Farías, conversation with the author, 17 March 2016.

33 Unlike Fiaminghi, Lauand did not paint the sides of the boxes on the back.

34 I have written about the dialectical relationship between the presumed binary ideologies of nationalism and internationalism elsewhere; see Aleca Le Blanc, "The Disorder and Progress of Brazilian Visual Culture in 1959," in *Breathless Days, 1959–1960,* ed. Serge Guilbaut and John O'Brian (Durham, NC: Duke University Press, 2017); and Aleca Le Blanc, "Serpa, Portinari, Palatnik and Pedrosa: The Drama of an 'Artistic Moment' in 1951 Rio de Janeiro," *Diálogo* 20, no. 1 (2017): 9–20.

35 There are, of course, other examples issuing similar contrasts. Even though in the 1940s, Tomás Maldonado played an important role as a theoretician propagating the importance of industrialization within the visual arts, by the 1950s he was again working with traditional materials, oil paint on canvas, inside simple rectangular wooden frames hung directly on the wall.

36 We cannot presume that Fiaminghi signed the work when it was made. During the 1950s, he was an ardent member of Grupo Ruptura and faithfully followed the tenets of concrete art. Therefore, it is quite possible that he signed the work much later, perhaps when he was preparing to sell it. In addition, *Alternado 2*'s very thin wooden frame was likely added later, since the paint on the frame does not match the color on the original panel. Oftentimes, artists would add a frame in order to conserve a piece that was beginning to warp.

37 At the time that they issued *Arturo,* these artists were not yet known as concrete artists; they were referred to as *invencionistas.* María Amalia García, correspondence with the author, 15 June 2016. Rhod Rothfuss, "El marco: Un problema de plástica actual," *Arturo,* no. 1 (1944): unpag. Published in English as Rhod Rothfuss, "The Frame: A Problem in Contemporary Art," in *Cold America: Geometric Abstraction in Latin America (1943–73),* exh. cat. (Madrid: Fundación Juan March, 2011), 420–21.

38 Ferreira Gullar, "Teoria do não-objeto," *Suplemento Dominical do Jornal do Brasil,* 19–20 December 1959, 1. For an English-language translation, see Ferreira Gullar, "Theory of the Non-Object," in *Experiência neoconcreta: Momento-limite da arte,* trans. Anthony Doyle (São Paulo: Cosac Naify, 2007), 142–45. This concept of the nonobject has been discussed extensively in the literature, most recently in Mónica Amor, *Theories of the Nonobject: Argentina, Brazil, Venezuela, 1944–1969* (Berkeley: University of California Press, 2016).

39 It is likely that Clark hired a fabricator to produce some of her technically complicated works, but according to Giulia Giovani, conservation scientist at LACICOR, Universidade Federal de Minas Gerais, there is archival evidence to suggest that Clark executed many of her works herself. Not only do personal expense records detail the specific materials that she purchased and used, but Clark is also quoted in a newspaper in 1957 describing the manual labor required: "It is not an easy job…I used a protective mask because the paint is highly poisonous.…I cut the wood, sand it, prime a Celotex™ board, then paint these supports with a spray-gun and industrial paint." Giulia Giovani, Luiz Antônio Cruz Souza, Yacy-Ara Froner, and Alessandrea Rosado, "The Use of Industrial Paint on Wood by Lygia Clark," *Studies in Conservation* 61, S2 (2016): 291–93. doi: 10.1080/00393630.2016.1184054.

40 Lygia Clark, "Lecture at the Escola Nacional de Arquitetura, Belo Horizonte, Fall 1956" (1956), in *Lygia Clark: The Abandonment of Art, 1948–1988,* ed. Cornelia H. Butler and Luis Pérez-Oramas, exh. cat. (New York: Museum of Modern Art, 2014), 54–55. This translation originally appeared in *Lygia Clark,* trans. Fundació Antoni Tàpies, exh. cat. (Barcelona: Fundació Antoni Tàpies, 1998), 71–73.

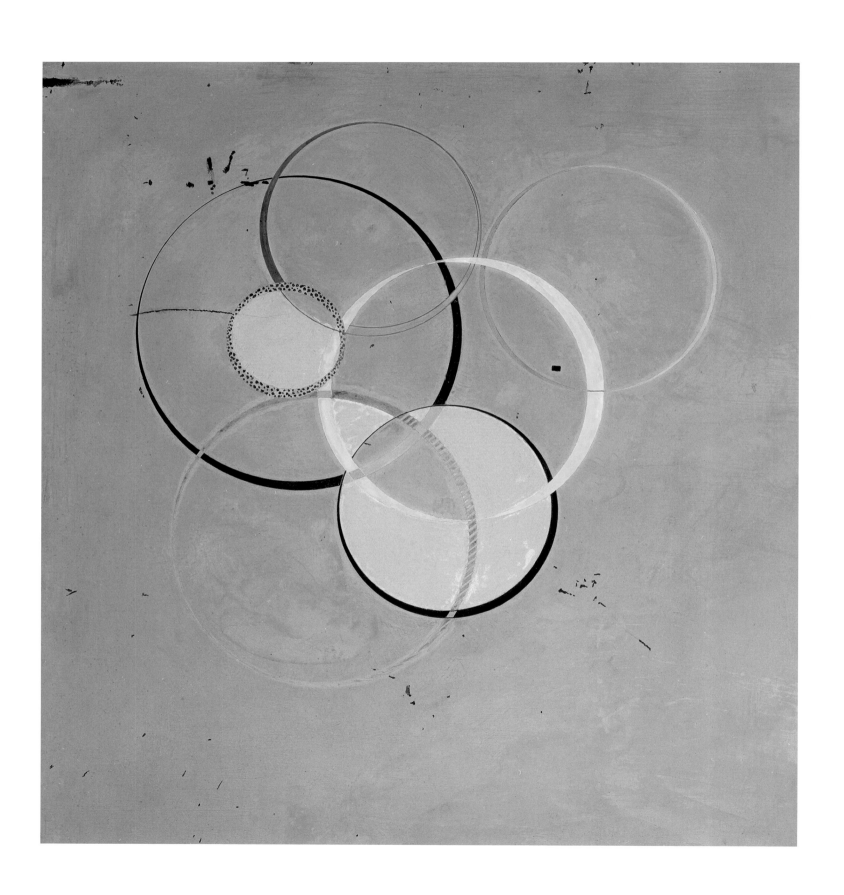

MAKING CONCRETE ART

Pia Gottschaller

When the neo-concrete artist Hélio Oiticica stated in around 1960 that "all true art does not separate technique from expression," the twelve Argentine, Uruguayan, and Brazilian artists to be discussed here were already able to look back on roughly twenty-five years of their own avant-garde research.[1] The resulting works—paintings, sculptural objects, and works in hybrid categories such as "nonobjects"—are all characterized by a severely reduced, geometric vocabulary, the seeming simplicity of which often belies the artists' painstaking approach to materials and technique. The relative scarcity of compositional elements to distract the eye invited the concrete and neo-concrete artists to lavish their attention on every little detail: the exact method used to paint a straight line, for example; or the process employed to achieve a perfectly homogeneous surface. Their struggle to realize utopian concepts using earthbound means is inscribed into the surfaces of their artworks, and the degree to which the artists admitted individual traces of the human hand indicates where they placed themselves within the tradition of modernist abstraction.

The Italian philosopher and writer Umberto Eco wrote that "the work of art is at the same time the trace of that which it wanted to be, and of that which it actually is, even if the two values do not coincide."[2] What follows is an examination of this gap between intent and realization as it emerges from a consideration of historic events; documents such as manifestos, artists' statements, and interviews; art historical litera-ture; and insights gleaned from close examination and scientific analysis of the works themselves. By thus re-creating the genesis of this selection of works in the Colección Patricia Phelps de Cisneros, this study aims to make a first contribution toward a deeper understanding of a period in the history of art-making that in some respects has so far been only sketchily known.

This study's findings can be organized and presented in several ways because the selected works were made by artists working in different countries and cities and during only

partially overlapping time periods. Despite numerous intersections in development and aims between the artists, the discussion below largely follows a chronological order, from 1946 to 1962. Within that chronology, the discussion is divided into two broad geographic categories: Buenos Aires and Montevideo, in the Río de la Plata region; and São Paulo and Rio de Janeiro. The earliest concrete works represented here were made by artists in the first-mentioned region, starting in 1945/46, and the earliest Brazilian work discussed here dates from 1952. Brief introductions to the artistic movements and groups in which the artists organized their activities, found at the beginning of these two sections, are meant to situate the artists' material choices in a larger context. Pertinent technical issues, such as support and paint preferences, are discussed as they arise from descriptions of the works themselves. However, the overall emphasis is placed on the highly inventive artistic processes that, to differing degrees, accomplished the Zen equivalent of clapping with one hand: the impersonalization of the traces of their own making by artists in the Río de la Plata region, the nearly complete erasure thereof in Grupo Ruptura in São Paulo, and the swing of the pendulum toward somewhat more tactile surfaces again in Grupo Frente and the neo-concrete movement in Rio de Janeiro.

Río de la Plata:
Asociación Arte Concreto-Invención, Arte Madí, and Perceptismo

Accounts of the emergence of the Asociación Arte Concreto-Invención (AACI), Arte Madí, and Perceptismo in Buenos Aires generally begin with the publication of a magazine, *Arturo,* in April 1944. A group of young Argentine and Uruguayan artists and poets—among them Tomás Maldonado, Edgar Bayley, Lidy Prati, Rhod Rothfuss, Carmelo Arden Quin, and Gyula Kosice—banded together to collate poems, articles, and reproductions of artworks in order to promote "invención contra automatismo" (invention against automatism). The publication presented anything but a unified stance.[3] But it paid homage to Piet Mondrian and Joaquín Torres-García, the revered masters of neo-plasticism and "universalismo constructivo," as a way of stating that these young artists considered themselves the new avant-garde—aware of historical precursors while distancing themselves from the prevailing local, figurative traditions.

The most programmatic contribution came from Rhod Rothfuss, in the form of an essay titled "El marco: Un problema de plástica actual."[4] Following a brief summary of the development of modern art from Paul Cézanne to neo-plasticism and constructivism, Rothfuss comes to the conclusion that an orthogonal painting will always be read like a window, as an illusionistic, partial rendering of the world in the Albertian tradition: "A painting with a regular frame leads to a sense of continuity of the object beyond the margins of the painting. This situation only disappears when the frame is structured rigorously according to the composition of the painting."[5] The artists' first proposal that addressed the problem of the shape an artwork was the *marco recortado* (cutout frame), which is essentially constructed from the inside out: the perimeter of the work follows the edges of the geometric composition, leading to irregularly shaped supports with corners jutting out at sometimes

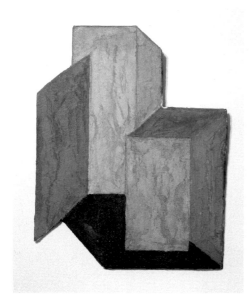

sharp angles.[6] The reduction to colored forms lying parallel to each other in a single, unified plane allowed the artists to claim the abolition of the hierarchy between figure and ground. Despite the artists' acknowledgment of important precursors such as László Péri's works from the 1920s, the marco recortado represents a major contribution to the history of art (fig. 1).[7]

In the so-called heroic[8] period of Argentine art-making that followed *Arturo* until 1948, set within the politically turbulent period of Peronismo, the artists were joined by others in search of similar goals, such as Alfredo Hlito, Raúl Lozza, Juan Melé, and Gregorio Vardanega: they aimed to address the problem of representation and figure-ground dialectics in artworks that referenced nothing outside of themselves, least of all nature. They distributed their ideas in numerous manifestos, pamphlets, and journals, and exhibited mostly in private homes and commercial galleries.[9]

A fundamental reference point for these artists became Theo van Doesburg, founder of de Stijl in 1917 and a close ally of Mondrian's for several years, who in April 1930 published the manifesto "Art Concret: The Basis of Concrete Painting."[10] It appears that Van Doesburg's concepts were initially introduced to the Argentine and Uruguayan artists in the mid-1930s via Torres-García's column in the Argentine newspaper *La Nación* and subsequently through concrete art's self-appointed promoter Max Bill, with whom Maldonado would maintain an active exchange from 1948 until the mid-1950s.[11]

With the exception of Marxist political aims, which are not included in the manifesto, "Art Concret" clearly lays out all the principles fervently embraced both by the Argentine artists and by the Brazilian concrete artists a few years later: art is universal and artworks should not contain "any natural form, sensuality or sentimentality." They should be constructed only with planes and colors leading to "no other meaning than what it represents." Most relevant for the current context, however, is concept number five: "The technique should be mechanical, that is to say, precise rather than impressionistic."[12] In "Comments on the Basis of Concrete Painting," published as an addendum to the manifesto, Van Doesburg further specifies his vision of clarity:

> Most painters work like pastry-cooks and milliners. In contrast we use mathematical data (whether Euclidean or not) and science, that is to say, intellectual means.
>
> Before it is physically made material, the work of art is fully conceived by the spirit. Thus its production must reveal a technical perfection equal to that of the concept. It should not reveal any trace of human weakness such as trembling, imprecision, hesitation, nor any unfinished parts.
>
> In the name of humanism one has tried to justify quite a lot of nonsense in art. If one cannot manage to draw a straight line with the hand, one may use a ruler. [...]
>
> If one cannot draw a circle by hand, one may use a compass. All instruments which were created by the intellect due to a need for perfection are recommended.[13]

FIG. 1 | László Péri (British, b. Hungary, 1899?–1967).
Raumkonstruktion 3, 1922 (reconstruction from the early 1950s), painted concrete, 52.5 × 39.5 × 2 cm. Paris, Musée National d'Art Moderne, Centre Georges Pompidou.

As we will see in the following, the exact lengths to which concrete artists went in order to achieve this "technical perfection" in surfaces and lines differed in significant ways.

By November 1945, tensions between the various *Arturo* contributors erupted, resulting in a split into two groups: the staunchly rationalistic, Marxist-influenced AACI, with its intellectual leaders Tomás Maldonado and Edgar Bayley, and the more playful, Dada-inspired Madí group, led by Gyula Kosice. The latter would divide again in 1948 when Arden Quin set up a rival Madí group in Paris. Of the artists under discussion here, Rothfuss would side with Kosice, while Hlito, Lozza, Melé, and Vardanega joined AACI. As art historians María Amalia García and Gabriel Pérez-Barreiro have pointed out, it is difficult to reconstruct the precise order of events between 1945 and 1947 due to antedated works, questionable attributions, posterior reconstructions, contradictory memories, and a general lack of documents.[14]

But all accounts credit Raúl Lozza and fellow AACI member Juan Alberto Molenberg with the next evolutionary step: the creation of the "coplanar" (sometimes called "coplanal"). In 1946, Molenberg cut three pieces of cardboard into polygonal shapes, painted them white, and initially connected them with sticks.[15] The spatial separation of the painterly elements in this work, *Función blanca,* was Molenberg's solution to the problem of how to eliminate the picture plane as an illusionistic element while being able to control the exact position and orientation of elements relative to each other.

Lozza contemporaneously worked along similar lines. Then, as a response to the subsequent challenge of the wall being read as a separate plane, a background, that could be painted or decorated by a collector any which way, in 1947 Lozza (alongside Melé) devised "portable walls"—that is, solid, monochrome supports to which the sculptural shapes were permanently attached (for an example by Melé, see pl. 29). In the same year, Lozza founded Perceptismo, which remained ultimately a one-man undertaking. Perceptismo is based on Lozza's personal color theory, *cualimetría,* which includes a rather impenetrable set of mathematical formulas that describe the relative relationship of color to form.

The Flattened Brushstroke

Most of the Argentine artists in this study trained at fine–art academies, and this exposure not only profoundly influenced their relationship to materials and technique but also provided them with an intellectual environment in which to find similarly minded artists. Melé in 1939 began to take night classes at the Escuela Nacional de Bellas Artes Manuel Belgrano, where he met Gregorio Vardanega and Tomás Maldonado. In 1942, Melé entered the Escuela Nacional de Bellas Artes Prilidiano Pueyrredón, where he met Maldonado again, yet both Melé and Vardanega kept their respectful distance for a while and started to exhibit with the AACI only in October 1946, at the Sociedad Argentina de Artistas Plásticos.

Melé's *Marco recortado nc. 2* from that same year is among the earliest works in this study to be discussed (see pl. 28). Very few marcos recortados survive, for a combination

of reasons: a dearth of personal resources, resulting in the use of sometimes unstable materials such as cardboard; a scarcity of art materials due to war shortages; and dislocations that often led to works being damaged or lost altogether. Several of the artists considered here moved to Europe, North America, or Mexico, some of them permanently, leaving artworks behind in sometimes uncertain care. As the earliest marcos recortados were made from fragile cardboard,[16] they were easily damaged, lost, or destroyed.

The supports of the marcos recortados were irregularly shaped and needed to be perfectly flat, so it made sense for the artists to switch from cardboard and traditional canvas to more solid boards or panels. For *Marco recortado no. 2,* one of a few early examples that survive, Melé chose a hardboard panel consisting of wood chips left over from other wood-manufacturing methods (see pl. 28b). Following the Masonite process, first patented by William H. Mason in the United States in 1926, wood chips are hydrolyzed and pressed into flat metal plates or screens (or both), held together only by the naturally present lignin, rather than an added adhesive. The panels have either two smooth sides or one smooth and one textured, canvas-imitating side. It was the perfectly smooth surfaces of these panels, without canvas texture or wood grain, that made them such a popular choice with the concrete artists. Hardboard panels are also easy to cut, lightweight, and an inexpensive alternative to solid wooden panels. But they are prone to warp and twist, which is probably the reason Melé nailed wooden bars cut to size to the reverse of the panel. The bars also added some depth (2 centimeters to the 0.5-centimeter-deep panel; see pl. 28a), protected the edges from fraying and denting, and at the same time provided a hanging mechanism. Melé was well suited to making such an object himself, as he had inherited from his father, a cabinetmaker, a love of working with tools.[17]

After a brush application of thick white ground to the smooth side of the panel, Melé proceeded to add the yellow, red, and green forms in oil paint. The ground is alkyd-based and therefore likely a house paint mixed with solvent, which is more suitable for acidic and hygroscopic hardboard than an aqueous preparation.[18] Depending on factors such as layer thickness, artists' oil paints can take months and even years to fully dry, whereas house paints were specifically developed to be dry within a few hours. Ready-mixed house paints were first developed at the end of the nineteenth century for interior and exterior applications. The main binders in house paints introduced between the 1890s and the 1950s are oleoresin, nitrocellulose, alkyd, and polyvinyl acetate. These inexpensive paints come in large cans and are formulated to be self-leveling—that is, to produce a flat paint film without much visible brushwork. In contrast, traditional oil paints are much more expensive and their viscosity allows brushwork and impasto to be preserved, if the artist desires such an effect.

Before Melé added black paint to the sides and painted the black grid to unify the composition and emphasize the structure, he applied at least one second thin oil layer in each area of the composition, staying mostly within the same tonal range (fig. 2). The chromatic range, particularly among the fourteen greenish forms, is so finely elaborated

that no hue appears twice. The brushwork is clearly visible, except in the narrow grid lines that Melé painted with the help of a straightedge such as a ruler: this technique results in a discreet straight ridge where the brush meets the edge of the tool. The ridge is less sharp where the paint is brushed parallel to the tool rather than in a right angle toward it. Comparison of the surface of this work to the very similarly constructed *Marco recortado no. 3* (1946) at the Museo Sívori in Buenos Aires makes evident that the presence of a thick layer of varnish on the Cisneros work creates a saturation, a color depth, that the unvarnished *Marco recortado no. 3* does not display (figs. 3, 4; cf. fig. 2).[19]

Cuadrilongo amarillo, the second work in the Colección Cisneros that follows the principles of the marco recortado, albeit in harmonious cohabitation with principles of the coplanar, is by Rhod Rothfuss (see pl. 32). Rothfuss was born Carlos María Rothfuss in 1920 in Montevideo, where he trained as an artist and where in 1940 he met his future Madí colleague from Uruguay, Carmelo Arden Quin. Rothfuss, about whom little is known, was introduced to Maldonado, Prati, and their colleagues in Buenos Aires in 1942, but he kept his teaching job in Montevideo and only occasionally visited the Argentine capital. By around 1955, the year from which *Cuadrilongo amarillo* dates, most of Rothfuss's artistic activities seem to have ceased, and in fact less than half a dozen safely attributable works of his survive.

The shape of *Cuadrilongo amarillo* is determined by the narrow oblong yellow element that sits vertically on the left-hand side of the work. Rothfuss cut the outline of the 5-millimeter-deep multiply paper panel so that it could accommodate the placement

FIG. 2 | Juan Melé (Argentine, 1923–2012).
Detail of *Marco recortado no. 2,* 1946, showing central large yellow and aqua-colored forms with brighter-hued underlayers and a shiny varnish on top. See pl. 28.

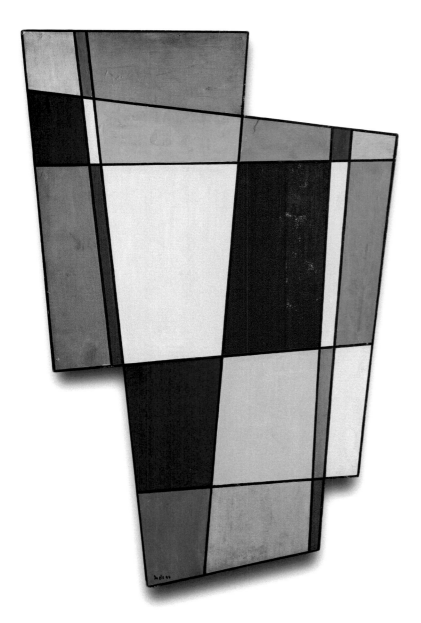

FIG. 3 | **Juan Melé (Argentine, 1923–2012).**
Marco recortado no. 3, 1946, oil on hardboard,
85 × 55 cm. Buenos Aires, Museo Sívori.

FIG. 4 | **Juan Melé (Argentine, 1923–2012).**
Detail of top left corner of *Marco recortado no. 3,*
with visible brushwork, underlayers, and an
unvarnished, matte surface.

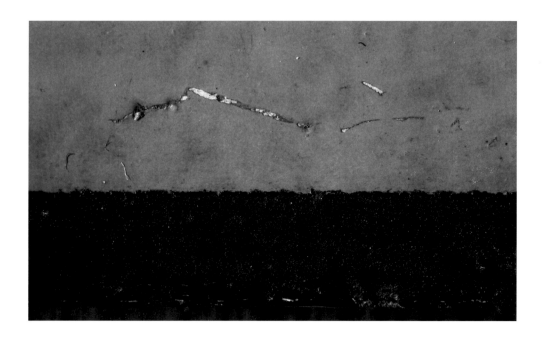

of the yellow rectangle beyond the otherwise orthogonally aligned outer edges of the other forms (see pl. 32a). Rothfuss then prepared the surface with an application of an unpigmented, strongly fluorescing organic layer (perhaps shellac), followed by thin layers of an off-white alkyd-based paint.[20] The abraded and delaminating edges of the paper panel indicate how fragile the support has become through oxidization as well as how this inevitable aging process also affected the earliest marcos recortados, which would have been made from very similar cellulosic boards. By contrast, the colored rectangles were cut from the sturdier hardboard, which was again followed by the application of a whitish ground and alkyd-based paint layers, this time in red, green, yellow, and blue. As a final step, Rothfuss brushed on the black borders with gum-based, matte gouache, probably with the help of a set square (fig. 5). As his friend the sculptor Horacio Faedo told Pérez-Barreiro in 1993: "I remember popping in at any time and sharing his mate amargo (always freshly prepared) and always finding him humble and straightforward, as though what he was doing were not even worthwhile, with his pencil, paintbrush, set square, compass and Golden section compass."[21] Rothfuss's adoption of the black outlines might be a tribute to Torres-García, his compatriot, whom Rothfuss visited first on 17 March 1943, and who remained an influential figure for him.[22]

As a photo of *Cuadrilongo amarillo* in raking light shows, the surfaces of the attached elements are glossier than the exposed off-white background of the panel, which might be due to the presence of pine resin in the colored paints (see pl. 32c). However, this contrast, which accentuates the sense of two parallel pictorial planes, is today somewhat more pronounced because the unexposed background paint on the panel underneath the elements—which, unlike the rest of the background, did not undergo a bleaching treatment in 2011—also appears similarly shiny and homogeneous.[23] The fact that the

FIG. 5 | **Rhod Rothfuss (Uruguayan, 1920–69).** Detail of *Cuadrilongo amarillo,* 1955, showing large green element with black, matte gouache and glossy, smooth alkyd paint; off-white ground visible in scratch. See pl. 32.

background is monochrome white, which would blend optically with a white wall behind it, links it to the concept of portable walls as put forward by Lozza (and also Melé), but any sense of illusion is mitigated by the jutting extension around the *cuadrilongo amarillo,* the yellow shape on the left-hand side.

Painted black grids, a legacy from constructivism and Torres-García, feature prominently in marcos recortados, and a few unusual examples survive from Lozza. In these works, instead of applying the grid with paint and brush like Melé did, Lozza tensioned and adhered black or white ribbon cloth to the paint surface. He adopted this material from one of his day jobs, women's underwear design.[24] As he came from a rural working-class background and did not receive any formal artistic training, Lozza perhaps felt less constricted by academically taught painting techniques than did his colleagues. He stated in interviews with Pino Monkes, conservator of paintings at the Museo de Arte Moderno de Buenos Aires, that the most important artistic aim of Perceptismo was to "matar el ilusionismo"—to kill the illusion of space.[25] *Relieve no. 30* from 1946 represents a crucial step in this undertaking, through a centrifugal composition consisting of four thin, irregularly shaped, hand-sawed wooden pieces (see pl. 25). Lozza liked to scour his neighborhood for discarded furniture, a continuous source of free and seasoned wooden panels.[26] The pieces are connected with a continuous, looping length of wire, to which the elements are attached with nails and wooden blocks (see pl. 25a). The wire in between the elements is painted a matte black, perhaps in an effort to reduce the reflective quality of the metal.

The uppermost, alkyd-based paint layers appear matte and remarkably close in hue (and medium) to those in Rothfuss's work (cf. pl. 32). In particular, the green element underwent a circuitous genesis from white ground to two different red hues (mixtures of cadmium red, two organic reds, dolomite, and the ubiquitously detected zinc white), followed by a blue layer (probably French ultramarine) and the final opaque mossy green (a mixture of chrome yellow and probably Prussian blue). The three other elements display similarly convoluted layering, yet remained tied to the same tonal range (fig. 6). The ochre element is likely a later addition for two reasons: it is painted on the reverse, unlike the others, with some ochre paint specks on the wire indicating that the paint was applied after assembly; and one of the binders identified in the yellow paint layers is acrylic. Two dates are inscribed on the work—"1946" on the reverse of the ochre element and "1945" on the dark red one—but the presence of acrylic, which wasn't yet available in the 1940s, suggests that the yellow element must have been executed or reworked later still. All of these observations show that at different points during his process Lozza experimented with a range of color combinations—it was evidently a matter of arriving at the ideal balance between hue and shape within each element, as well as with regard to the overall relationship between forms.

In the above-mentioned interview with Monkes, Lozza explained that through trial and error he found that a mixture of Rembrandt tube oil paints and Alba house paints[27] provided him with the desired combination of tinting strength, drying time, and

FIG. 6 | Raúl Lozza (Argentine, 1911–2008).
Paint cross section of *Relieve no. 30,* 1946, at 200x magnification, from reverse of dark red element, with seven red oil and alkyd paint layers containing three different synthetic organic dyes (PV23, PR57, PR3) as well as zinc white, titanium white, dolomite, and gypsum. A white ground layer, present underneath the paint layers on the element, is missing here. See pl. 25.

hardness[28]—oil paint by itself would have dried too slowly and into a more malleable surface. In his words, "matar el brillo" (to kill the gloss of paint to a matte, more velvety sheen) was a central part of his process, for which he used water and initially powdered pumice stone, later sandpaper, in laborious, repeated campaigns.[29] Medium analysis carried out on samples from *Relieve no. 30* indeed confirms the presence of alkyd (with pine resin) and linseed oil in the red and green elements, albeit in separate layers.[30] A mixture of linseed oil and alkyd was detected in the white ground of the ochre element, along with polishing marks in the form of minute scratches on the surface of all four elements.

Examination of the following three works by Alfredo Hlito and two works by Tomás Maldonado suggests that Hlito's and Maldonado's interest in extensively manipulating surface qualities was limited (unlike in Lozza's case) and that they were more or less unencumbered by the desire to embrace recent advances in paint technology; instead, they focused on formal problems. Hlito and Maldonado first met as students at the Escuela Nacional de Bellas Artes Manuel Belgrano in 1940. Hlito was more introverted than the charismatic and disputatious Maldonado, produced a steady output of articles and essays, and was in charge of the design section of *Nueva Visión,* the magazine he cofounded with Maldonado. Hlito's earliest known works from 1945 are clear homages to Torres-García, but nothing seems to survive from 1946, one of the group's most experimental years. The five paintings discussed here—executed on preprimed canvas and square in format—date to after the artists' return to the orthogonal format in around 1947 and 1948, which Maldonado in an essay from 1948 attributed to the realization that the Argentine concrete artists' dissolution of the ground was unsatisfactory, that the transformation of the constructions into "transportable structures was a serious mistake," and that he saw potential in a development of Max Bill's proposal—"to make the ground vibrate by means of subtle nonfigurative elements"—by waging a "battle against the limited in the free realm of space."[31]

Hlito preferred to work in oil on canvas throughout his life.[32] Although no store labels are present on the stretchers of Hlito's three works to be discussed, there are two on paintings from 1952, also in the Colección Cisneros, that indicate he bought stretchers with white oil-and-chalk-based grounds at Pinturería Colón, an artist's supply store on calle Sarmiento in Buenos Aires.[33] The three paintings here are from 1947, 1948, and 1949, and are characterized by an extremely thin and homogeneous layer of white oil paint extending over the entire preprimed surface (see pls. 18, 19, 20). Hlito then proceeded to transfer his compositions with graphite, which at least in the case of *Ritmos cromáticos III* he had first worked out in a sketch on paper, followed by painting, again with oil paint, the various straight lines.[34] Comparison of the sketch for *Ritmos cromáticos III* with the painting itself makes clear that the grid structure dividing the surface all the way to the support's edges—according to the half and golden mean[35]—remained unchanged, even down to the differently weighted line widths, but Hlito deviated from the sketch's restriction to primary colors to include gray as well as the secondary colors green and purple. Both Hlito

and Maldonado often chose these colors, presumably as a willful, creative, or symbolic misreading of neo-plasticism—and of Mondrian's work in particular.[36]

To paint the composition, Hlito used a ruling pen: in the case of the thinnest black lines, sometimes a single pass was sufficient, while for the wider bars and colored rectangles, he would first draw the two outer edges of the bar or shape with the ruling pen, followed by filling the spaces in between with more oil paint and a brush (fig. 7). The technical mastery evident in the finely equilibrated compositions is exceptional and can undoubtedly be attributed to the extensive experience Hlito had as a technical draftsman. With regard to craftsmanship, Hlito said that he had no "masters" but had to "invent for himself a manner to paint." Like several of his colleagues, Hlito was deeply disappointed when he saw for the first time in Europe in 1953 Mondrian's pasty textures and black lines "that were like furrows."[37]

Ruling pens have been used throughout the twentieth century in technical drawings by architects and graphic designers, but work best with free-flowing ink rather than oil paint, the latter of which Hlito used. As Maldonado attested in an interview with the author, he also worked with this tool for some time but found its use challenging because oil paint has to be thinned with a diluent such as turpentine to the exact right consistency in order to make it flow from the pen, which holds only a small amount between its metal tips due to capillary action.[38] Because the width of the line is regulated by the opening of the tip, adjustable by a small wheel, a long wide line is particularly difficult to paint as the amount of paint allows only a few centimeters of length to be drawn in one stroke.

FIG. 7 | Alfredo Hlito (Argentine, 1923–93).
Detail of blue element in top right corner of *Ritmos cromáticos III,* 1949, with scratched double line left by ruling pen and dilute oil paint, and a thicker brush application of paint below the line. See pl. 20.

The pointed metal tips often leave incisions in a softer underlayer, as can be observed in Hlito's *Ritmos cromáticos II*, the earliest of the three works, and Hlito often refrained from drawing the vertical lines—that is, the left- and right-hand edges of the rectangles. Instead he "cleaned up" the scalloping ends, the messier beginning and end points of the lines, by scratching away excess paint with a razor blade to straighten up the sides (fig. 8).

In the absence of any known images of ruling pens used by Hlito, a photograph of the collection of ruling pens in Bauhaus master Josef Albers's possession can give an idea of the large variety available (fig. 9). Albers, who was greatly admired especially by the Brazilian neo-concretists Lygia Pape and Lygia Clark, used a ruling pen in a few early paintings on Masonite from around 1937 but ultimately switched to painting freehand with a palette knife. The main optical difference between lines painted with self-adhesive tape and those painted with ruling pens is that the latter dry to a softer, rounder edge rather than a sharp ridge. In choosing a technique that resulted in softer edges, while keeping those edges as straight as humanly possible with this tool, Hlito opted for a more craftsman-like quality in his works. The exceedingly high degree of perfection allows the viewer to fully concentrate on the rhythmical activation of the painting's surface.

Hlito's peer Maldonado, who served as the unofficial spokesman of the AACI, is a well-educated intellectual with a long career in teaching and publishing that spans from industrial design to information theory and philosophy. His close relationship with the Swiss artist and designer Max Bill prompted him, in 1948, to be the first Argentine concrete artist to travel to Zurich and Milan, establishing contacts with similarly minded artists such as Bruno Munari, Richard Lohse, and Georges Vantongerloo. Unlike Hlito, who

FIG. 8 | Alfredo Hlito (Argentine, 1923–93).
Detail of lower yellow element in center of *Ritmos cromáticos II*, 1947, with graphite underdrawing; scratches in white background and discolored retouching at end of green bar. See pl. 18.

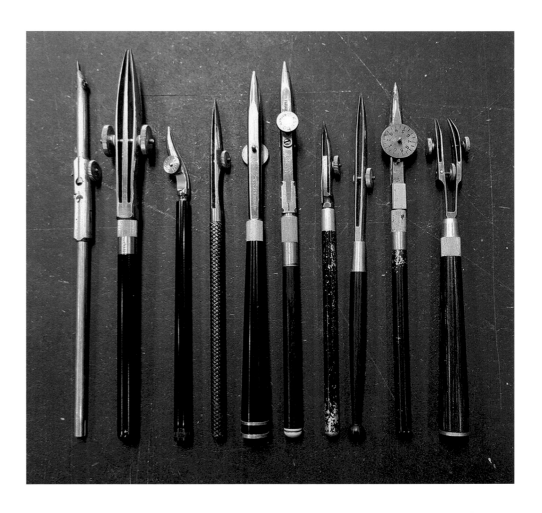

credited Torres-García's work as a motivation to become an artist,[39] Maldonado, after an initial period of admiration, became exasperated by the older artist's symbolism and integration of Amerindian pictographs. At the time of *Arturo,* Torres-García still provided a crucial link for the younger abstract artists due to his association with the avant-garde movements in Paris before his return to Montevideo in 1934. But with access to more publications after the end of World War II, these young Marxists, and for a while card-carrying Communists, saw that Russian constructivism provided a much more suitable model than Mondrian's and Torres-García's spiritually inflected trajectories.

Maldonado's proverbial killing of the father figure happened in a 1946 essay titled "Torres García contra el arte moderno," in which Maldonado criticized the older artist for his "pseudo Uruguayan Constructivism," the causes for which Maldonado detected in "the narrowness of his colonial mind" that makes him "incapable of appreciating the profound and emotive meaning that palpitates on a white surface, washable, painted with duco."[40] Duco was the brand name of a popular industrial paint by the North American company DuPont. Initially, in the 1920s and 1930s, it was based on nitrocellulose (also called pyroxylin), a synthetic resin suitable for automobile finishes. By the late 1940s,

FIG. 9 | **Collection of ruling pens owned by Josef Albers, at the Josef and Anni Albers Foundation, Bethany, Connecticut.**

the formulation had changed from nitrocellulose to oil-modified alkyd,[41] and a nitro-cel ulose version was also sold at one point under the trade name Dulux. The uncertain-ties surrounding these facts have led to considerable confusion, as often the artists themselves remained unaware of the change in binding medium. Duco (and similar prod-ucts by other manufacturers) was famously used by the abstract expressionist artist Jackson Pollock, with Pollock most frequently employing the alkyd-based version.[42] The use of the nitrocellulose version of Duco has been documented for the Mexican muralist David Alfaro Siqueiros in the 1930s,[43] and in the 1950s for the Venezuelan artist Alejandro Otero in his *Colorítmos* series, and the Uruguayan "no figurativos" José Pedro Costigliolo and Maria Freire.

Returning to Maldonado's indictment of Torres-García's trajectory, where Duco assumes the role of main witness, the lowercase *d* in *duco* signals that he, like many art sts in the Americas, used it as a synonym for house paint generally. It is all the more interesting, therefore, that in the aforementioned interview Maldonado stated that he only painted with tube oil paints in those years because he is technically quite conservative. Analysis of the multilayered paint sequences in his works confirm that they were mostly painted with a drying oil, such as linseed, but at least one gray stripe in *Composición 208* and the larger purple circular segment in *Tres zonas y dos temas circulares* turn out to be alkyd-based (see pls. 26, 27).[44] He might have used imported Duco or a domestic, more affordable brand such as Alba, preferred by Lozza. However, the fact that Maldonado used alkyd paint so sparingly and did not manipulate the texture to make it visually distinct from the other areas painted with artists' tube oil paint suggests two things: first, that he was simply experimenting or choosing it for other properties such as hue; and second, that in his text about Torres-García he did not necessarily refer to his own art-making but indicated his awareness of contemporary art practices in general.

Every shape in these two paintings by Maldonado has been painted freehand, in multiple layers, with brushwork generally following the outlines of the shapes. The art-ist explained that although he started using self-adhesive tape in 2000, he did not in the "heroic" period between 1944 and 1948 because, in his experience, the only kind available was incompatible with oil paint.[45]

Composición 208 bears a stamp on the stretcher by L. Kober, an artist's supply shop in Neu-Ulm, Germany, and a stamp by A. Schutzmann, a well-known colorman near Munich who also produced paints (see pl. 26b).[46] The painting's previously assigned date, 1951, suggests in the absence of any signature or date on the work itself that it was made between Maldonado's first trip to Europe in 1948 (which did not take him to Germany, however) and his move to Ulm in 1954, when he took up a teaching position at the Hochschule für Gestaltung. In a recent communication with the author, Maldonado explained that he made a sketch for this work in tempera on carton in Buenos Aires in 1952, brought it with him to Ulm, and executed the painting there in oil on canvas, probably in 1955.[47] As the Brazilian artist and graphic designer Alexandre Wollner said in a recent interview, students at the Hochschule, where Wollner was a student from 1954

to 1958 and where Maldonado was a professor until 1967, were encouraged to focus on design rather than painting.[48] Soon after his arrival, Maldonado also stopped his painting activities, not resuming them for well over forty years, as it would turn out.

São Paulo and Rio de Janeiro: Grupo Ruptura, Grupo Frente, and Neo-concretism

While Argentina in the 1940s and 1950s was struggling with the establishment of a democratic order, with severe setbacks due to militaristic coups and economic instability, Brazil was succeeding in making more positive strides toward a stable society. Several recent art historical accounts of the development of the Brazilian avant-garde movements in the 1950s have unfolded in a sociopolitical context, stressing the pivotal role the government, led by presidents Getúlio Vargas and Juscelino Kubitschek, played in encouraging the fast growth of domestic industries.[49] This undertaking was also fraught with many difficulties, but the desire to become a forward-looking, democratic country had already gained momentum during World War II, when increasing independence from imported goods established Brazil as an indispensable international player. And although Brazil undoubtedly ended up usurping Argentina's cultural and economic hegemony, recent research suggests that Argentina's industrial development in the sectors that concern us here, industrial paint and hardboard panel manufacture, was perhaps not lagging that far behind in the same period. The intersection of industry and concrete art especially in the context of Grupo Ruptura, based in the economic capital of São Paulo, was to a great extent inscribed into the rhetoric of the group by its own members.

Waldemar Cordeiro, a key member of Grupo Ruptura, was, like Maldonado, a strikingly tall, erudite, opinionated, and natural spokesman who joined forces with fellow Paulistas Geraldo de Barros, Kazmer Féjer, and Luiz Sacilotto, among others (Hermelindo Fiaminghi and Judith Lauand participated later), and the group followed avant-garde traditions by publishing the Ruptura manifesto on the occasion of its first exhibition, at the Museu de Arte Moderna de São Paulo (MAM-SP) in December 1952. The group's programmatic name, "rupture," derived from the desire to part with "those who create new forms out of old principles," namely naturalism and "hedonistic non-figurativism." The manifesto's text continues to extoll "the new," which the artists see in "the renovation of quintessential values of visual art (space-time, movement and material)."[50] Not explicitly stated at this point were several other aims of the group, expanded upon in later publications (along with the introduction of the term *concrete*), which especially in the case of Cordeiro and de Barros were fed by Socialist ideas that called for artworks to be reproducible, affordable objects devoid of any subjective traces of the artist's hand. Like their Argentine colleagues, artists in Grupo Ruptura reduced their imagery to clearly outlined, schematic forms that did not allow associations with outside referents, and many works betray their interest in laws of perception, in particular the systematic studies of Gestalt psychologists in Germany in the early twentieth century. As art historian Mónica Amor has written, Gestalt "refers to events (perceptions, experiences, thought processes)

that cannot be described as the sum of their parts (sensations). Gestalt psychologists suggested instead that humans organize sensations into perceptive wholes that are discernible in figure-ground relationships."[51] One well-known example is our ability to mentally complete an incompletely drawn circle, as illustrated in Maldonado's *Tres zonas y dos temas circulares* (see pl. 27).

Roughly a year and a half after Grupo Ruptura's presentation of works to the public, Grupo Frente's first exhibition opened at Galeria do IBEU in Rio de Janeiro.[52] Based in the same city, Grupo Frente was a more loosely connected group with a visually pluralistic output. The critic Mário Pedrosa and the poet Ferreira Gullar often spoke on behalf of the group, which included Aluísio Carvão, Lygia Clark, Lygia Pape, and Ivan Serpa, the latter of whom had taught several of the artists in his art classes at the Museu de Arte Moderna do Rio de Janeiro (MAM Rio).[53]

The main philosophical differences between the two groups came to the fore during their only joint exhibition, in 1956 and 1957, at the *Exposição nacional de arte concreta* at MAM-SP and subsequently at the Ministério da Educação e Cultura in Rio. The publicly conducted disputes between Cordeiro and Gullar centered around a supposed lack of formal and chromatic rigor on the Cariocas' part—with Cordeiro singling out Serpa's use of brown as a sign of "disorientation"[54]—whereas an apparently slavish adherence to systematic and phenomenological principles of composition on the Paulistas' part was in turn attacked. A subtext to this conflict was the age-old rivalry between the two cities that included stereotyping inhabitants into rational, cold, and businesslike versus sensuous, hot, and carnivalesque. According to Gullar, the artists active in the two cities in 1957 could be further grouped with regard to their approach to materials: "The Rio group, with the exception of Lygia Clark, uses oil paint from tubes; the [group in] São Paulo employs ripolin or variants of this type of paint."[55] Ripolin was the name of an oleoresinous paint, originally developed in the Netherlands in the 1890s as a mixture of oil with the addition of resin to speed up oil's long drying time as well as to impart hardness and gloss. Intended for indoor and outdoor applications, its use has also been documented in artworks from the 1910s and 1920s by Pablo Picasso, Francis Picabia, and László Moholy-Nagy, among others.[56] Although Gullar's statement is not entirely accurate, as we will see, it nonetheless provides a first indication of the important role material choices played in the discourse of the period.

After the polemical discussions surrounding the exhibition in 1956 and 1957, the concrete undertaking gradually lost momentum over the next few years. Several of the Cariocas—in particular Carvão, Clark, and Oiticica—perceived a need to surmount the prioritization of theory over practice as well as the flatness and didactic aspect of many of the works. Clark and Oiticica also sought a deeper integration of art into the sociopolitical realm. Inspired by these artists' first explorations, Gullar in 1959 wrote his "Teoria do não-objeto" ("Theory of the Non-Object") and the subsequent "Diálogo sobre o não-objeto" ("A Dialogue on the Non-Object"), in which he dismissed the frame as the by now outmoded mediator between fiction and reality.[57] Gullar's new category of art object, the

nonobject, defied categories by being neither painting nor sculpture. It questioned the self-referentiality of concrete art, instead seeking engagement with the "real space, the body and the vernacular," as Mónica Amor has observed.[58] Art historian Irene Small has described some of Clark's and Oiticica's new strategies as "folding the frame"—literally folding metals into reliefs as well as renouncing frames and pedestals.[59]

Toward an Ideal Industrial Finish

Like many Brazilian concrete artists, Geraldo de Barros could not support himself and his family with his artistic work. Before he set up the successful furniture design companies Unilabor and Hobjeto in 1954 and 1964, respectively, he had a day job at Banco do Brasil. His first recognition as an abstract artist came in 1951 in the form of an exhibition of his experimental photographic work, the so-called *Fotoformas.* De Barros's small *Objeto plástico* dates from a year later, 1952, after his return from an extended stay in Europe, and was made with alkyd-based paints on an unusual wooden panel (see pl. 10): the reverse is embossed with a canvas-imitating texture underneath a tough, white ground. The artist's daughter, Fabiana de Barros, considers this work "proto-concrete" because de Barros signed it in the bottom right-hand corner with his initials, in Bauhaus-tradition lowercase. Later that year and throughout his concrete phase, which ended in 1954, de Barros habitually scratched a logotype into the paint layers (see pl. 11c).[60]

The centrifugally arranged geometric shapes on a smooth white background were applied with a brush and probably self-adhesive tape. Close examination of the shapes reveals that they stand slightly proud because they were first painted in white, on top of the white background, followed by ochre, red, and black (see pl. 10a). Presumably dissatisfied with the outcome, de Barros then added another white layer over the entire surface to provide a "blank slate" for the final color scheme, in which only the ochre parallelogram in the bottom left quarter remained the same color (see pl. 10b); the red shapes and ochre vector were initially painted black, and the now-black shapes were initially red.

When comparing this work with de Barros's second work in the exhibition, *Função diagonal* (1952), it is evident that over the course of 1952 the artist made a quantum leap in terms of perfecting his technique (see pl. 11). De Barros's keen interest in principles of Gestalt psychology led him to inscribe the square-format hardboard panel with an overlay of alternating black-and-white squares, each half the area of the previous one, so that the largest black square is 128 times larger than the smallest white one. Because of the overlaying and the gradual rotation of the squares by forty-five degrees, no square is seen in its entirety until the final square in the center of the composition.[61] The panel displays a very smooth, gray, alkyd-based ground, which was either commercially prepared or sanded by the artist. De Barros then brushed on a matte layer of white chalk-based paint, followed by laying out the composition with a blue ballpoint pen and a ruler. He subsequently masked the edges of the outer black forms with Scotch tape[62] and spray-painted them, leaving perfectly straight paint ridges with occasional "bleed" where paint seeped under the tape (see pl. 11b). Next, de Barros taped off the edges of the outer black triangles and brushed

a second coat of white onto the diamond shape, after which he taped off the edges of the inner shapes and spray-painted them black (fig. 10). The subtle difference in sheen between the more matte, brushed white and the somewhat shinier, sprayed black areas is the result of careful polishing of the black areas (see pl. 11a).

All the steps of this process culminated in a surface impressively free of manual traces, the closest to the ideal of an industrial finish that to the Socialist de Barros equaled a "less elitist" approach to art.[63] But an additional, highly unusual technical aspect came to light during medium analysis of the paints: the black and white paints turn out to be a polyurethane-modified short-oil alkyd. The paints also contain castor oil, a nondrying oil, and pentaerythritol. While the latter two components are related to the alkyd formulation, the admixture of the synthetic plastic urethane especially at this time, in 1952, indicates that it was not a store-bought paint.[64] As Fabiana de Barros suspects, it may have been concocted by Kazmer Féjer, a Hungarian-born Ruptura artist and industrial chemist who in his kitchen experimented with paints and other plastic substances.[65]

Of the Ruptura artists, de Barros and Cordeiro were the most open to trying out new materials, as they were always in search of faster-drying and self-leveling paints. Féjer, a willing accomplice in their quest, might have shared with the artists some of his

FIG. 10 | **Geraldo de Barros (Brazilian, 1923–98).**
Detail of largest black form in center of *Função diagonal,* 1952, with scratched-away bleed of black paint and spray droplets on white, brushed underlayer. See pl. 11.

discoveries in the commercial sector, such as novel ways of mixing pigments into plastics. He apparently developed *rosa boneca* (doll pink), a method of tinting plastic rather than painting porcelain to make dolls' cheeks pink. Féjer sold his discovery to the Brazilian company Estrela, which from the 1950s made dolls from polyethylene and no longer from porcelain.[66] In 1977, while already living in Paris, Féjer filed a hugely lucrative patent for a method of dispersing pigments in thermosetting plastics.[67]

Cordeiro, Féjer, de Barros, Wollner, and Fiaminghi all shared studios at various times, and Cordeiro also experimented with Féjer's mixtures despite his fear of Féjer burning down the shared house.[68] However, Cordeiro's *Idéia visível* from 1956 was not executed with the same kind of paint, polyurethane-modified alkyd, although medium analysis showed that it was also an unusual short-oil alkyd formulation, perhaps with tung oil (see pl. 9). The background paint, containing a dark red synthetic pigment, was brushed on unevenly, followed by laying out the interlocking equilateral triangles, lines, and spirals first with a pencil—a number of stray pencil lines in the center suggest that perhaps there was no preparatory sketch (fig. 11). Cordeiro employed a ruling pen and viscous white and black paint to first draw the outer edges of the lines, then filled the spaces between the

FIG. 11 | **Waldemar Cordeiro (Brazilian, 1925–73).** Detail of center section of *Idéia visível,* 1956, showing pencil lines and white painted lines with drying cracks underneath more thinly painted black lines. See pl. 9.

FIG. 12 | **Waldemar Cordeiro at work in the 1950s with a ruling compass and a template cut from plastic sheeting.**

lines with more paint. One set of black lines in the center of the composition was at one point scratched away again. Unlike some of his contemporaries such as Judith Lauand, Cordeiro in these years did not reach for self-adhesive tape or a spray gun (the latter only from 1960 onward); instead he preferred a ruling pen or compass and a brush (fig. 12). These tool choices, with their characteristic impact on how paint sits on a surface, stand in contrast to Cordeiro's progressive rhetoric about the widening "gap between romantic and handcrafted art, and concrete and industrial art"[69] and were perhaps, notwithstanding subsequent highly experimental processes, rooted in his classical training at the Accademia di Belle Arti in Rome prior to his immigration to Brazil in 1948.

The hardboard panel of *Idéia visível* is very similar to the one de Barros used for *Função diagonal:* it has a smooth, gray, alkyd-based ground and is 5 millimeters deep and roughly 60 × 60 centimeters in size (see pl. 9b). Standard hardboard panels came in depths of 3 to 5 millimeters and a length of 1.20 meters, which might indicate that the artists had the panels cut in half, considering the enduring popularity of this format. The very specific support descriptions of only the concrete artists' works in the exhibition catalogs of the São Paulo biennials from 1951 to 1961 allow the conclusion that these artists initially used mostly European imported hardboard panels, with trade names such as Nordex, Kelmite, and Pavatex; then, as a result of the emergence of Brazilian companies such as Eucatex and Duratex in the mid-1950s, they also began to work with local brands.[70] Eucatex, named for the eucalyptus tree from which the panels were made, also began to be used as a synonym for hardboard, much like Masonite in the United States.[71]

The Ruptura artists including Cordeiro habitually adhered wooden box constructions to their works to impart a more object-like depth and make the works appear to hover in space.[72] The reverse, rough side of *Idéia visível* is painted a similarly dark red as the front, but unlike de Barros's *Função diagonal,* there are no glue or mechanical traces of a previous hanging device (see pl. 9b; cf. pl. 11d). De Barros in the 1970s replaced the original wooden hanging device with the current aluminum frame to prevent warping of the panel, which in humid climates such as Brazil's can swell by up to 25 percent of its volume.[73] A photograph of the installation of *Idéia visível* by Cordeiro himself, at the *Exposição nacional de arte concreta* at MAM-SP in 1956, shows the work framed as it is now, with 1.5-centimeter-wide, flat wooden laths painted white (fig. 13).[74] In addition, the work is turned ninety degrees to the right, with the longest white spoke pointing toward the ceiling. However, the work has been displayed for many years, in the absence of any inscriptions on the reverse, with the same spoke oriented horizontally. Changes in an abstract artist's mind with regard to the orientation of a work are not uncommon, especially when working in a series as Cordeiro did here, but in the current absence of further visual documentation, both the prominent frame and the vertical orientation must be considered original.[75]

Cordeiro's contemporaries Hermelindo Fiaminghi and Judith Lauand created their paintings with essentially the same materials: house paint on hardboard or plywood with particularly deep hanging devices of up to 5 centimeters. For *Alternado 2* (1957; see pl. 16),

FIG. 13 | **One of the rooms of the *Exposição nacional de arte concreta* at the Museu de Arte Moderna de São Paulo, 1956. Cordeiro's *Idéia visível* is the second work from the right, with the white frame and the longest white spoke of the composition pointed toward the ceiling.**

Fiaminghi applied alkyd-based paint with the help of a ruling pen and a soft brush to the smooth side of a hardboard panel that he had first primed and sanded.[76] In the interest of creating easily legible forms, heeding the Gestalt principle "Prägnanz" (conciseness of form in relation to ground), he mapped out the elongated and partially interlocking loz-enges of *Alternado 2* on the chalk-based, whitish polished background by using pin points at all four corners of each form, followed by connecting the points with incisions (using a thin blade or pointed tool; see pl. 16b). As revealed by infrared imaging of the work, the red shapes were first painted an opaque, brownish red with a ruling pen, followed by taping the outlines and painting the lozenges with a darker red paint that contains an organic azo pigment (PR3) (see pl. 16a). Fiaminghi probably also drew the outline of the gray lozenges with a ruling pen, but the higher density of the opaque paint might prevent them from being detectable.

Fiaminghi excelled at fine-tuning differences in gloss and chroma between different areas: after the opaque gray shapes had dried, he polished the entire surface, thereby flattening the edges of the gray lozenges and making them more compact. By contrast, the subsequently applied red, semitransparent shapes still display the sharp edges left by the taping process (fig. 14). The artist himself attributed his interest in transparency and strong chromatic contrasts to his training as a chromolithographer in the 1930s.

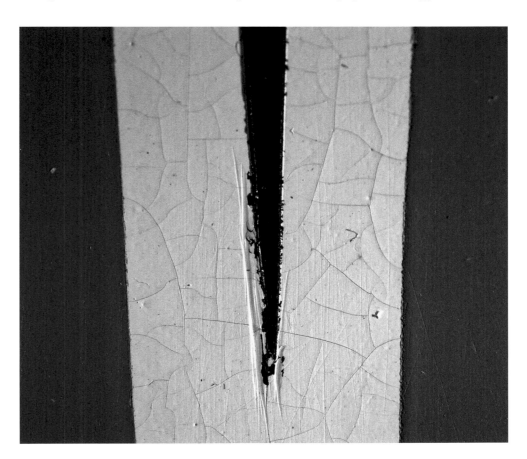

FIG. 14 | Hermelindo Fiaminghi (Brazilian, 1920–2004). Detail of center of *Alternado 2,* 1957, with red, glossy, sharp-ridged tip of lozenge showing incised lines and paint bleed (partially removed with mechanical tool). Partial polishing of the surface left minute scratches in the white background and gray lozenges. See pl. 16.

The infrared image also reveals an earlier pencil signature in the bottom left corner of the work, which is now covered by white overpaint that appears to have been added along with the narrow wooden strip frame. However, all of the labels and inscriptions on the reverse indicate that the work was always displayed in the current orientation (see pl. 16c), and another work by Fiaminghi from 1956, signed along the left-hand edge, suggests that his intention in both cases was to make his signature less visually prominent.[77]

In *Seccionado no. 1* (1958; see pl. 17), Fiaminghi introduced two new strategies to increase the visual differentiation between similarly hued areas emerging from a complex overlay of squares and circles. The distinction between forms and ground is blurred by the mirroring of the composition along a vertical and horizontal axis and by the fact that the shapes read like negative and positive inversions. Fiaminghi decided to paint on the screen-imprinted, rough side of the panel, which textured the paint surface especially in the glossy areas. The screen pattern becomes clearly visible when the work is viewed in specular light (see pls. 17a, 17b). In addition, the artist brushed an exceedingly thin matting layer, containing talc, onto the salmon-colored background,[78] whereas the very shiny orange and red shapes were painted with an alkyd medium that includes pine resin. Industrial paint manufacturers add varying amounts of pine resin and other types of natural resin in order to impart gloss, faster drying time, and hardness. Fiaminghi exploited these different formulations here to his full benefit—the salmon-colored alkyd paint indeed does not contain any pine resin, thus allowing it to retain mattness.

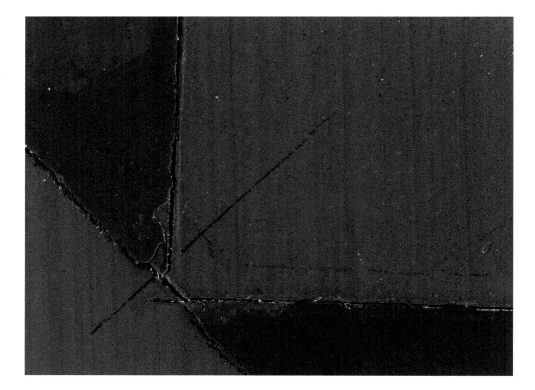

FIG. 15 | Hermelindo Fiaminghi (Brazilian, 1920– 2004). Detail of bottom left quadrant of *Seccionado no. 1,* 1958, with salmon-colored background and streaky matting layer, graphite and ballpoint pen underdrawing, incised lines, and paint losses from tape removal. See pl. 17.

The artist created the complex curved and straight-edged elements in several steps, including drawing and incising the design as well as taping and cutting away the tape after the paint had dried (fig. 15). But the curved segments made the use of regular 1-centimeter-wide tape practically impossible, and Fiaminghi explained that because of the current unavailability of Letraset (a black thin tape, used by graphic designers, that could be stretched to create round outlines), he cut "masks" from wide strips of Durex.[79] The North American company 3M introduced Scotch tape in Brazil under the name Durex in 1946.

Like Fiaminghi, Judith Lauand was not a member of Ruptura from the outset; she was a latecomer in 1955. Lauand underwent a traditional fine-arts education at the Escola de Belas Artes de Araraquara, in the state of São Paulo, and made her first concrete work, *Composição I,* in 1954. By her own account, she was fascinated by the wide variety of industrial paints,[80] she meticulously polished monochromatic expanses, and she taught herself to use self-adhesive tape as well as ruling pens in pictorial solutions to problems arrived at through "a process of mathematical thinking."[81]

Concreto 61 (1957) is an example of Lauand's "use of the spray-gun instead of a brush to achieve a depersonalized paint," as the artist explained in around 1994 (see pl. 23).[82] She applied an off-white layer of alkyd-based paint to the entire surface, then taped off the black vectors and sprayed on a layer of black alkyd paint. This was followed again by masking off the black vectors themselves and spraying another layer of off-white paint onto the background. The purpose of the last layer might have been to hide imperfections such as paint bleed from underneath the tape. The razor-sharp edges of Lauand's elements indicate that she, like all artists in this study who used tape, decided on transparent tape made from cellophane, unlike the majority of contemporary European and North American artists, who preferred masking tape, which is made from crimped paper and which leaves a slightly ribbed edge (see pl. 23a).

In her work, Lauand often found several possible solutions to the same pictorial problem, thus applying another Gestalt principle embraced by many artists in this study: seriality, in the sense of creating several works in a series based on similar themes. Two small-scale works on plywood, *Concreto 36* and *Concreto 37,* are examples (see pls. 21, 22). The inscriptions on the reverse—"tinta esmalte" (enamel paint) on *Concreto 36* and "tinta en massa Wanda" (a pigment-rich, light-colored type of industrial primer) on *Concreto 37* (see pls. 21b, 22c)—suggest that both paints were industrial products, with Wanda being a very popular industrial paint produced in Brazil. Despite being different paint products, medium analysis indicates they are both alkyd-based—their identical nature probably unbeknownst to the artist. But this fact explains why they dried to such a similar and unusual, reticulated pattern: Lauand probably applied the paint with a roller, or else sprayed the viscous paint onto the unprimed panels from relatively far away, and polished the surface of *Concreto 37* to reduce some of the paint bumps (see pls. 21a, 22a).[83] *Concreto 61, Concreto 36,* and *Concreto 37* are in any case examples of the great interest Lauand had in the experimentation with and manipulation of a wide range of materials.

Reanimation of the Surface

Aluísio Carvão's work from his Grupo Frente and neo-concrete period differs from the work of his colleagues in that he focused on color, often earthy in hue, and various subtle differentiations thereof within a single work. Born in Belém, Carvão started out as a self-taught artist who made his own easels, brushes, and paints, and only with his move to Rio in 1949 did he begin to have access to higher-quality art materials and more formal artistic training in Ivan Serpa's renowned classes at MAM Rio.[84]

Construção 6 (1955) is an unusual work in this study because it incorporates relief elements: narrow wooden sticks painted white, which Carvão had cut to size by a carpenter (see pls. 2, 2a).[85] The second work to be discussed, *Cromática 6* (1960), also differs fundamentally from works of his concrete colleagues, in the sense that Carvão "activated" the dichromatic yellow and ochre-colored surface with granular paint layers (see pl. 4). Vera Pedrosa, Mário Pedrosa's widow, recounted that Carvão leached his paints by removing excess media such as oil,[86] which led to extremely dry, underbound paint layers. Cross sections of these two works demonstrate that his homemade, brushed ground and paint layers are tightly packed with colorless, lumpy aggregates of fillers such as gypsum, talc, silica, barite, and dolomite (see pl. 4c). Surprisingly few coloring agents are present; however, in addition to chrome yellow, zinc chromate—a pigment with high tinting strength commonly used as a rust inhibitor for metal surfaces—was identified. Polyvinyl acetate (PVA) was identified as the medium in *Construção 6,* and a mixture of alkyd, drying oil, and beeswax in *Cromática 6.* The beeswax was probably added by Carvão to increase mattness, and although the synthetic PVA is a rarity in this study, it was and still is commonly found in waterborne house paints.

When viewing *Construção 6* under ultraviolet light, it becomes apparent that the artist achieved the very subtle tonal differences between fields of the grid by brushing exceedingly thin layers on top of the first light ochre–colored background layer, with only minimal additions of black and blue pigments (see pl. 2b). The background fluoresces strongly where no toning layers were applied—that is, along the brown lines and in the "nucleus," a warm ochre rectangle in the bottom right quadrant. In contrast, Carvão structured the surface of *Cromática 6* by slightly increasing the overall coarseness of the paint layers on the yellow left-hand side, mixing in fibrous matter and what appear to be grains of sand (fig. 16). Scientific analysis, however, showed that no sand is present. Andréa Proença, the artist's stepdaughter, explained in a recent interview with Zanna Gilbert that Carvão never used sand and instead incorporated Maizena, a Brazilian brand of cornstarch, into his paints.[87] Cornstarch, a white powder, becomes translucent when added as a thickening agent to soups and sauces, and in cold (rather than hot) liquids it tends to form clumps. These small aggregates probably resulted in the grainy effect we can observe on the surface of *Cromática 6.*[88] The two parallel, bright yellow and orange lines traversing the field were drawn with ink and a ruling pen into a recessed groove, and, similar to the nucleus in *Construção 6,* are the only indicators of an earlier chromatic stage of the work; indeed, it is surprising how much the extremely thin, uppermost toning

layers in *Cromática 6* manage to suppress the vibrancy of the underlying yellow and
orange paint layers (see pl. 4c).

Comparison of the surface qualities and layer sequences of these works by Carvão
with those encountered in Lygia Clark's works makes the heterogeneity of the Rio-based
group almost tangible. From 1947 to 1949, Clark trained with the painter and landscape
designer Roberto Burle Marx in Rio, and from 1950 to 1951 with Fernand Léger in Paris.
In 1954, Clark developed an interest in what she termed the *organic line,* which in her
work emerges for example in the gap between two adjacent picture planes, such as in
the space between the canvas and the frame in *Composição no. 5* (see pl. 6). This work
belongs to a series called *Quebra da moldura* (Breaking the frame), which kept Clark
occupied throughout 1954 and in which she attempted the "destruction of the painting
through the frame."[89]

Clark's visual strategy in this technically very complex work consisted of applying
a multitude of bright green paint layers to the very wide frame made from tropical
hardwood as well as to the store-bought stretcher and canvas, placed in the center with
the above-mentioned narrow physical gap between the edges of the canvas and the
frame (see pl. 6c).[90] The frame-canvas-frame width ratio is 1:3:1. While almost all of the
paint layers on the frame were sprayed on, as evidenced by the streaky surface sheen
especially in the black areas, all paint layers on top of the primed canvas in the center

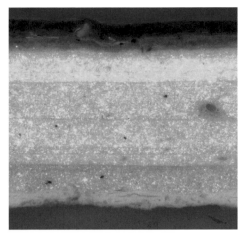

were brushed. A patchy, bright green, shiny layer was applied last to the canvas and to the grayish-green L-shaped form in the bottom left corner of the frame, uniting the center with the periphery (see pl. 6b).

For both the frame and canvas, Clark chose paints containing linseed oil, but while on the frame it is likely an oleoresinous house paint (with large amounts of pine resin present), on the canvas it is unadulterated tube oil paint. The stark difference in layering, as documented in cross sections from the frame (figs. 17a, 17b) and canvas, allows only a partial reconstruction of the process:[91] a staggering fourteen green paint layers are present underneath the L-shaped form on the frame, but only three green and three gray and black layers are present in the top right-hand corner of the frame, and about five green layers on the canvas. What can be ascertained is that Clark initially planned for the canvas and the bottom left-hand corner of the frame, as well as a narrower L shape in the opposite corner (no longer visible because of subsequent black paint applications), to be equally bright green.[92] Only then did she begin to "break the frame" for good by gradually toning down the frame with gray and black paint, entailing several taping campaigns. The resulting spatial ambiguity is further enhanced by what appear to be intentionally misaligned black lines on the canvas (see pl. 6a). These lines stand proud, as they were first laid out with a ruling pen and then reinforced with a brush, probably to counteract and at the same time match the width of the negative space between frame and canvas.[93]

In *Planos em superfície modulada* (1956), the organic line was created also by joining supports, in this case plywood panels, which exude a smell suggestive of cedar (see pls. 7, 7d). Clark explained in interviews in 1957 and 1959 that after her decision to stop painting on canvas, she learned how to saw, plane, and glue wood as well as how to operate equipment used for spray-painting cars.[94] Anecdotes told by conservators and art historians close to the artist suggest that at one point, however, she left all of the manual labor to professional craftspeople, presumably in the interest of a high degree of perfection.[95] This coincided with a switch to alkyd-modified nitrocellulose paints, first introduced in 1926 by DuPont as a more brushable alternative to earlier, more brittle nitrocellulose

FIG. 17A | Lygia Clark (Brazilian, 1920–88).
Paint cross section of *Composição no. 5*, 1954, at 400x magnification, from lower left edge of frame, with nine paint layers above the ground applied by spray, and the uppermost two layers hand-mixed and applied by brush. Identified pigments are French ultramarine, yellow ochre, viridian, chrome yellow (and probably chrome green), cadmium yellow, lead white, titanium white, and large amounts of zinc white. See pl. 6.

FIG. 17B | Lygia Clark (Brazilian, 1920–88).
Paint cross section of *Composição no. 5*, 1954, under ultraviolet illumination with zinc white being ubiquitously present and fluorescing most strongly. See pl. 6.

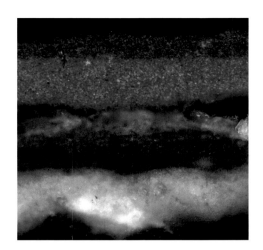

FIG. 18 | **Lygia Clark (Brazilian, 1920–88).**
Paint cross section of *Planos em superfície modulada,* 1956, at 400x magnification, from left edge of intersection between bright green and brown rectangles, with a white chalk-based ground; four thin oil-based paint layers of pink synthetic organic dye and French ultramarine; a crumbly white layer containing aluminum oxide; a green nitrocellulose-based paint layer with phthalo blue and an unidentified green pigment; and a brown nitrocellulose-based paint layer with chrome yellow orange. See pl. 7.

formulations for car finishes.[96] Nitrocellulose paints are solvent-based, dry very fast, and lend themselves to applications in multiple thin, flat layers, usually with the help of a spray gun. Archival documents show that Clark chose primers and paints with brand names such as Polidura, Wanda, and Niulac.[97] *Planos em superfície modulada* and *Casulo no. 2* (see pl. 8), a sculpture from 1959 consisting of a single sheet of bent metal, were spray-painted after assembly with alkyd-modified nitrocellulose paint, of the kind often used on cars.

But as ultraviolet examination of *Planos em superfície modulada* shows, the set of painted organic lines—the colored rectangles that abut and transverse the negative gaps between the two wooden panels—evolved slowly. A bright yellow fluorescence underneath parts of the bright green and brown forms indicates another stepped, vertical form that continues along the lower edge of the panel to the bottom right-hand corner, as well as an additional smaller horizontal rectangle underneath the brown form of the inset panel (see pl. 7b). A cross section taken from the intersection of the bright green and brown areas with the gap allows the conclusion that these underlying shapes are bright pink (fig. 18).[98] They consist of about four thin layers of an organic pink pigment mixed with French ultramarine, zinc white, and linseed oil.[99] Visual examination also revealed the presence of a dark blue layer and black layer in some areas, but their positioning in the sequence is unclear, in part because the high density of the gray paint layer might prevent the detection of the full extent of the underlayers. It appears, however, that initially the set of painted organic lines did not transcend the physical gaps. At any rate, the color choices of the original composition differed radically from the final interplay of the more muted, earthy hues.

This study concludes with a discussion of works by Willys de Castro, whose *Objeto ativo (cubo vermelho/branco)* from 1962 is the youngest work included here. Because of personal and philosophical differences with Cordeiro, de Castro never joined the Ruptura artists of his hometown; instead, in November 1959, he began to exhibit with the neo-concretists.

De Castro was a modern-day Renaissance man with regard to his talents and occupations: he had careers as a graphic, costume, and set designer and as a composer, singer, and poet. The visual arts were a comparatively late calling for him. The earlier *Composição modulada* (1954) dates from a period in which he still only intermittently made visual artworks (see pl. 12). De Castro realized the geometric composition with alkyd-based paints (sprayed and brushed) and a ruling pen, as well as with a selective use of tape—and, most relevantly for the future direction of his work, he also painted the narrow sides of the hardboard panel as a way of dilating the perceptual depth of the viewer. The color scheme extends to the sides following the one laid out on the surface, including the hardly perceptible white, yellow, and black lines that connect the larger irregular shapes at the perimeter of the work (see pls. 12a, 12b). Although de Castro had trained as an industrial chemist, and in fact in the 1950s also designed several advertisements for the Brazilian paint manufacturer Tintas CIL, he experienced some technical difficulties particularly in the shiny yellow areas. This is somewhat surprising, since the presence of a drying oil, glycerol, pine resin, and chrome yellow in the alkyd paint should have contributed to a fast drying time, but perhaps the sheer accumulated thickness of the layers led to the formation of the

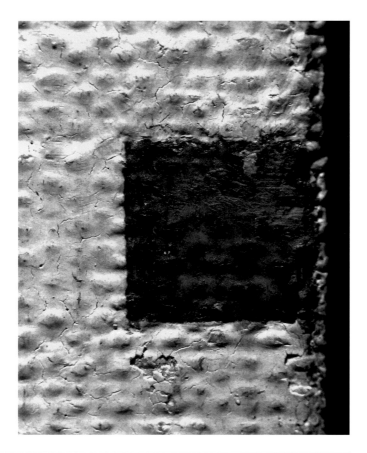

FIG. 19 | **Willys de Castro (Brazilian, 1926–88).**
Detail of square at right edge of *Objeto ativo (amarelo),* 1959–60, with oil-based paint layers containing cobalt blue and a yellow organic pigment (PY3); a yellow retouching layer (also oil-based) extends out onto the left edge of the blue square. See pl. 14.

FIG. 20 | **Willys de Castro (Brazilian, 1926–88).**
Detail of three-sided white square, *Objeto ativo (cubo vermelho/branco),* 1962, showing the razor-sharp edge of the white, viscous area next to the original paint ridge 2 mm to the right. See pl. 15.

"paint skin," which kept the paint underneath the surface from drying evenly. At one point, presumably still during the artist's lifetime, bubble wrap was accidentally pressed onto the surface, which stuck to the paint skin and left circular impressions in the softer paint layers underneath.[100]

We cannot know if experiences such as these, or perhaps de Castro's professional knowledge of the often inferior aging properties of house paints, led to his switch to traditional oil paints. Without a doubt, the development of his surface textures chronicles the subtle yet momentous development from concrete and depersonalized, to neo-concrete and tactile with discreet paint impasto. The *objetos ativos* (active objects), a term de Castro adopted for his works of the neo-concrete period, abandon a privileged frontal perspective, inviting the viewer to move around the works in space.

De Castro was known to be a perfectionist, and this trait shimmers through in everything that characterizes the three objetos ativos: for example, the detailed and accurate inscriptions on the reverse as well as the solid, neat working method (see pl. 14d). A single sheet of paper was wrapped around and glued to a piece of wood in *Objeto ativo* (1959; see pl. 13); white, preprimed canvas was glued to a hardboard panel in *Objeto ativo (amarelo)* (1959–60; see pl. 14d); and similar white, preprimed canvas was glued to a cube construction made from plywood and wooden corner splices in *Objeto ativo (cubo vermelho/branco)* (1962; see pl. 15c). In the latter case, de Castro took extreme care not to have any overlap of the canvas seams at the edges of the cube: he cut a single piece of canvas the exact length of four squares (1 meter) and one additional "flap" stacked at one end, in other words, with a height of 0.25 meter at one end and 0.5 meter at the other. The canvas is so firmly glued down, perhaps with the help of a roller, that the five plies of the plywood can be counted.

In *Composição modulada,* de Castro laid out the composition with incised lines, while in the three objetos ativos he used graphite. The artist's careful brush-application of the paint near the blue and the white elements parallel to their edges in *Objeto ativo (amarelo)* (fig. 19) and *Objeto ativo (cubo vermelho/branco),* respectively, make it difficult to ascertain whether he used an aid. However, the fact that a few of the brushstrokes in the white squares of *Objeto ativo (cubo vermelho/branco)* are oriented in a right angle toward their edges suggests that he used a straightedge, and the subsequent narrowing of the white squares by scraping away a band of 2 millimeters all around might have eliminated a ridge (fig. 20). After de Castro inpainted the gap with red oil paint, the new length of each side of the white squares came to 12.5 centimeters, exactly half the length of each side of the cube, and the white paint edges are razor-sharp—an astounding manual feat and testament to de Castro's superior craftsmanship. The fine difference in paint levels, with the white planes standing ever so slightly proud, enhances the illusion of white cubes floating immaterially in space. De Castro stated in 1960 that "the technical requirements of the lasting and clear execution of the generating idea…are what guarantee the artistic state of the work, and increasingly what prevent it from returning to the primitive brutality of the raw materials."[101]

Coda

While art historical narratives often tend toward highlighting overall thematic trends and predispositions within a certain period of art-making, by necessity a description of individual artists' processes such as in the current study must move from a bird's-eye view all the way to elemental, microscopic components and back out to a larger examination of artistic intent and results. It has to consider a multiplicity of factors, which prevent straightforward categorizations and instead call for more nuanced explanations: we are looking at an amalgam of visual observations like the presence of brushwork, often preserved in layers of oil paint (as seen in Melé's or Maldonado's paintings), along with analytical and process-related explanations for the particularly smooth surfaces in works by de Barros, for instance, as well as contextual considerations that are often hard to pinpoint.

One case in point for this multiplicity of factors in relation to particular paint surface qualities is Vardanega's *Sin título* (1948; see pl. 34). In 1948, Virgilio Villalba, Melé, and Vardanega moved to Paris, where they met Georges Vantongerloo, a Belgian artist who had been a member of de Stijl, Cercle et Carré, and Abstraction-Création. In the 1930s, Vantongerloo had begun to prepare panels with white, perfectly polished, porcelain-like grounds, not unlike the ones found in late fourteenth- and fifteenth-century Italian panel paintings. Vardanega in particular adopted Vantongerloo's process of scrupulous handpolishing, traces of which can be discerned with the naked eye as tiny scratches and indentations in the background of *Sin título* (see pl. 34b). But one specific aspect distinguishes Vardanega's and Vantongerloo's works from many of the later concrete propositions in Brazil: Vantongerloo wanted to "dematerialize matter,"[102] while the artists of Grupo Ruptura, for instance, aimed to achieve an industrial surface finish, in the tradition of Bauhaus masters or Russian constructivists. In other words, the results of a painting process can be very similar, in this case a smooth polished surface, whereas the context within which the works were made conveys a different meaning. Such contextual considerations also include exterior factors outside of the artists' control: for example, the Russian constructivist Alexander Rodchenko did not yet have at his disposal modern house paints or spray equipment; he still had to struggle with traditional oil paints and brushes. By contrast, the wide range of paints and tools available to and used by the Argentine and Brazilian concrete artists amounts to a case study of twentieth-century painting process. Thus, when comparing expressed artistic aims and actual achievements, it is vital to take also into consideration technological limitations placed upon artists in any given period. More importantly still, once all technical obstacles are removed, when exactly does a work of art cease to be imbued with a human aura, and is that even a lofty goal? This question of how much visible manipulation of materials with hands, rather than machines, is acceptable and desirable runs like a red thread through abstract art-making in the twentieth century, and artists have given, and are still giving, many different answers.

NOTES

The discussion of some technical aspects of the works relies on the analysis and interpretation of results by several colleagues in the Science Department at the Getty Conservation Institute: binder analysis by Joy Mazurek, assistant scientist; pigment and inert filler analysis by Alan Phenix, scientist, and Lynn Lee, assistant scientist; as well as infrared imaging by Douglas MacLennan, research lab associate.

1 Hélio Oiticica, from undated document no. 0004 in the Projeto Hélio Oiticica archive, in Mari Carmen Ramírez, *Hélio Oiticica: The Body of Color,* exh. cat. (Houston: Museum of Fine Arts, Houston, 2007), 220.

2 Umberto Eco, *Das Offene Kunstwerk* (Frankfurt am Main: Suhrkamp, 1990), foreword to the second German edition, 10. Unless otherwise noted, all translations are by the author.

3 For instance, the cover of *Arturo,* which shows a print by Tomás Maldonado, is indebted to surrealism, a movement the artists criticized in the same issue.

4 Rhod Rothfuss, "El marco: Un problema de plástica actual," in *Arturo,* no. 1 (1944): unpag. Published in English as Rhod Rothfuss, "The Frame: A Problem in Contemporary Art," in *Cold America: Geometric Abstraction in Latin America (1943–73),* exh. cat. (Madrid: Fundación Juan March, 2011), 420–21.

5 Rothfuss, "The Frame," 420.

6 Most English publications on the subject translate *marco recortado* as "cutout frame" or "shaped canvas," but both translations are slightly misleading: the Argentine works generally have irregularly shaped perimeters and only rarely actual frames, and the term "shaped canvas" was first introduced in the context of North American painters active in the 1960s such as Frank Stella, who actually worked with canvas (rather than rigid supports). In the absence of a more suitable succinct term and to avoid confusion, "cutout frame" was adopted in this text.

7 For more on Peri, see, for example, *Laszlo Peri: Werke 1920–24 und das Problem des "Shaped Canvas,"* exh. cat. (Cologne: Kölnischer Kunstverein, 1973).

8 Tomás Maldonado, "Un gato con muchas vidas," in *Arte Abstracto Argentino: Conferencias* (Buenos Aires: Fundación Proa, 2007), 15.

9 For a chronology of events, see, for example, Alexander Alberro, "To find, to create, to reveal: Torres-García and the Models of Invention in Mid-1940s Río de la Plata," in Joaquín Torres-García, *The Arcadian Modern,* ed. Luis Pérez-Oramas, exh. cat. (New York: Museum of Modern Art, 2015), 115–18.

10 Theo van Doesburg, "Art Concret: The Basis of Concrete Painting," in Joost Baljeu, *Theo van Doesburg* (London: Cassell & Collier Macmillan, 1974), 180–81.

11 María Amalia García, *El arte abstracto: Intercambios culturales entre Argentina y Brasil* (Buenos Aires: Siglo Veintiuno Editores, 2011), 43, 124.

12 Van Doesburg, "Art Concret," 180, 181.

13 Theo van Doesburg, "Comments on the Basis of Concrete Painting," in Joost Baljeu, *Theo van Doesburg* (London: Cassell & Collier Macmillan, 1974), 182.

14 García, *El arte abstracto,* 56; Gabriel Pérez-Barreiro, "The Negation of All Melancholy," in *Arte Concreto Invención, Arte Madí,* exh. cat. (Basel: Galerie von Bartha, 1994), 6.

15 Due to the deterioration of the cardboard version of *Función blanca,* Molenberg at an unspecified date made a new version from plywood. Juan Alberto Molenberg, interview by Pino Monkes, Buenos Aires, 2001, quoted with the kind permission of its author. According to Pino Monkes, this remaking of very early cardboard marcos recortados with more stable materials was done by several of the concrete artists in the Río de la Plata region. Pino Monkes, various conversations with the author, 2015–16.

16 See, for example, Molenberg, interview by Pino Monkes; and Manuel Espinosa, interview by Pino Monkes, Buenos Aires, 2001, both quoted with the kind permission of their author.

17 Juan N. Melé, *La vanguardia del cuarenta en la Argentina: Memorias de un artista concreto* (Buenos Aires: Cinco, 1999), 19, 21.

18 The presence of an industrial paint as a ground layer does not coincide with the information given in an interview with Pino Monkes, where Melé stated that he prepared the grounds himself and never used industrial paint (although perhaps he was referring only to his early canvas paintings). Melé further stated that he both made his own oil paints and used Lefranc & Bourgeois tube paints, which were less expensive than Van Eyck (Sennelier) and Rembrandt (Royal Talens) oil paints. Juan Melé, interview by Pino Monkes, Buenos Aires, 2000, quoted with the kind permission of its author.

19 The topmost varnish layer seems to be a synthetic resin and therefore cannot be of the period, but a second, partial varnish layer underneath might be: Melé, in the interview with Monkes, says that in the 1940s and 1950s he originally varnished his works with store-bought dammar, a natural resin, but that over the years he added more layers of other products. Melé, interview by Monkes.

20 Without giving a source, Mario Sagradini mentions Rothfuss's use of synthetic enamel paints by Inca and Cabu. Mario Sagradini, "Rhod Rothfuss (1920–1969): Vida y producción del artista uruguayo, confundador y teórico de Madí, del marco estructurado al shaped canvas" (unpublished paper, University of Texas at Austin, 1999), 34.

21 Horacio Faedo, "Un momento con Rothfuss," dictated to Gabriel Pérez-Barreiro, Colonia del Sacramento, Uruguay, June 1993; cited in Pérez-Barreiro, "The Negation," 10.

22 Alberro, "To find, to create, to reveal," 111.

23 Microfading tests indicate that the off-white color of the paint underneath the green element would appear somewhat more white if it were exposed to light. It is unclear whether the topmost, bright white layer of the background, which underwent the conservation treatment, was always this matte and white. SEM/EDS (scanning electron microscopy—energy-dispersive X-ray spectroscopy) analysis carried out on a partial cross section taken from the background just above the green element indicates the presence of titanium dioxide (probably in anatase form), with very small amounts of zinc and lead oxide present.

24 Raúl Naón, conversation with the author, Buenos Aires, 23 May 2014.

25 Raúl Lozza, interview by Pino Monkes, Buenos Aires, 1999–2000, quoted with the kind permission of its author.

26 Lozza, interview by Monkes.

27 Alba was Argentina's most important manufacturer of artistic, interior, and exterior paints, starting production in 1928.

28 Lozza, interview by Monkes.

29 Lozza, interview by Monkes.

30 There are two possible explanations for why not all of the samples show the binder mixtures of oil and alkyd: this work still falls into the early experimentation period, and only a selection of the many paint layers present on *Relieve no. 30* could be sampled.

31 Tomás Maldonado, *El arte concreto y el problema de lo ilimitado: Notas para un estudio teórico / Concrete Art and the Problem of the Unlimited: Notes for a Theoretical Study; Zurich 1948* (Buenos Aires: Ramona, 2003), 11–15.

32 The binders of the oil paints identified are linseed oil, the most commonly found type in tube oil paints; and walnut and poppy oil.

33 The two paintings from 1952 are *Desarrollo de un tema* and *Líneas de arquitectura.*

34 The sketch is reproduced in Gabriel Pérez-Barreiro, "Invention and Reinvention: The Transatlantic Dialogue in Geometric Abstraction," in *Cold America: Geometric Abstraction in Latin America (1943–73),* exh. cat. (Madrid: Fundación Juan March, 2011), 73.

35 Pérez-Barreiro, "Invention," 72. The only other compositional change was observed in *Ritmos cromáticos II,* where the uppermost black rectangle was initially green.

36 The exact motivations for the Argentine color choices are the subject of a separate research strand within the project. See also Peréz-Barreiro's excellent discussion of Hlito's work in relation to Richard Lohse and Georges Vantongerloo in his "Invention," 68–75.

37 Hlito, "Biografía sincrónica de un pintor," in *Alfredo Hlito: Escritos sobre arte,* ed. Sonia Henríquez Ureña de Hlito (Buenos Aires: Academia Nacional de Bellas Artes, 1995), 205.

38 Tomás Maldonado, interview by the author, Milan, 11 December 2014.

39 Hlito, "Homenaje a Torres-García," in *Alfredo Hlito: Escritos sobre arte,* ed. Sonia Henríquez Ureña de Hlito (Buenos Aires: Academia Nacional de Bellas Artes, 1995), 127.

40 Tomás Maldonado, "Torres García contra el arte moderno," in *Boletín de la Asociación de Arte Concreto Invención,* no. 2 (1946): unpag.

41 Susan Lake, Eugena Ordonez, and Michael Schilling, "A Technical Investigation of Paints Used by Jackson Pollock in His Drip or Poured Paintings," in *Modern Art, New Museums: Contributions to the Bilbao Congress,* ed. Ashok Roy and Perry Smith (London: International Institute for Conservation of Historic and Artistic Works, 2004), 140.

42 Lake, Ordonez, and Schilling, "A Technical Investigation," 139–40.

43 Harriet A. L. Standeven, *House Paints, 1900–1960: History and Use* (Los Angeles: Getty Conservation Institute, 2011), 5.

44 The main binders identified in samples from Maldonado's paintings in the Colección Cisneros are: linseed oil in *Tres zonas y dos temas circulares;* drying oil, beeswax, and a natural resin in *Composición 208;* and drying oil in *Composición* (1950).

45 Maldonado, interview by the author. Maldonado's friend Max Bill also started using tape (Scotch 810 Magic Tape, made from frosted rather than clear cellophane) with oil paint and a spatula from at least 1958 "because it is thin and adheres well," as Bill's son Jakob explained. Jakob Bill speculated that his father used the tape first in his architecture office, which is a cross-fertilization of practices witnessed also in several other artists included in this study. Jakob Bill, e-mail messages to the author, 14 and 26 March 2013. In earlier works from around 1946, Max Bill used a ruling pen.

46 A paper label by L. Kober and a canvas stamp by Schutzmann are also present on Maldonado's *Azul con estructura* (1954) at the Museo de Arte Moderno de Buenos Aires.

47 Tomás Maldonado, e-mail message to the author, 11 April 2016.

48 Alexandre Wollner, interview kindly conducted by Fabiana de Barros and translated by Michel Favre for the author, São Paulo, 23 April 2016.

49 See, for example, Mónica Amor, *Theories of the Nonobject: Argentina, Brazil, Venezuela, 1944–1969* (Oakland: University of California Press, 2016); and Irene V. Small, *Hélio Oiticica: Folding the Frame* (Chicago: University of Chicago Press, 2016).

50 Reprinted in *Waldemar Cordeiro: Fantasia exata,* ed. Analívia Cordeiro, exh. cat. (São Paulo: Itaú Cultural, 2014), 169.

51 Amor, *Theories of the Nonobject,* 72.

52 The exhibition opened in July 1954. Rio de Janeiro remained Brazil's capital until 1960, when Brasília was inaugurated.

53 At the second exhibition a year later in the same museum, Hélio Oiticica was also represented.

54 Waldemar Cordeiro, "Theory and Practice of Rio de Janeiro Concretism," in *Waldemar Cordeiro: Fantasia exata,* ed. Analívia Cordeiro (São Paulo: Itaú Cultural, 2014), 180.

55 Ferreira Gullar, "1–o Grupo de São Paulo," *Suplemento Dominical do Jornal do Brasil,* 17 February 1957, 9. Melé and Lozza said in their interviews with Monkes that they did not use Ripolin paint in their artworks. Melé, interview; Lozza, interview.

56 For example, see Maria Kokkori, Ken Sutherland, Jaap Boon, Francesca Casadio, and Marc Vermeulen, "Synergistic Use of Py–THM–GCMS, DTMS, and ESI-MS for the Characterization of the Organic Fraction of Modern Enamel Paints," *Heritage Science* 3:30 (2015). doi: 10.1186/s40494-015-0058-x.

57 Ferreira Gullar, "Teoria do não-objeto," *Suplemento Dominical do Jornal do Brasil,* 19–20 December 1959, 1; and "Diálogo sobre o não-objeto," *Suplemento Dominical do Jornal do Brasil,* 26 March 1960, 4–5. For an English-language translation of both essays, see Ferreira Gullar, "Theory of the Non-Object" and "A Dialogue on the Non-Object," in *Experiência neoconcreta: Momento-limite da arte,* trans. Anthony Doyle (São Paulo: Cosac Naify, 2007), 142–45, 145–50.

58 Amor, *Theories of the Nonobject,* 6.

59 See Small, *Hélio Oiticica.*

60 Fabiana de Barros and Michel Favre, Skype conversation with the author, 11 March 2016.

61 The author thanks Roy Gilbert for his mathematical analysis of the compositions by de Barros and Cordeiro.

62 F. de Barros and Favre, conversation with the author.

63 F. de Barros, e-mail message to the author, 2 March 2016.

64 Water-based polyurethane-modified alkyd was not patented in the United States until 1978.

65 F. de Barros and Favre, conversation with the author; and Fabiana de Barros and Michel Favre, e-mail message to the author, 15 March 2016.

66 F. de Barros and Favre, conversation with the author; and F. de Barros and Favre, e-mail message to the author, 15 March 2016. See www.estrela.com.br/nossa-historia.

67 The author thanks Joy Mazurek for locating the patent DE2753984 A1, filed in 1977 and published in 1979.

68 Analívia Cordeiro, interview with the author, 11 April 2016.

69 Waldemar Cordeiro, "Industrial Art," in Waldemar Cordeiro: Fantasia exata, ed. Analívia Cordeiro (São Paulo: Itaú Cultural, 2014), 185.

70 The complete set of exhibition catalogs of the São Paulo biennials can be found at https://issuu .com/bienal/docs. The company Duratex did not use the Masonite method, which is based on hydrolysis; rather, it used mechanical defibration, a method invented by Arne Asplund in 1935.

71 Brazilian hardboard panels are probably made from mixtures of wood residues, including the native Paraná pine, which in the 1950s was gradually replaced by eucalyptus. The high tarnin content of the panels lets them become very acidic over time.

72 Analívia Cordeiro confirmed the same process for her father's work of the period. A. Cordeiro, interview with the author, 11 April 2016, and e-mail message to the author, 4 May 2016.

73 Ulrik Runeberg, "Mikrobieller Befall und bildträgerinduzierte Verfärbungen," Restauro 1 (2010): 31.

74 The author thanks Zanna Gilbert for drawing her attention to this installation shot, and Irene Small for kindly sharing information about the photo itself. It is reproduced in Small, Hélic Oiticica, 27.

75 The fact that the edges of the panel have not been fully painted also suggests that the painting was framed from the very beginning.

76 Maria Lydia Fiaminghi, e-mail message to the author, 7 April 2016.

77 Círculos concêntricos e alternado, 1956, private collection.

78 The layer is too thin for medium identification.

79 Undated quote by Fiaminghi in Isabella Cabral and Amaral Rezende, Hermelindo Fiaminghi (São Paulo: Editoria da Universidade de São Paulo, 1998), 56.

80 Judith Lauand, interview by Humberto Farías, São Paulo, 15 September 2015, quoted with the kind permission of its author.

81 Lauand, quoted in Judith Lauand, Judith Lauand: Os anos 50 e a construção da geometria, Eng. trans. Arcobaleno Serviços Linguísticcs, exh. cat. (São Paulo: Instituto de arte contemporânea, 2016), 78.

82 Lauand, Judith Lauand, 78.

83 In her interview with Farías (see note 80 above), Lauand confirmed that she sometimes worked with a roller.

84 Claudio Telles, "Diamond Carvão," in Aluísio Carvão, exh. cat. (Salvador: Museu Metropolitano de Arte, 1996), 56, 57.

85 Telles, "Diamond Carvão," 58.

86 Telles, "Diamond Carvão," 59.

87 Andréa Proença, interview by Zanna Gilbert, Rio de Janeiro, 11 November 2016, quoted with the kind permission of its author.

88 Scientific analysis testing for the presence of cornstarch in samples of Construcão 6 and Cromática 6 is still underway.

89 Clark (1957), quoted in Cornelia H. Butler and Luis Pérez-Oramas, Lygia Clark: The Abandonment of Art, 1948–1988, exh. cat. (New York: Museum of Modern Art, 2014), 55.

90 The stretcher stamp is only partially legible: "L SALIER [?] DESENHOS E PINTURA LTDA/Rua dos Coqueiros, No. 80/INDUSTRIA BRASILEIRA."

91 A sketch for this work from 1954 with the composition laid out in its final version is reproduced in Butler and Pérez-Oramas, *Lygia Clark,* 88.

92 Approximate dimensions of these shapes are 33.7 × 57.4 cm (bottom left corner of the frame) and 34 × 33 cm (narrower L shape in the opposite corner).

93 The stretcher and canvas were fastened to the frame by folding the rear tacking edges outward onto the frame and attaching the canvas with nails. Black paint underneath these strips of canvas on the reverse of the frame indicates that the frame was painted before the canvas was inserted. The series of taped and overpainted lines in the bottom left-hand corner of the frame also indicates that Clark carefully adjusted the "misalignment" of the edge of the L shape on the frame with the black line on the painting.

94 See Giulia Villela Giovani, "A análise de técnicas e materiais aplicada á conservação de arte contemporânea—o uso da tinta industrial sobre madeira na produção pictórica de Lygia Clark" (master's thesis, Universidade Federal de Minas Gerais, 2014), 55, 76–77.

95 For sharing memories and insights on this subject, the author thanks, for example, Fernando Cocchiarale, curator at MAM-RJ, conversation with the author, Rio de Janeiro, 12 April 2016; and Peter Cohn, director of Dan Galeria, conversation with the author, São Paulo, 28 July 2015.

96 Standeven, *House Paints,* 72.

97 Giovani, "A análise de técnicas e materiais," 74, 76.

98 Clark increased the amount of French ultramarine as she kept adding paint layers, with the topmost paint layer appearing more purple than pink.

99 This coincides with the medium description of three works from the related *Superfície modulada* series as "oil on wood," in the catalog of the 3º Bienal de São Paulo in 1955. Above the pink oil layers lies a crumbly white paint layer that contains aluminum oxide. It is probably a commercial metal primer, applied to receive the subsequent nitrocellulose-based layers and perhaps to prevent visual interference between the colors of the lower and upper paint layers.

100 The bubble-wrap pattern is also faintly visible in the more thinly painted forms such as the black ones, but the damage is less pronounced there.

101 Willys de Castro, "Objeto ativo," in Roberto Conduru, *Willys de Castro,* Eng. trans. David Warwick (São Paulo: Cosac Naify, 2005), 220.

102 Georges Vantongerloo, "Eine Biographie," in *Georges Vantongerloo,* exh. cat. (Milan: Electa, 1986), 19.

PLATES

The photographic documentation of the artworks presented here is the result of a collaborative effort between the Getty Conservation Institute and the J. Paul Getty Museum. All thirty-four works are shown in their entirety from the front, and many of them have also been documented from alternate views, such as from the side, from the reverse, and in close-up. To capture the objects' physical structure and condition, we used a variety of visible light, infrared, and ultraviolet (UV) photographic techniques developed for the documentation and conservation of works of art. (For information about the techniques used to document these artworks, see "Some Remarks on Documentation and Analysis Techniques" [pages 130–31].)

Working from reproduced images of artworks has long been both a necessary stalwart and an acknowledged drawback of art historical inquiry, with inaccuracies registered in the realms of color, scale, surface quality, and three-dimensionality. Central to the artists' working methods and intentions are issues such as surface texture and the three-dimensional nature of many of the works; thus, we have reproduced images made as part of the technical study in the hope that they allow both scholars and the general public a more comprehensive understanding of the materiality and genesis of these artworks.

A final note with regard to the captions: measurements of the artworks are given in the customary order of height, width, and depth. The medium descriptions list the support of a work, such as canvas or hardboard, followed by the binding medium or media of the paint layers. The six main categories of binders identified are oil, oleoresin, alkyd, polyvinyl acetate (PVA), nitrocellulose, and acrylic.

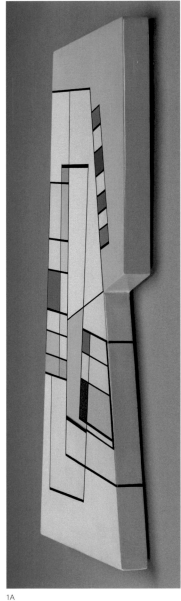

1A

1B

PLATE 1.

Carmelo Arden Quin (Uruguayan, 1913–2010).

Trío no. 2 (Trio no. 2), 1951, alkyd and acrylic on
plywood, 51.4 × 27 × 2.5 cm. Colección
Patricia Phelps de Cisneros, 1998.54.

PLATE 1A.

View from right side: sides of work painted gray
and creamy white with black lines.

PLATE 1B.

Full view of reverse: wooden bars nailed to
plywood panel.

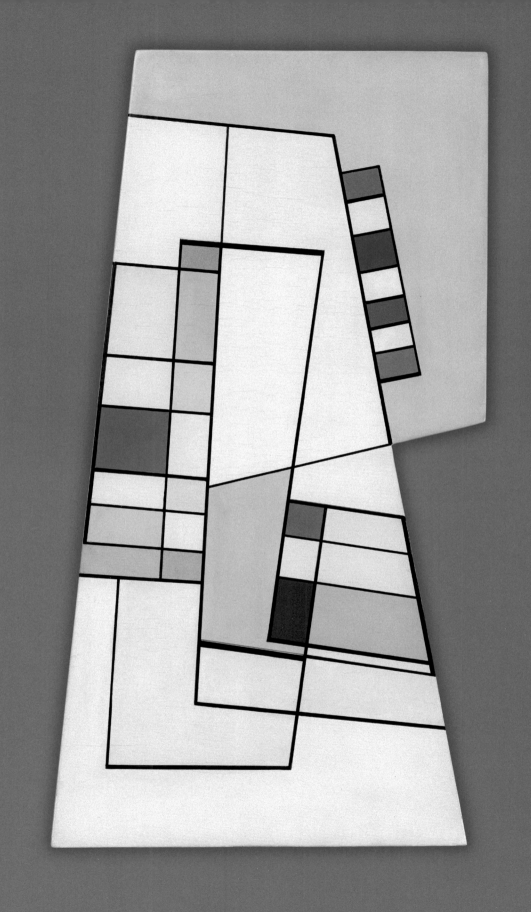

2A

2B

2C

PLATE 2.
Aluísio Carvão (Brazilian, 1920–2001).
Construção 6 (Construction 6), 1955, PVA on
plywood, 84.5 × 59.1 × 1 cm. New York,
The Museum of Modern Art. Promised gift of
Patricia Phelps de Cisneros through the
Latin American and Caribbean Fund
in honor of Peter Reed, PG79.2010, 1996.17.

PLATE 2A.
Detail of front, below center: paint layer of light
beige-colored rectangle ("nucleus") in top left
corner also extends underneath rest of painting;
dividing lines executed with yellow ink applied
with a ruling pen, with overlaid brown pencil and
graphite lines.

PLATE 2B.
Full view of front in UV light: strong fluorescence of
"nucleus" due to presence of zinc white.

PLATE 2C.
Full view of reverse: plywood panel with attached
outer bars and diagonal crossbar to prevent panel
from distorting.

3A

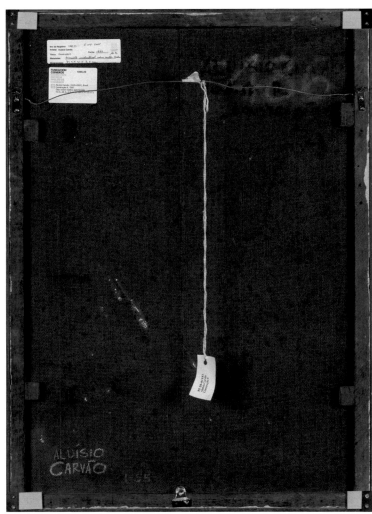

3B

PLATE 3.
Aluísio Carvão (Brazilian, 1920–2001).
Construção 8 (Construction 8), 1955, alkyd on
hardboard, 70.5 × 49.5 × 2.5 cm. New York,
The Museum of Modern Art. Promised gift of
Patricia Phelps de Cisneros through the
Latin American and Caribbean Fund
in honor of James Gara, 1995.25.

PLATE 3A.
Photomicrographic detail of front, bottom left
corner, in raking light: graphite lines visible at edges
of light blue rectangle; white background shows
polishing marks.

PLATE 3B.
Full view of reverse: hardboard panel with attached
wooden bars.

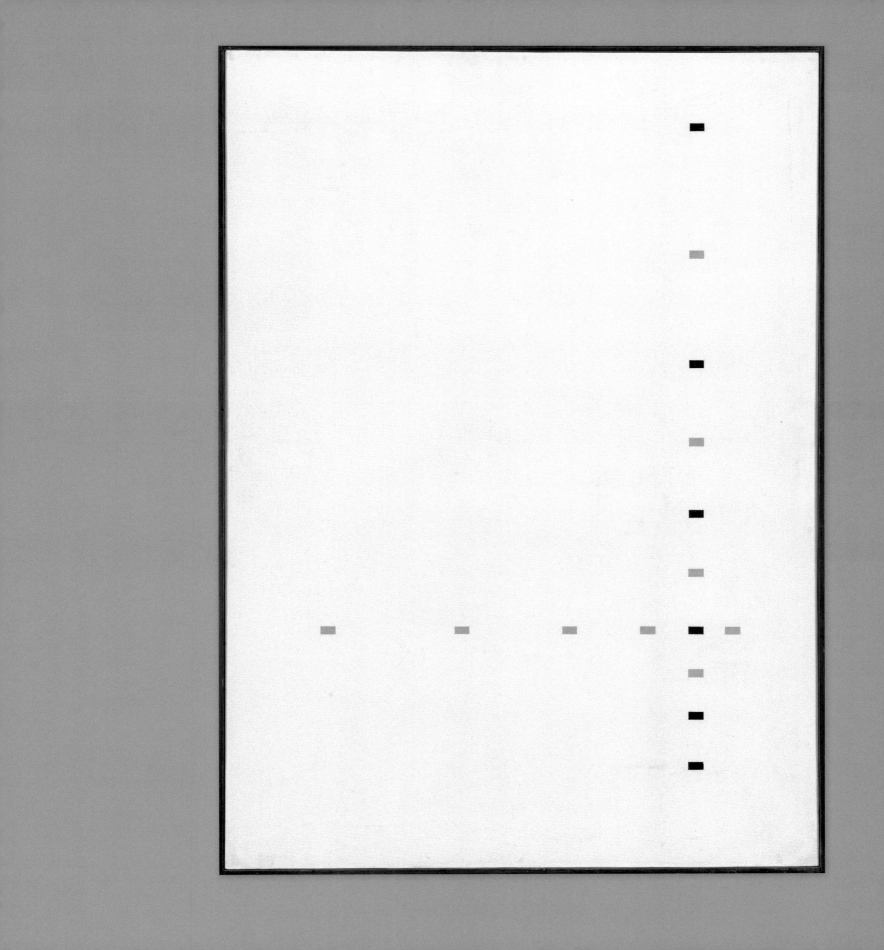

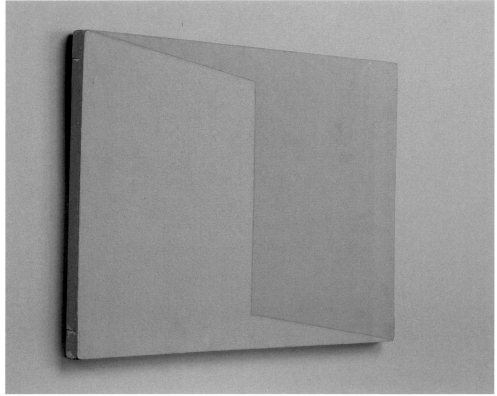

4A

4C

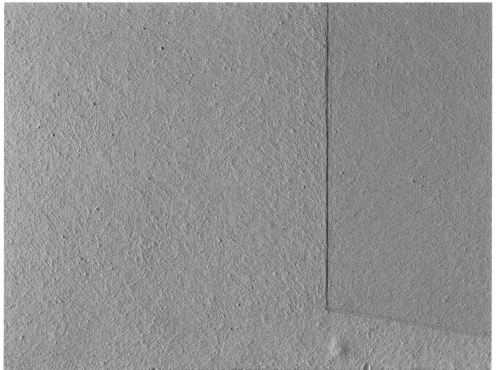

4B

PLATE 4.
Aluísio Carvão (Braz lian, 1920–2001).
Cromática 6 (Chromatic 6), 1960. alkyd, drying oil, and beeswax on hardboard, 26.4 × 34 × 1.5 cm. Inscribed "CROMATICA 6" in graphite on reverse of upper wooden bar. Colección Patricia Phelps de Cisneros, 1996.41.

PLATE 4A.
View from left side, with painted edge and paint losses, revealing white ground layer.

PLATE 4B.
Detail of front in raking light: slightly coarser texture of paint on left side.

PLATE 4C.
Cross section from bottom right edge: four layers of underbound paint, with the lower two layers being ochre-colored (containing chrome yellow, possibly zinc chromate, an organic yellow pigment, titanium white, gypsum, and barium sulfate), followed by a bright yellow layer (containing the same pigments) and a very thin toning layer containing titanium white and gypsum.

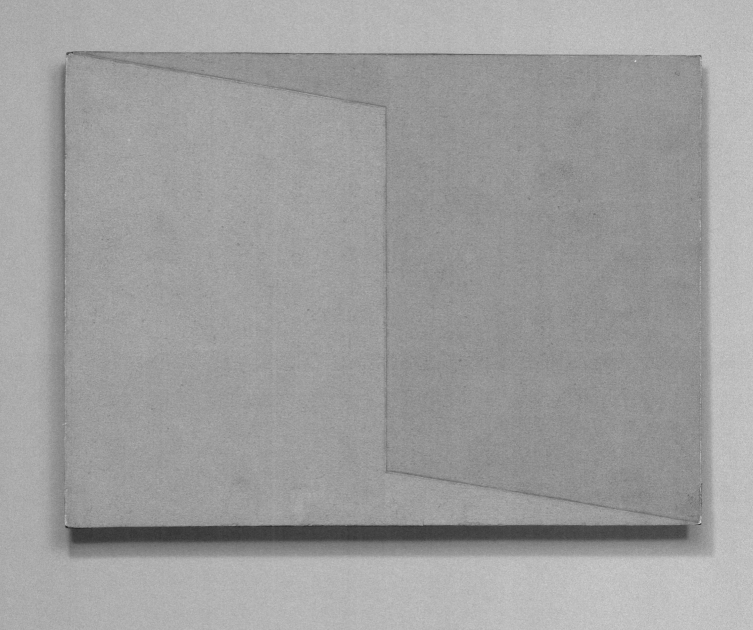

PLATE 5.
Aluísio Carvão (Brazilian, 1920–2001).
Superfície farfalhante V (Rustling surface V), 1960,
aluminum discs, nails, and paint
on plywood and wood, 28.2 × 28 × 3.5 cm.
Colección Patricia Phelps de Cisneros, 1997.154.

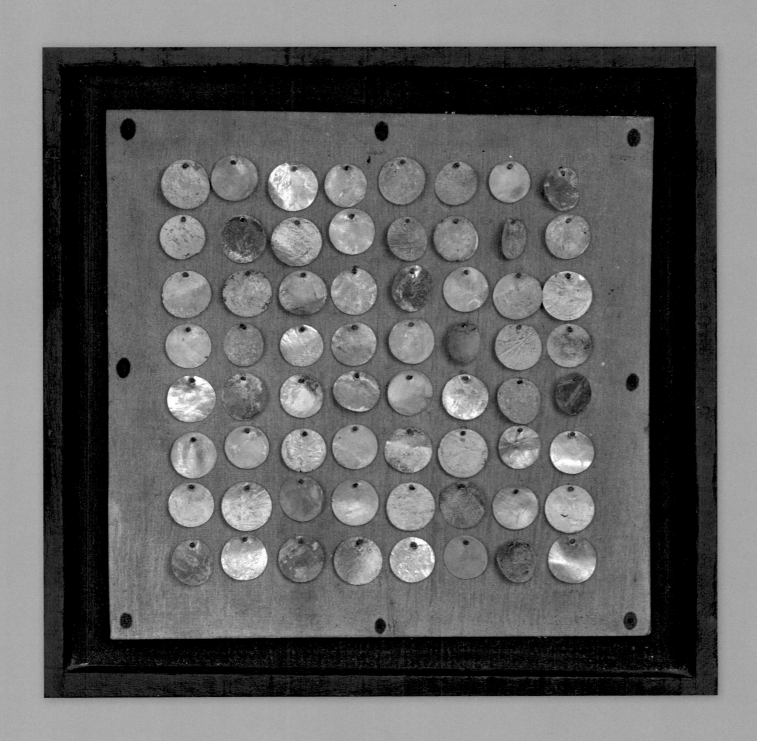

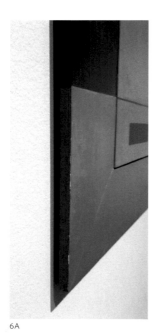

6A

6B

6C

PLATE 6.
Lygia Clark (Brazilian, 1920–88).
Composição no. 5 (Composition no. 5) from the
Quebra da moldura (Breaking the frame) series,
1954, oil and oleoresin on canvas and wood,
106.5 × 90.5 × 1.8 cm. New York, The Museum
of Modern Art. Promised gift of Patricia Phelps
de Cisneros through the Latin American and
Caribbean Fund, 1997.54.

PLATE 6A.
Detail of left edge: gray and black paint layers
applied to sides of wooden frame.

PLATE 6B.
Detail of front, bottom right corner: physical
gap between canvas (top) and frame (bottom)
and shifted alignment of black line and border
of L shape; horizontal wood grain visible in
foreground, canvas texture in background.

PLATE 6C.
Full view of reverse: wooden frame with metal
corner braces; protective fabric and backboard on
reverse of canvas (added by conservators).

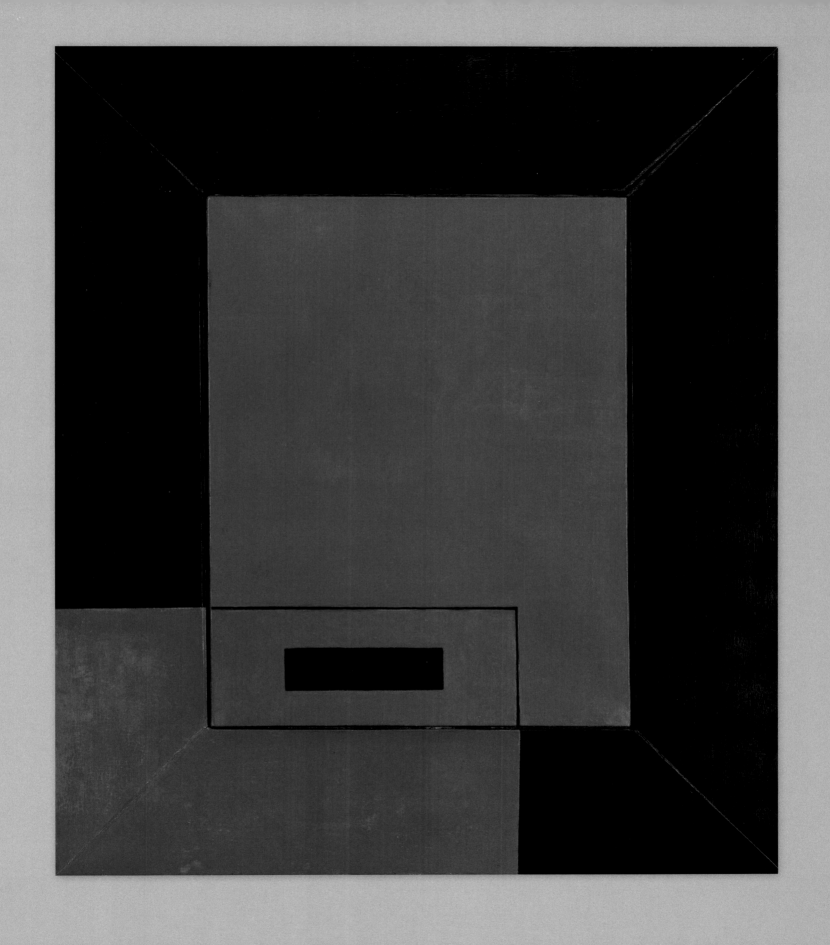

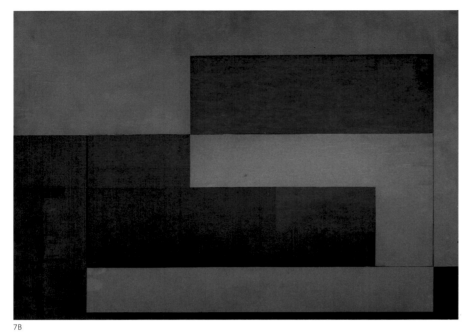

7B

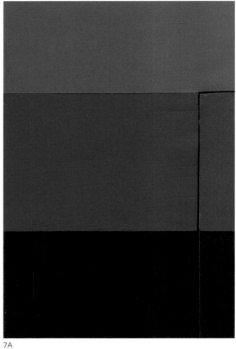

7A

7C

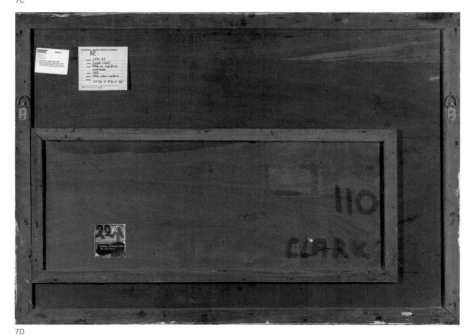

7D

PLATE 7A.
Detail of front, left side: physical gap between inset panel and surrounding panel as well as taped borders between gray, green, and brown areas.

PLATE 7B.
Full view of front in UV light: fluorescing shapes underneath green and brown areas on left side, along bottom edge, and at right side, as well as in center of inset panel.

PLATE 7C.
Side view of bottom left corner: three plies of plywood panel and attached wooden bar with brown and gray paint sprayed on top.

PLATE 7D.
Full view of reverse: wooden bars attached to outer edges of plywood panel and on top of physical gaps around edges of inset panel to hold it in place.

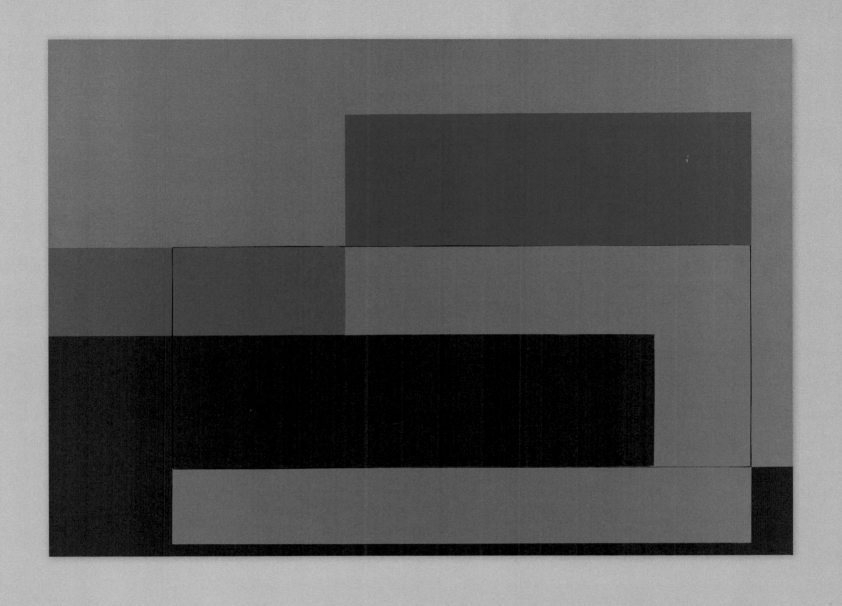

8B

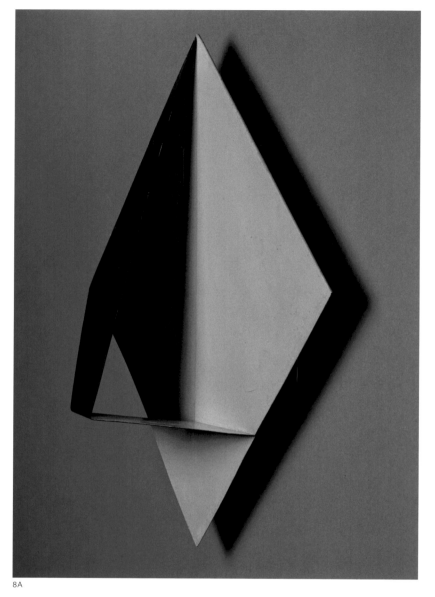

8A

PLATE 8A.
View of sculpture from right side.

PLATE 8B.
Photomicrographic detail of front, right side: pitted
texture of spray-painted white nitrocellulose.

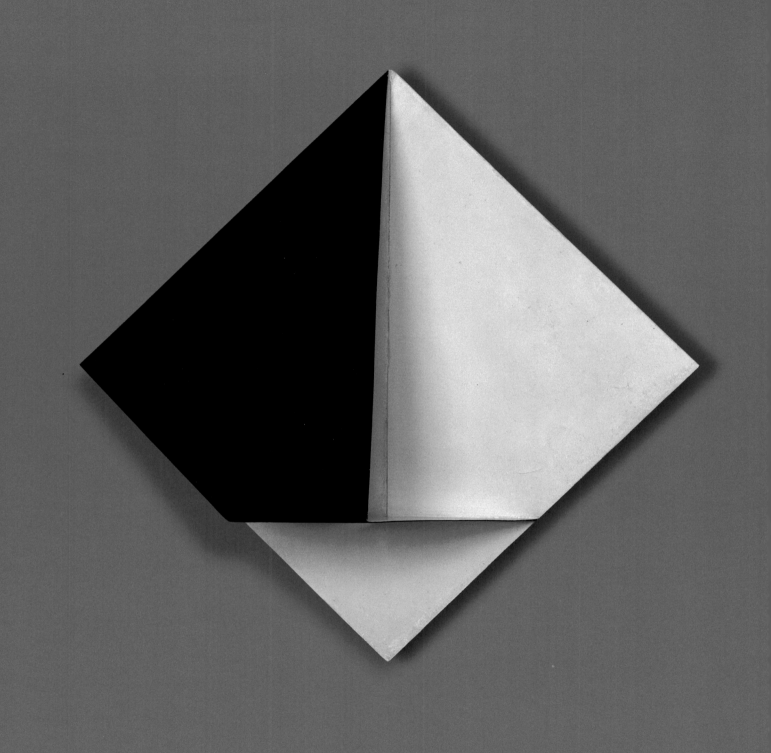

9A

9B

PLATE 9.
Waldemar Cordeiro (Brazilian, 1925–73).
Idéia visível (Visible idea), 1956, alkyd on
hardboard, 63.3 × 62.8 × 2 cm (framed).
New York, The Museum of Modern Art.
Promised gift of Patricia Phelps de Cisneros
through the Latin American and
Caribbean Fund, 1996.190.

PLATE 9A.
Detail of front, center: composition laid out with
graphite and painted with a ruling pen and brush,
white followed by black.

PLATE 9B.
Full view of reverse: hardboard panel painted dark
red, the word *vermelho* (red) faintly scratched into
wet paint.

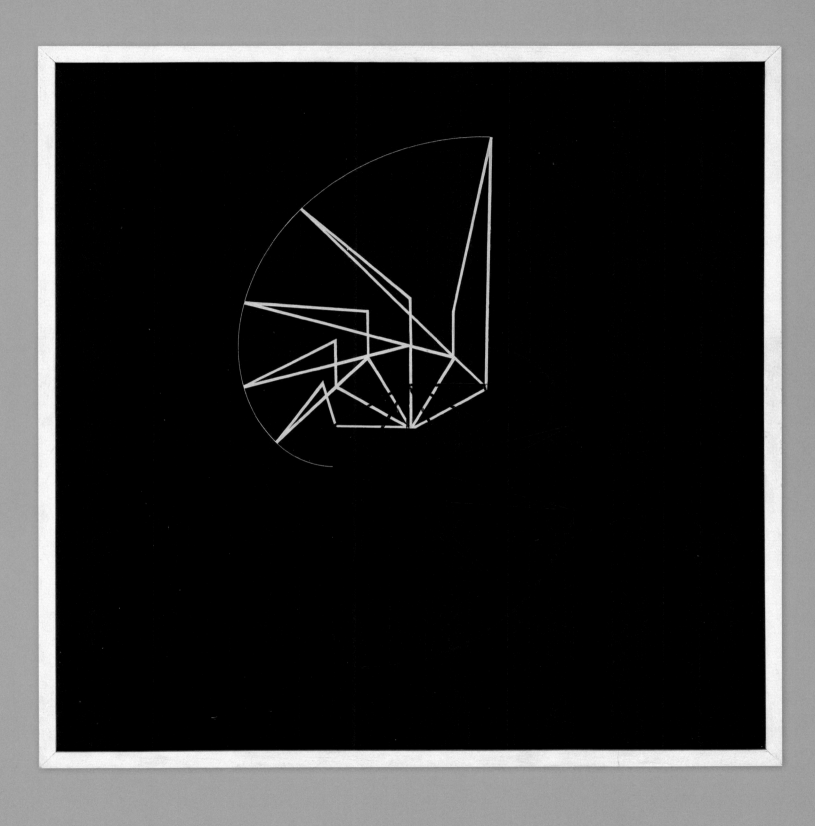

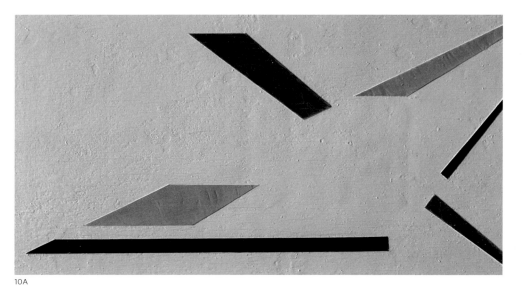

10A

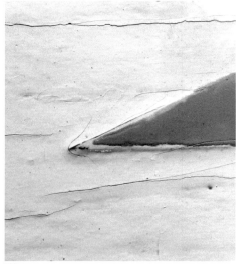

10B

10C

PLATE 10.
Geraldo de Barros (Brazilian, 1923–98).
Objeto plástico (Visual object), 1952, alkyd on
wood, 36.8 × 45.1 × 2.4 cm. Colección
Patricia Phelps de Cisneros, 1999.67.

PLATE 10A.
Detail of front, center, in raking light: colored
elements, painted with the help of self-adhesive
tape, stand proud on white background.

PLATE 10B.
Photomicrographic detail of front, left side:
tip of ochre element revealing white and black
underlayers.

PLATE 10C.
View of top edge: side of work painted white.

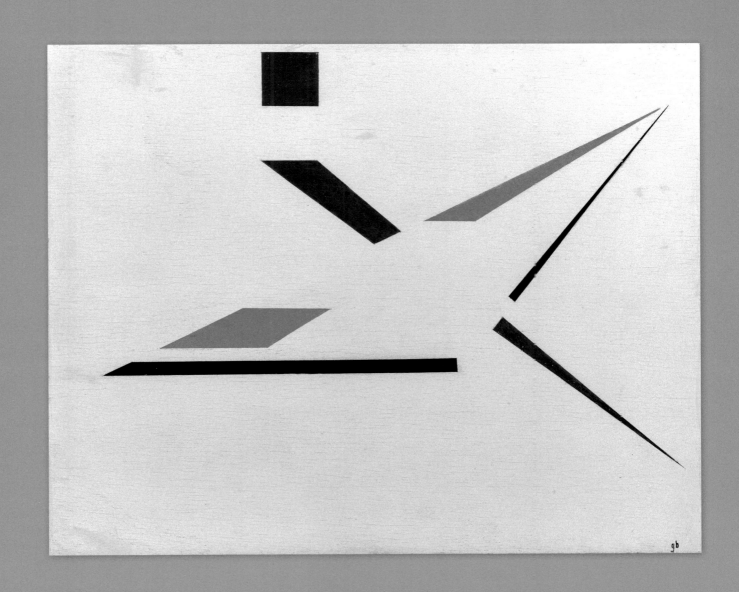

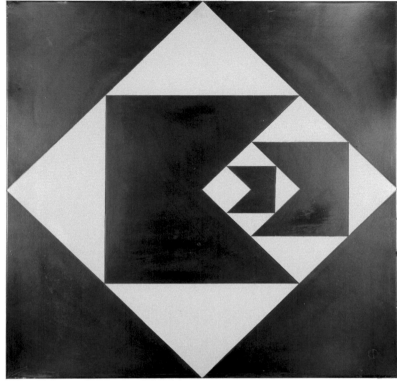

11A

11B

11D

11C

PLATE 11.
Geraldo de Barros (Brazilian, 1923–98).
Função diagonal (Diagonal function), 1952, alkyd on hardboard, 60.3 × 60.3 × 0.5 cm. New York, The Museum of Modern Art. Promised gift of Patricia Phelps de Cisneros through the Latin American and Caribbean Fund, 1995.16.

PLATE 11A.
Full view of front in specular light: differences in gloss between more matte white areas and shinier, polished black areas.

PLATE 11B.
Detail of front, center: paint bleed from underneath self-adhesive tape along black borders.

PLATE 11C.
Photomicrographic detail of front, bottom right corner: logotype scratched into black paint, revealing white underlayers.

PLATE 11D.
Full view of reverse: aluminum frame and traces of glue from previous hanging device.

12A

12B

PLATE 12.
Willys de Castro (Brazilian, 1926–88).
Composição modulada (Modulated composition),
1954, alkyd on hardboard, 40.3 × 40 × 2.4 cm.
New York, The Museum of Modern Art.
Promised gift of Patricia Phelps de Cisneros
through the Latin American and Caribbean Fund,
1997.21.

PLATE 12A.
Side view from top edge: gray and white forms
extend onto edge of panel.

PLATE 12B.
Side view from right: gray and yellow forms extend
onto edge of panel.

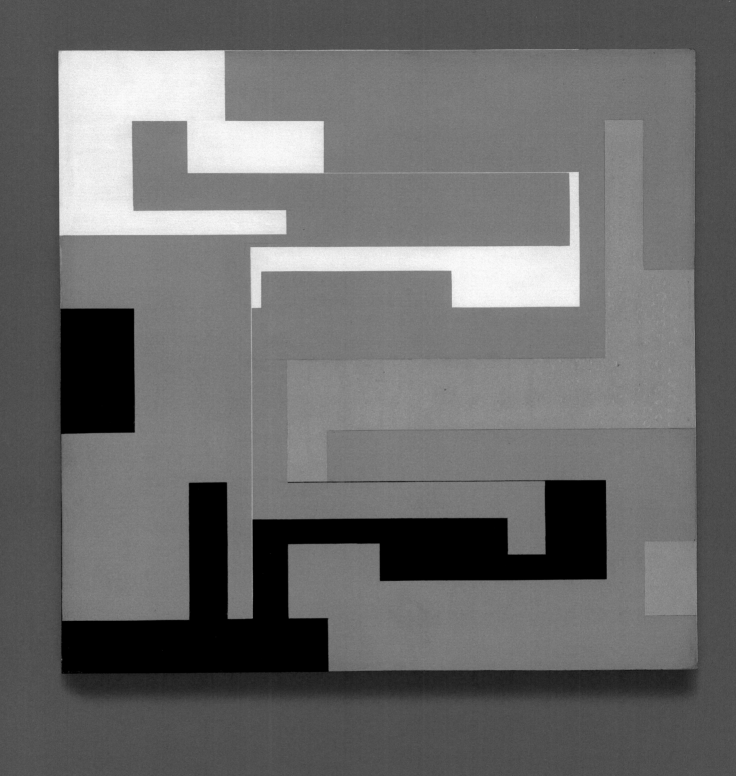

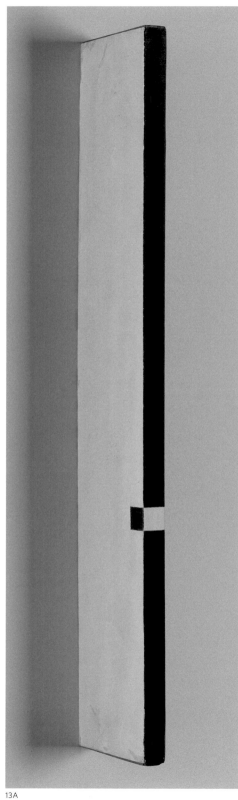

13A

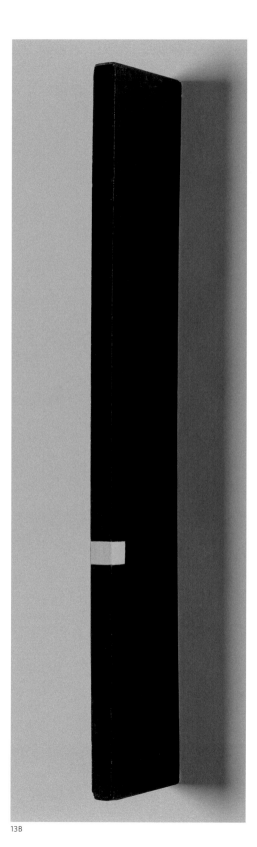

13B

PLATE 13.
Willys de Castro (Brazilian, 1926–88).
Objeto ativo (Active object), 1959, gouache on
paper on wood, 32.5 × 1 × 5.5 cm. Colección
Patricia Phelps de Cisneros, 1996.63.

PLATE 13A.
View of left side: discolored white paper with
square drawn with pencil lines and painted with
black gouache.

PLATE 13B.
View of right side.

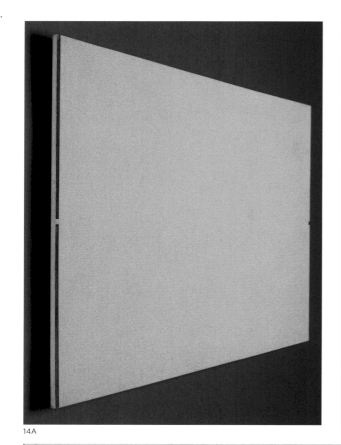

14A

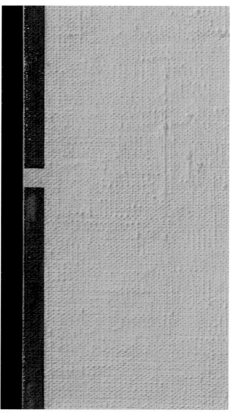

14B

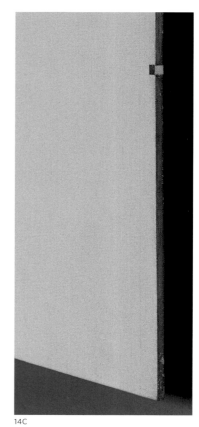

14C

14D

PLATE 14.
Willys de Castro (Brazilian, 1926–88).
Objeto ativo (amarelo) (Active object [yellow]),
1959–60, oil on canvas on hardboard, 35 × 70 ×
1.8 cm. New York, The Museum of Modern Art.
Promised gift of Patricia Phelps de Cisneros
through the Latin American and Caribbean Fund
in honor of Lord and Lady Foster, 1997.56.

PLATE 14A.
View of left side with canvas turnover edge
painted yellow.

PLATE 14B.
Detail of front, left edge: blue band on top of
yellow background layer.

PLATE 14C.
Detail of right side with canvas turnover edge
painted blue and yellow.

PLATE 14D.
Full view of reverse: wooden hanging device and
preprimed canvas glued to hardboard.

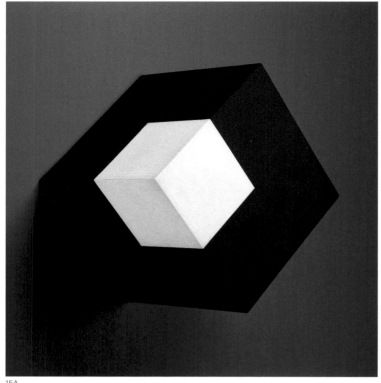

15A

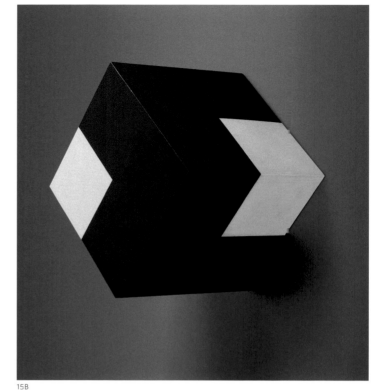

15B

15C

PLATE 15.
Willys de Castro (Brazilian, 1926–88).
Objeto ativo (cubo vermelho/branco) (Active object
[red/white cube]), 1962, oil on canvas on plywood,
25 × 25 × 25 cm. View from front. New York,
The Museum of Modern Art. Promised gift of
Patricia Phelps de Cisneros through the Latin
American and Caribbean Fund in honor of
Tomás Orinoco Griffin Cisneros, 1997.127.

PLATE 15A.
View from left side.

PLATE 15B.
View from right side.

PLATE 15C.
View of interior: preprimed canvas glued to
plywood cube construction.

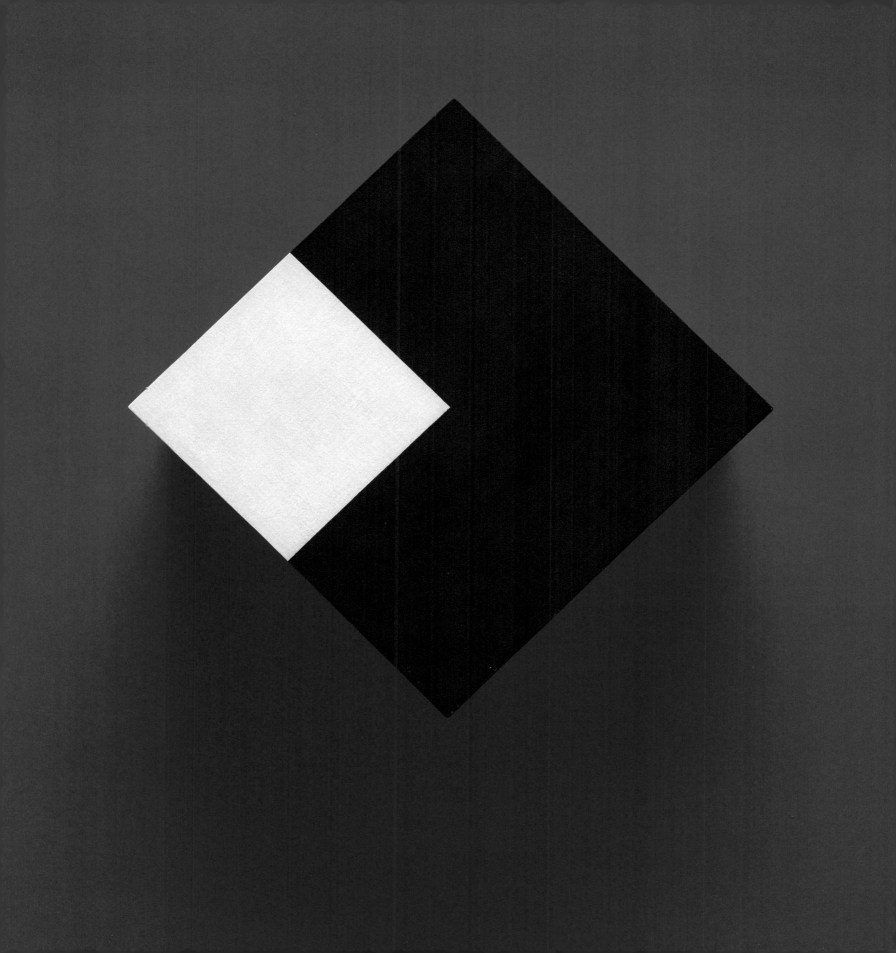

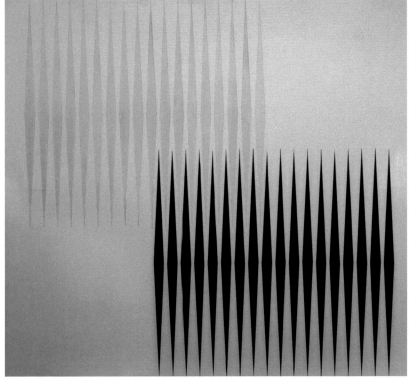

16A

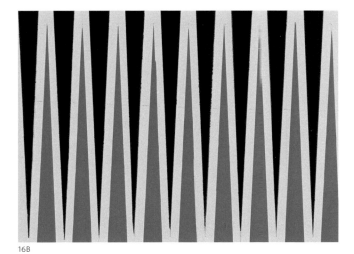

16B

16C

PLATE 16.
Hermelindo Fiaminghi (Brazilian, 1920–2004).
Alternado 2 (Alternated 2), 1957, alkyd on
hardboard, 61.9 × 62 × 4.5 cm (framed). New York,
The Museum of Modern Art. Promised gift of
Patricia Phelps de Cisneros through the
Latin American and Caribbean Fund in honor of
Catalina Cisneros-Santiago, 1997.62.

PLATE 16A.
Full view of front in infrared light: outlines of red
lozenges visible in upper left corner, indicating
application of denser paint with ruling pen; earlier
signature visible in lower left corner, now covered
with white paint.

PLATE 16B.
Detail of front, center: slight imperfections along
edges created by red paint bleed underneath self-
adhesive tape, and pinpoint holes and incised lines.

PLATE 16C.
Full view of reverse: wooden laths attached to
outer edges of hardboard panel and two sets of
wooden hanging devices adhered to center.

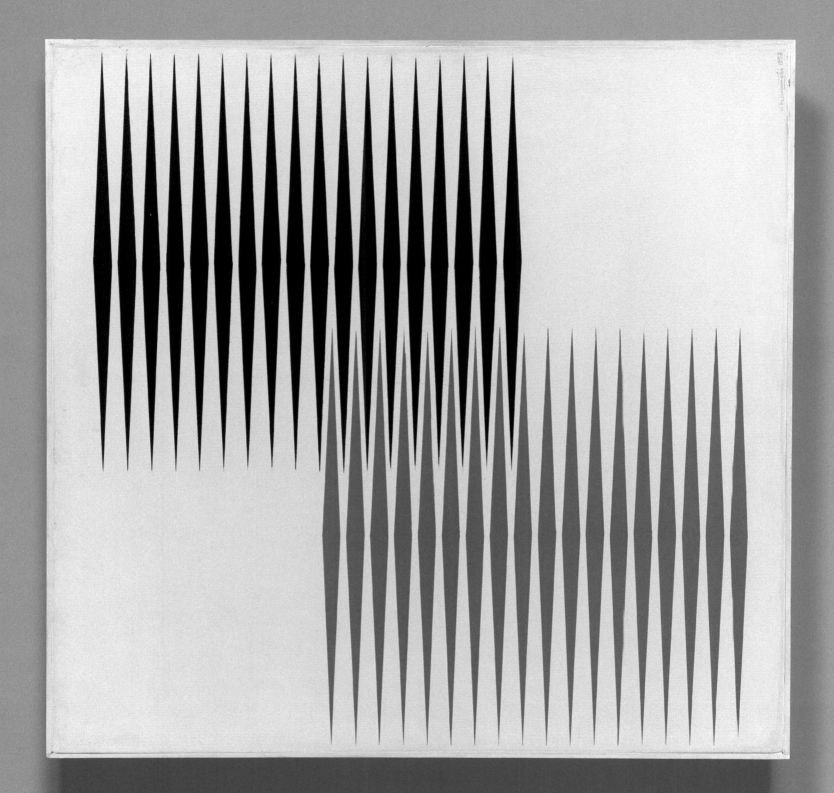

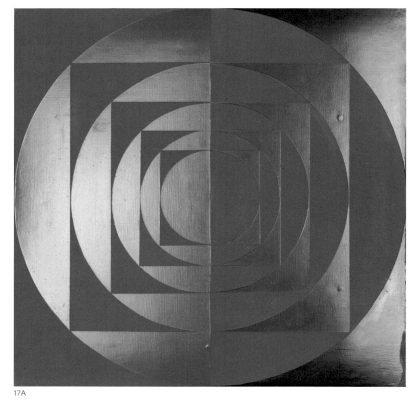

17A

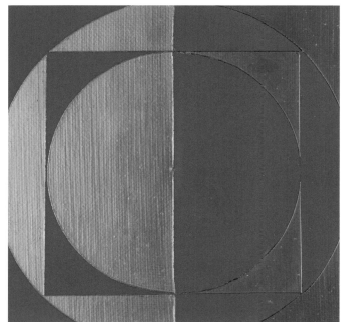

17B

17C

17D

PLATE 17.
Hermelindo Fiaminghi (Brazilian, 1920–2004).
Seccionado no. 1 (Sectioned no. 1), 1958, alkyd on
hardboard, 60 × 60 × 6 cm. Colección
Patricia Phelps de Cisneros, 1997.26.

PLATE 17A.
Full view of front in specular light: texture of
hardboard panel visible especially in shiny red
and orange areas.

PLATE 17B.
Detail of front, center: contrast between matte
and shiny areas.

PLATE 17C.
View of right side: concave warp of panel, painted
wooden hanging device.

PLATE 17D.
Full view of reverse: smooth side of hardboard
panel and wooden hanging device with parts of the
reverse painted orange.

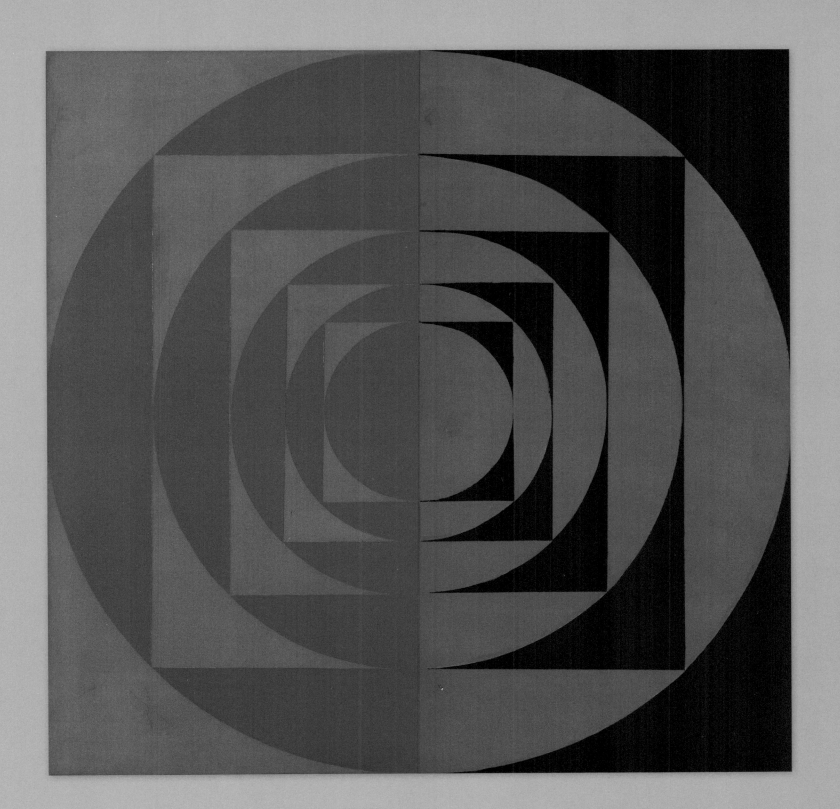

18A

18B

PLATE 18.
Alfredo Hlito (Argentine, 1923–93).
Ritmos cromáticos II (Chromatic rhythms II), 1947,
oil on canvas, 69.5 × 69.8 × 2 cm. Inscribed
"RITMO CROMATICO" in charcoal on reverse.
Colección Patricia Phelps de Cisneros, 1998.39.

PLATE 18A.
Photomicrographic detail of front, top right
corner: green paint layer visible underneath black
rectangle.

PLATE 18B.
Photomicrographic detail of front, center: vertical
graphite line underneath yellow paint; incisions
left by ruling pen; and scratch marks as well as
discolored inpainting.

19A

19B

PLATE 19.
Alfredo Hlito (Argentine, 1923–93).
Curvas y series rectas (Curves and straight series),
1948, oil on canvas, 70.5 × 70.5 × 2.3 cm.
New York, The Museum of Modern Art. Promised
gift of Patricia Phelps de Cisneros through the
Latin American and Caribbean Fund in honor of
Todd Bishop, 1997.53.

PLATE 19A.
Full view of reverse: signed and inscribed
"CURVAS Y SERIES RECTAS" with black paint.

PLATE 19B.
Photomicrographic detail of left center: end section
of yellow curve painted freehand with some white
paint of background on top.

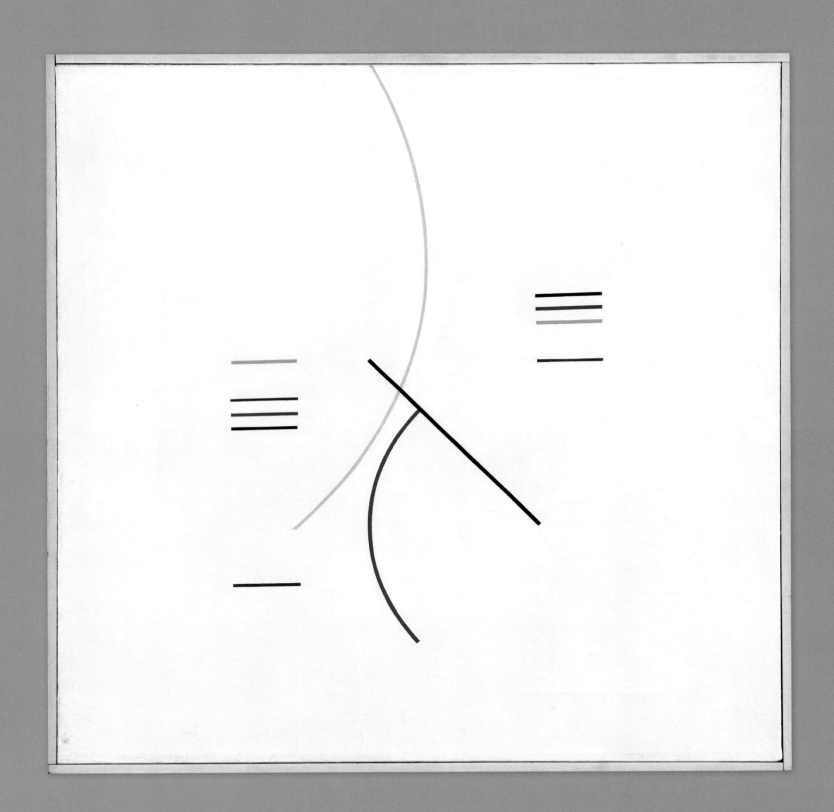

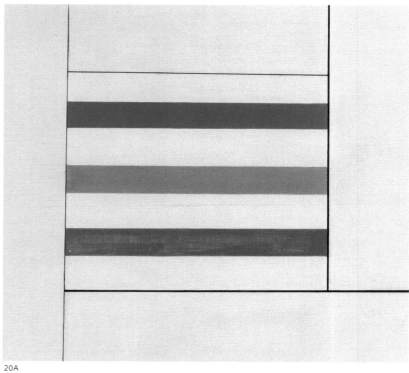

20A

20B

PLATE 20.
Alfredo Hlito (Argentine, 1923–93).
Ritmos cromáticos III (Chromatic rhythms III), 1949,
oil on canvas, 100 × 100 × 1.9 cm. New York,
The Museum of Modern Art. Promised gift of
Patricia Phelps de Cisneros through the
Latin American and Caribbean Fund, 1997.67.

PLATE 20A.
Detail of front, bottom right corner: paint application in purple element less dense and homogeneous than in gray and green areas.

PLATE 20B.
Detail of reverse, top right corner: inscribed
"COMPOSICION" with charcoal; dated and signed
with black paint.

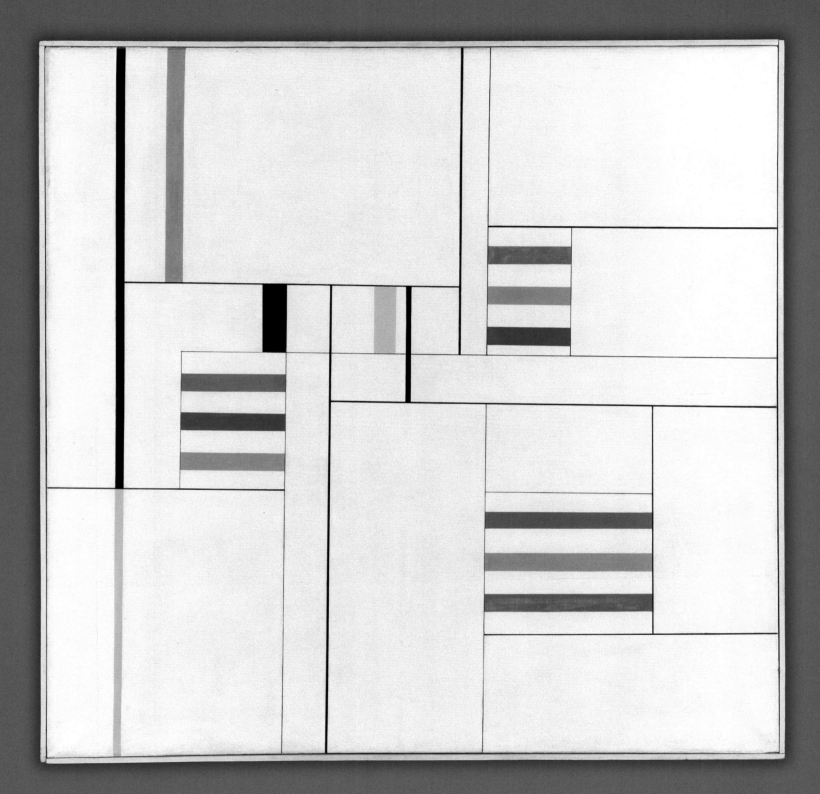

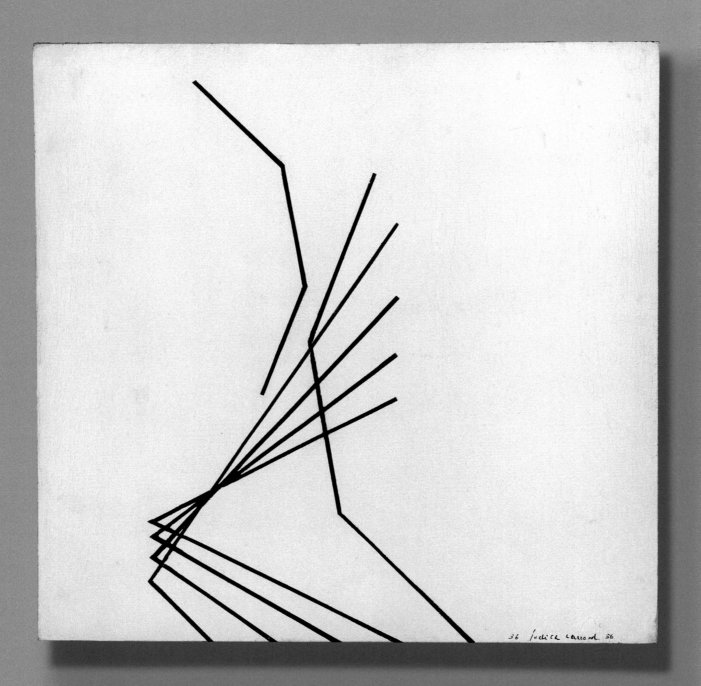

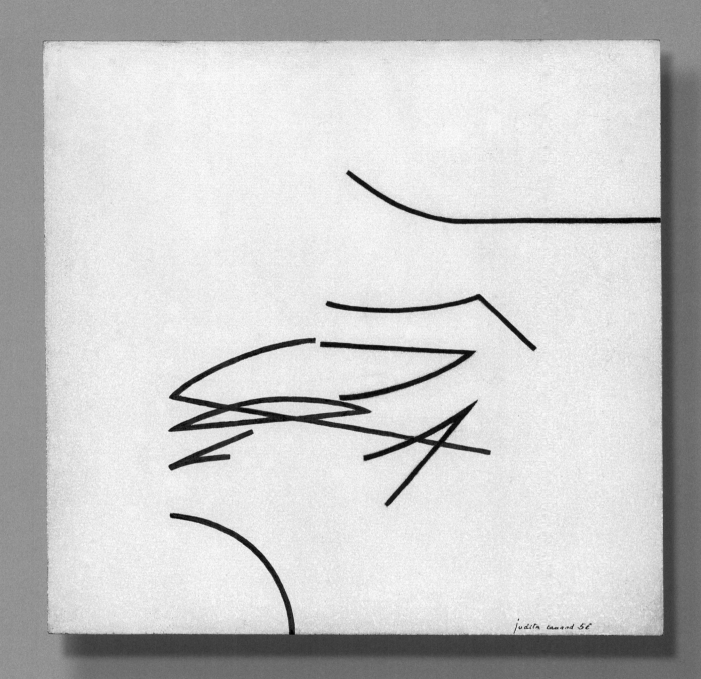

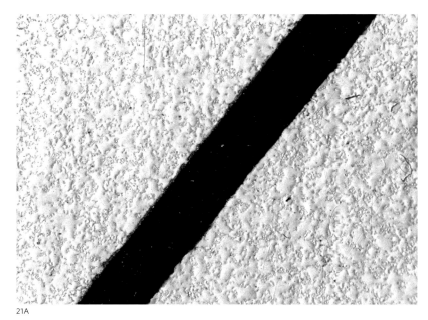

21A

21B

PLATE 21. (Previous spread, left.)
Judith Lauand (Brazilian, 1922–).
Concreto 36 (Concrete 36), 1956, alkyd on plywood,
30.1 × 30.2 × 5.4 cm. Colección Patricia Phelps
de Cisneros, 1996.42.

PLATE 21A.
Photomicrographic detail of front, center: reticu-
lated creamy-colored paint layer applied with roller
or spray gun, red lines on top created with ruling
pen, self-adhesive tape, and brush.

PLATE 21B.
Full view of reverse: adhered wooden strips of
different widths and hanging device at center.

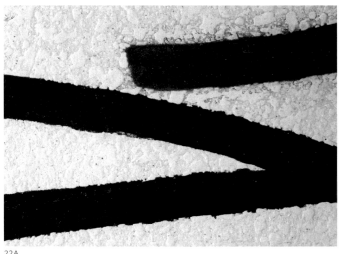

22A

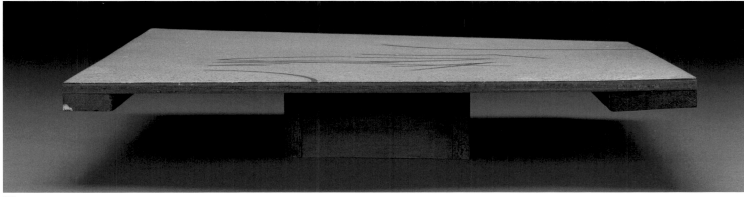

22B

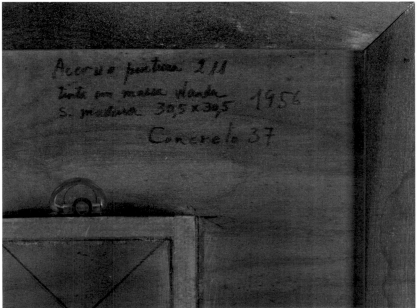

22C

PLATE 22. (Previous spread, right.)
Judith Lauand (Brazilian, 1922–).
Concreto 37 (Concrete 37), 1956, alkyd on plywood,
30.4 × 30.4 × 5.5 cm. Colección Patricia Phelps
de Cisneros, 1996.38.

PLATE 22A.
Photomicrographic detail of front, center: reticulated creamy-colored paint layer applied with roller or spray gun, red and green lines on top created with ruling pen and brush, followed by polishing.

PLATE 22B.
Side view from below: torqued plywood panel with deep wooden hanging device.

PLATE 22C.
Detail of reverse, top right corner: inscription with black marker listing artist's archival number, medium description, dimensions, date, and title.

23A

23C

23D

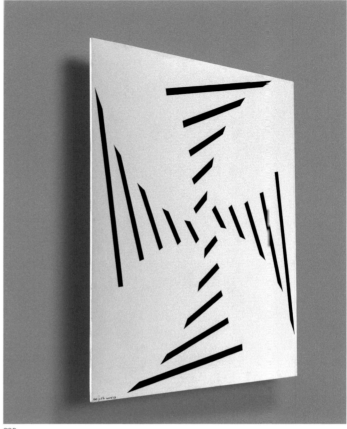

23B

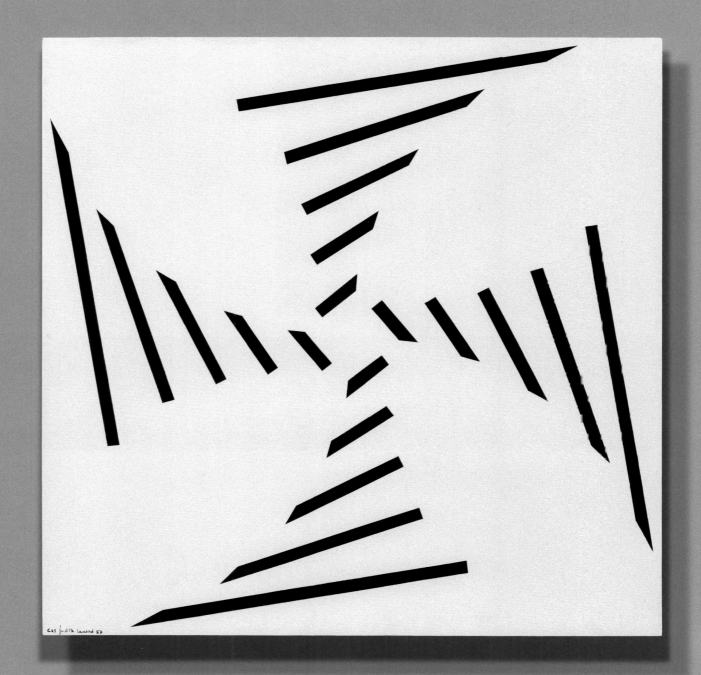

24A

24B

24C

PLATE 24.
Judith Lauand (Brazilian, 1922–).
Quatro grupos de elementos (Four groups of
elements), 1959, alkyd and PVA on hardboard,
59.8 × 59.9 × 3.6 cm (framed). Colección
Patricia Phelps de Cisneros, 1996.7.

PLATE 24A.
Photomicrographic detail of front, bottom right
corner: edge of blue form created with paint, brush,
and self-adhesive tape with distinct ridges from
taping process.

PLATE 24B.
Side view from below: concavely warped and
torqued hardboard panel with decorative frame
and wooden bars as distance holders.

PLATE 24C.
Full view of reverse: hardboard panel painted white
with streaky vertical pattern (probably due to
partial redissolving of white paint with unknown
medium).

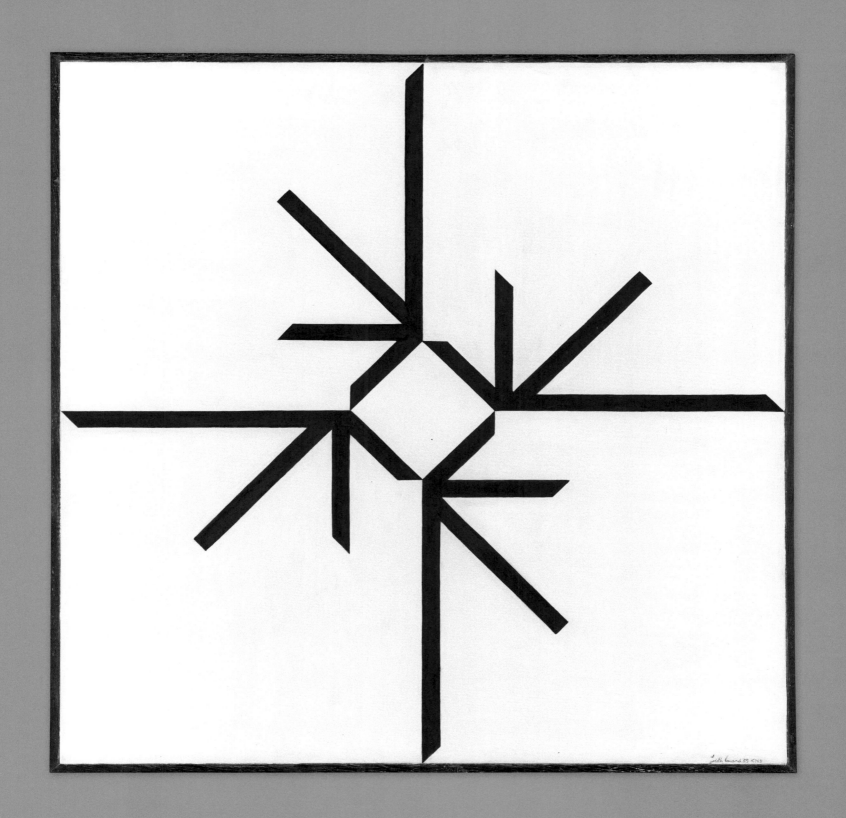

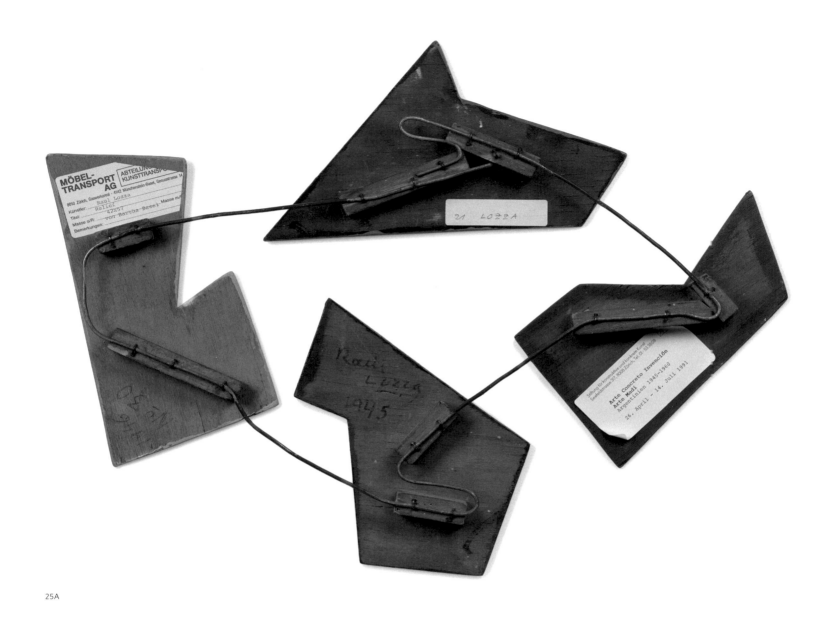

25A

PLATE 25.
Raúl Lozza (Argentine, 1911–2008).
Relieve no. 30 (Relief no. 30), 1945, oil, alkyd, pine
resin, wax, and acrylic on wood and metal wire,
40.6 × 53.3 × 3.8 cm. New York, The Museum
of Modern Art. Promised gift of Patricia Phelps
de Cisneros through the Latin American and
Caribbean Fund, 1998.52.

PLATE 25A.
Full view of reverse: wooden elements attached to
single length of wire with wooden blocks and nails.
Wire between elements painted black.

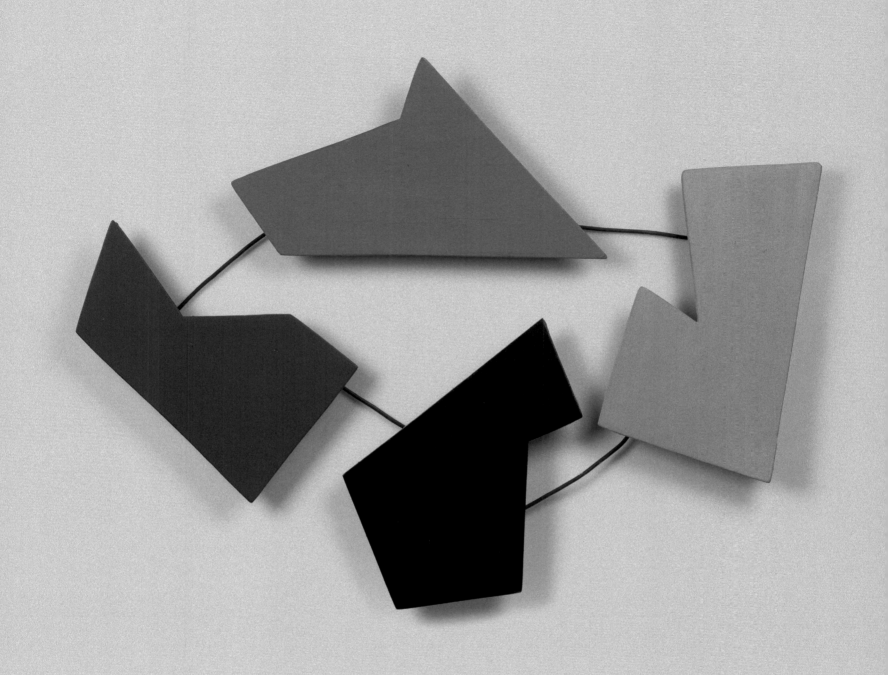

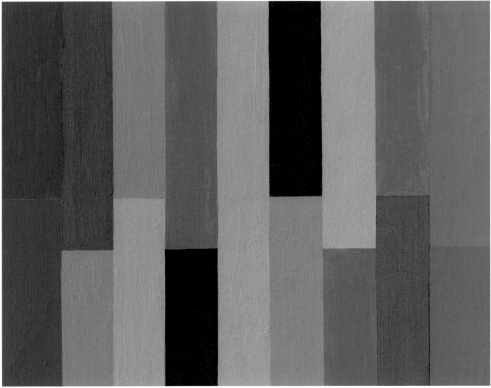

26A

26B

PLATE 26.
Tomás Maldonado (Argentine, 1922–).
Composición 208 (Composition 208), 1955, oil and alkyd on canvas, 50.2 × 50.2 × 2 cm. Colección Patricia Phelps de Cisneros, 1998.9.

PLATE 26A.
Detail of front, center: bands painted freehand and in several layers with drying cracks in orange areas.

PLATE 26B.
Detail of reverse: faded stamp on left-hand stretcher bar and stamp on canvas partially hidden underneath upper stretcher bar.

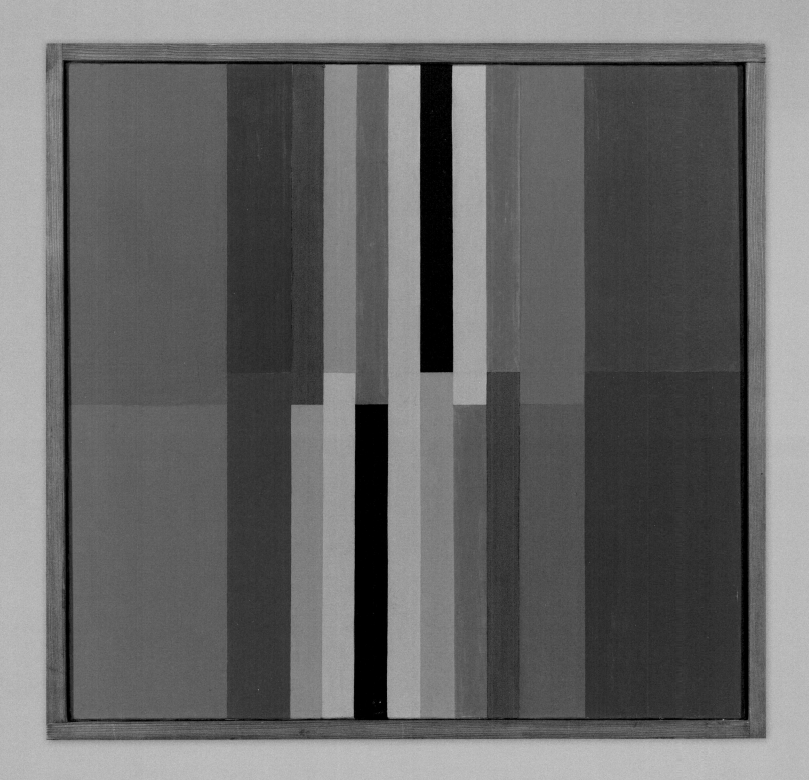

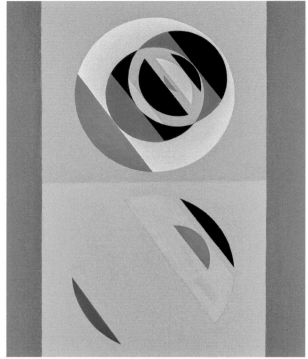

27A

27B

PLATE 27.
Tomás Maldonado (Argentine, 1922–).
Tres zonas y dos temas circulares (Three zones and
two circular themes), 1953, oil and alkyd
on canvas, 100 × 100 × 2.5 cm. Colección
Patricia Phelps de Cisneros, 1997.68.

PLATE 27A.
Detail of front, center: colored shapes painted
freehand and in several layers.

PLATE 27B.
Photomicrographic detail of top right corner:
white ground, followed by bright yellow and bright
orange underlayers, and darker yellow and orange
paint layers above.

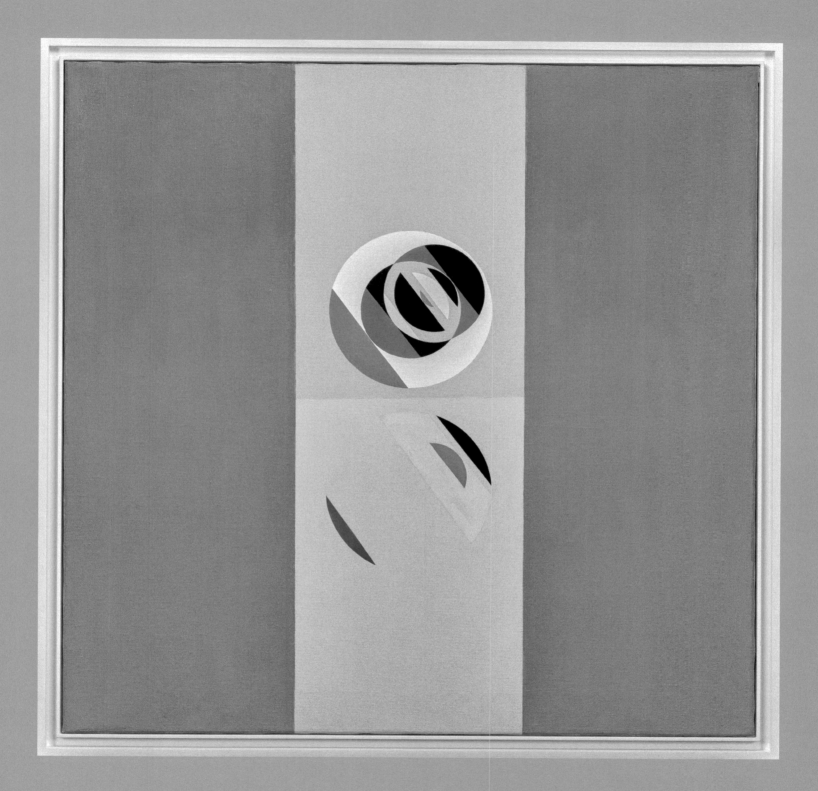

28A

28B

PLATE 28.
Juan Melé (Argentine, 1923–2012).
Marco recortado no. 2 (Cutout frame no. 2), 1946,
oil on hardboard, 71.5 × 50.2 × 2.4 cm.
New York, The Museum of Modern Art.
Promised gift of Patricia Phelps de Cisneros
through the Latin American and Caribbean Fund,
1997.102.

PLATE 28A.
Detail of top right corner from above: wooden bars
painted black.

PLATE 28B.
Full view of reverse: hardboard panel with nailed-
on wooden bars.

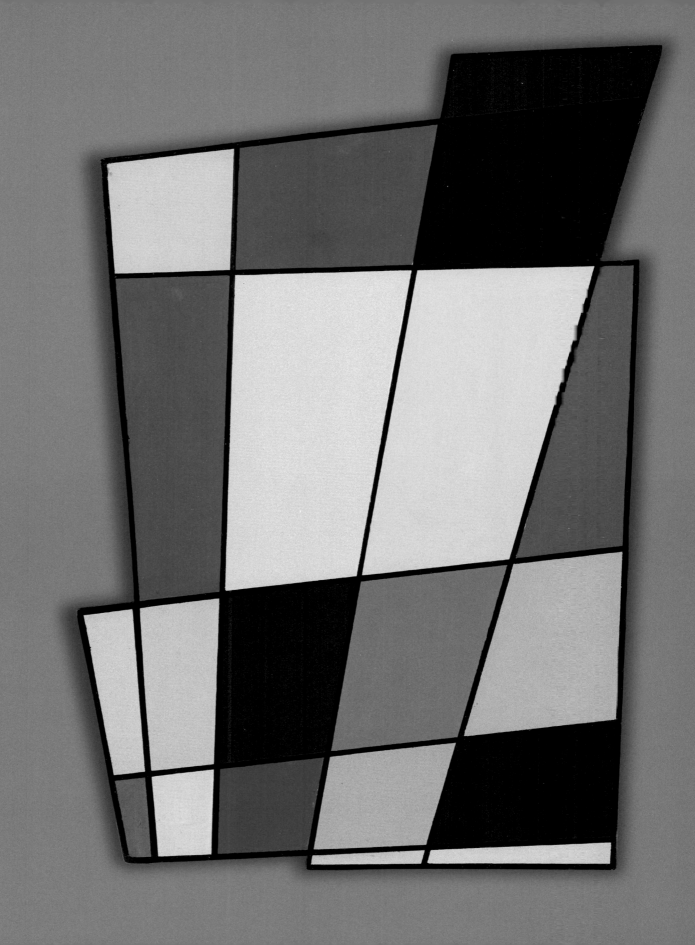

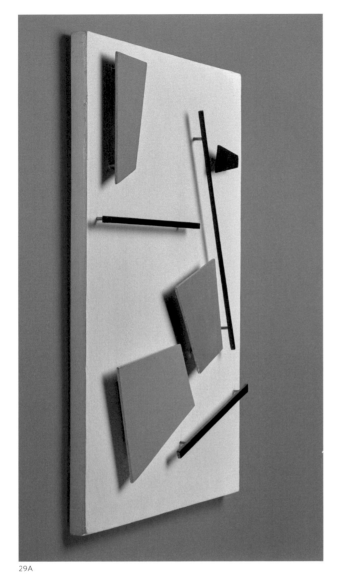

29A

29B

PLATE 29.
Juan Melé (Argentine, 1923–2012).
Planos concretos no. 35 (Concrete planes no. 35),
1948, oil and acrylic on wood and hardboard,
and copper tubing, 65.1 × 45.1 × 2.1 cm.
Colección Patricia Phelps de Cisneros, 1994.1.

PLATE 29A.
View from left side: approximately -cm-long
pieces of copper tubing used as distance holders
between elements and background.

PLATE 29B.
Full view of reverse: hardboard panel with wooden
bars painted white.

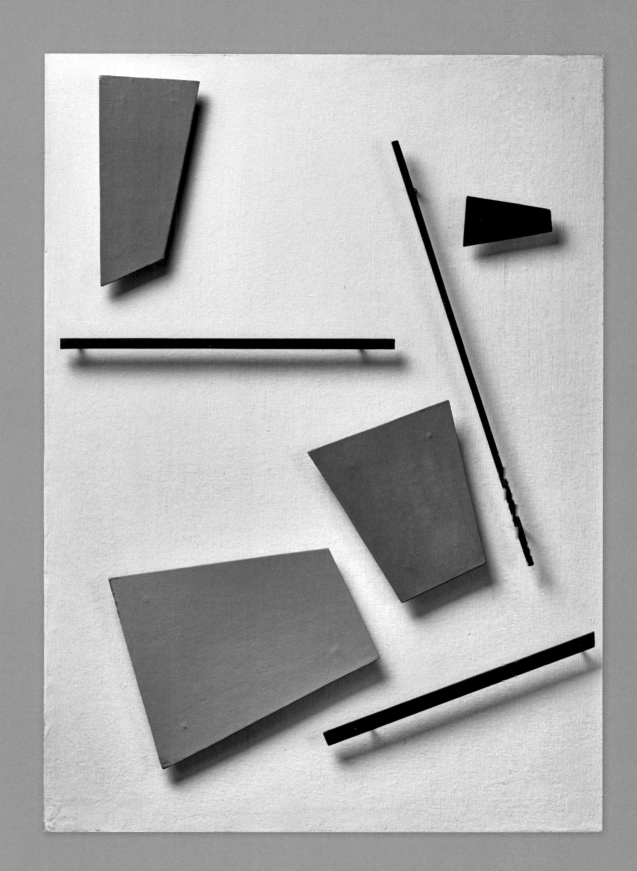

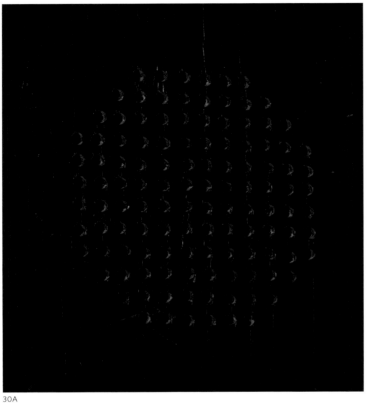

30A

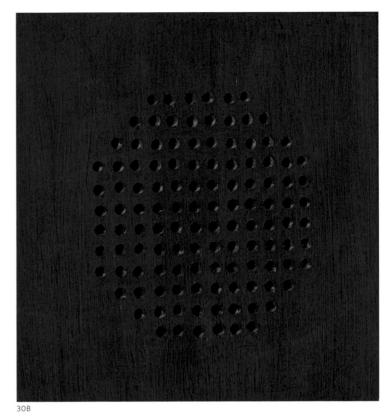

30B

PLATE 30.
Hélio Oiticica (Brazilian, 1937–80).
Sem título (Grupo Frente) (Untitled [Frente group]),
1957, alkyd and oleoresin on wood and fiberboard,
39.4 × 39.4 × 3 cm. New York, The Museum
of Modern Art. Promised gift of Patricia Phelps
de Cisneros through the Latin American and
Caribbean Fund in honor of Isay Weinfeld, 1997.82.

PLATES 30A and 30B.
Details of front from left side: black paint in holes in
top left corner and red paint in holes in bottom
right corner.

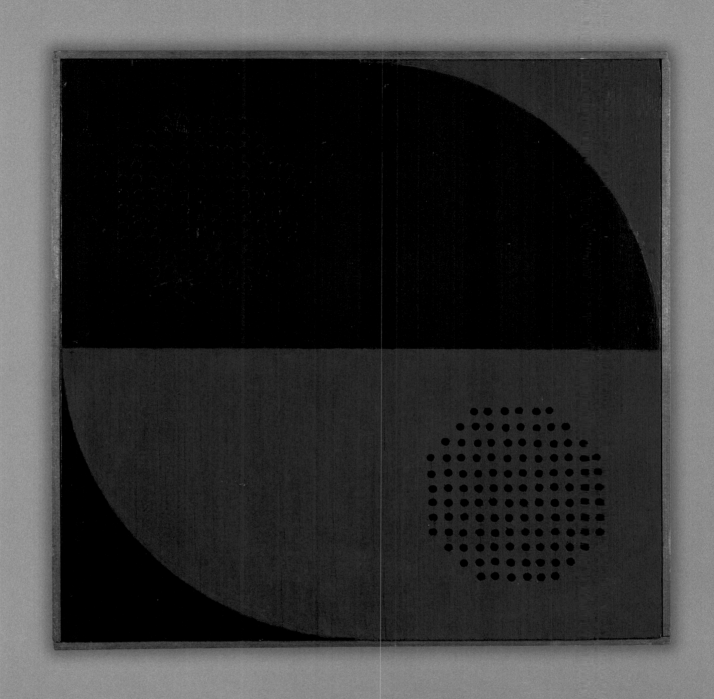

31A

PLATE 31.
Hélio Oiticica (Brazilian, 1937–80).
Monocromático vermelho (Red monochrome),
ca. 1959, alkyd on hardboard, 30 × 30 × 2.5 cm.
New York, The Museum of Modern Art.
Promised gift of Patricia Phelps de Cisneros
through the Latin American and Caribbean Fund
in honor of Paulo Herkenhoff, 2000.10.

PLATE 31A.
Detail of bottom left corner: side of work
painted red. Different orientations of brushwork
visible on front.

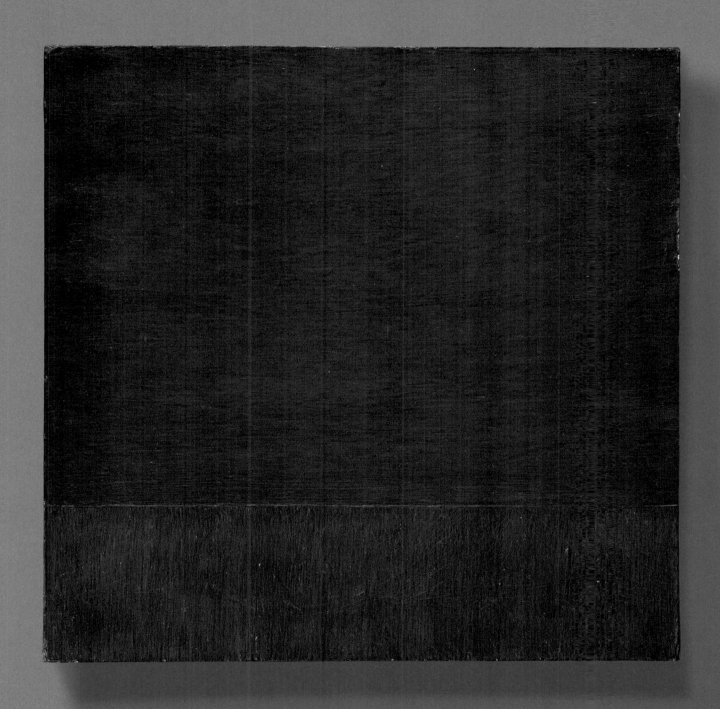

32A

32B

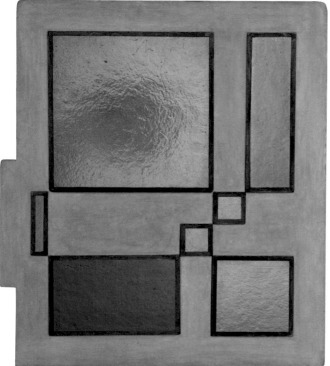

32C

32D

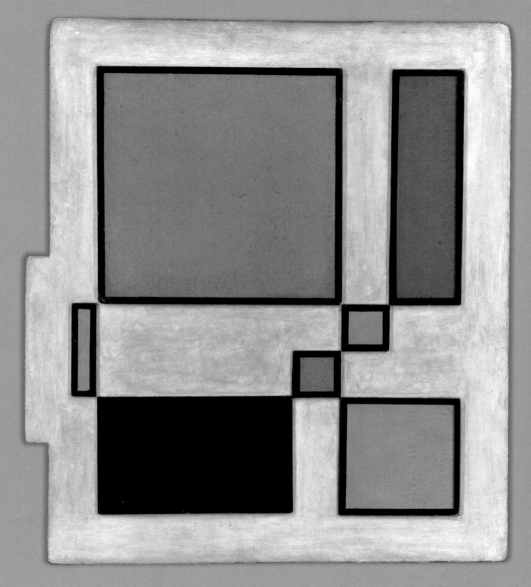

PLATE 32.
Rhod Rothfuss (Uruguayan, 1920–69).
Cuadrilongo amarillo (Yellow rectangle), 1955, alkyd and gouache on hardboard and paperboard, 36.5 × 32 × 0.5 cm. New York, The Museum of Modern Art. Promised gift of Patricia Phelps de Cisneros through the Latin American and Caribbean Fund in honor of Gabriel Pérez-Barreiro, 2010.69.

PLATE 32A.
Detail of front, left side.

PLATE 32B.
Detail of front, bottom right corner: painted sides of paperboard and attached hardboard elements.

PLATE 32C.
Full view of front in specular light: high surface gloss of attached elements on top of matte background.

PLATE 32D.
Full view of reverse: original and nonoriginal hanging hardware; ink inscriptions by the artist.

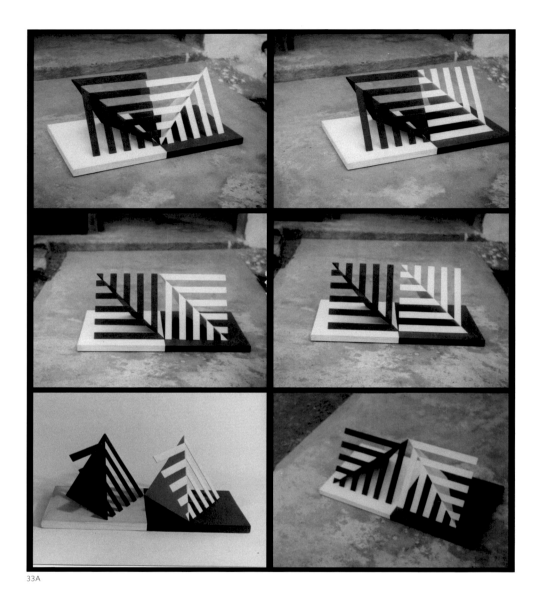

33A

PLATE 33.
Luiz Sacilotto (Brazilian, 1924–2003).
Concreção 58 (Concretion 58), 1958, alkyd on
aluminum and wood, 20 × 60 × 30.5 cm.
New York, The Museum of Modern Art.
Promised gift of Patricia Phelps de Cisneros
through the Latin American and Caribbean Fund in
honor of Rodrigo Cisneros-Santiago, 1997.131.

PLATE 33A.
Historical photographs showing alternate arrange-
ments of aluminum elements on plinth.

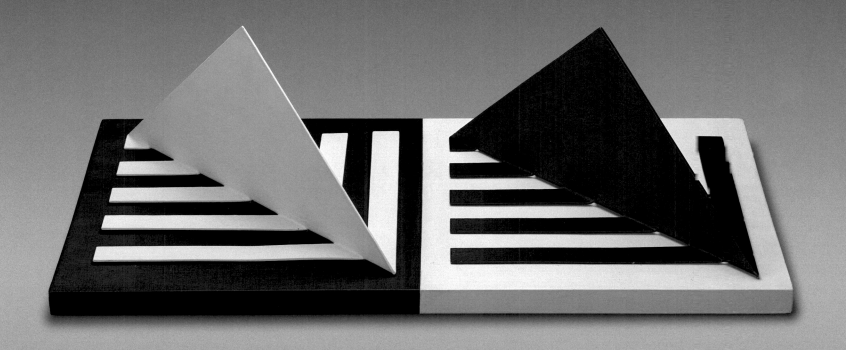

34A

34B

PLATE 34.
Gregorio Vardanega (Argentine, b. Italy, 1923–2007).
Sin título (Untitled), 1948, oil and oleoresin on fiberboard, 82.9 × 62.9 × 2.1 cm. New York, The Museum of Modern Art. Promised gift of Patricia Phelps de Cisneros through the Latin American and Caribbean Fund, 1997.93.

PLATE 34A.
Photomicrographic detail of front, green circle in top left corner: sgraffito technique of scratched-away green, transparent oil paint revealing creamy-colored background.

PLATE 34B.
Detail of front, bottom right corner of frame: partially faded blue ink inscription "VARDANEGA G. 1948."

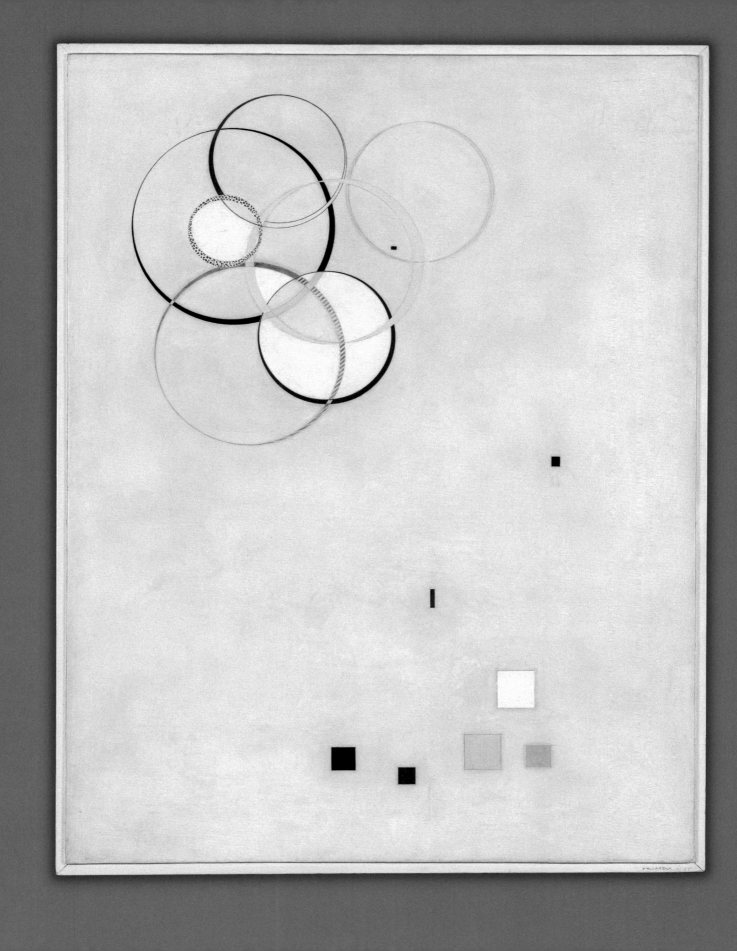

SOME REMARKS ON DOCUMENTATION AND ANALYSIS TECHNIQUES

Douglas MacLennan and Fia Gottschaller

The main body of images in the Plates section of the catalog were captured with a variety of photographic documentation techniques. For standard visible light photography, the light sources are positioned to achieve an overall even illumination across the entire surface of an object. The photographer can also add polarizing filters to the lights and camera lens to reduce unwanted specular glare or to increase overall contrast in the final image. Advanced focus stacking techniques allow for the increase of the apparent depth of field of three-dimensional objects to better mimic the human eye's own viewing response. Visible light photomicrographs are images obtained by attaching a camera sensor to a stereomicroscope. They reveal fine details of artworks and are generally taken at magnifications ranging between 10x and 40x. Photomicrographs often provide keys to a more thorough understanding of layer sequences and specific aspects of painting technique (see pl. 18b).

Raking light illumination is a visible light technique used to emphasize surface topography across an object. It employs a single light source placed at a very low incident angle to the surface being illuminated. This low angle of illumination brings out variations across the surface, such as differences in paint texture and layering. In contrast, specular illumination highlights differences in surface gloss by positioning the light source at a more direct angle to the work, usually just next to the camera lens. Glossy surfaces scatter light differently than matte or uneven surfaces, and some of the concrete artists in this study made very specific paint choices to create areas of high gloss and matte contrast (see pl. 17a).

Digital visual imaging techniques extend beyond the realm of what is possible to capture in the relatively narrow range of visible light. Infrared photography requires an instrument with sensitivity in the infrared region of the electromagnetic spectrum, which begins at around 700 nanometers, just beyond the red end of the visible spectrum. Infrared imaging is important for the examination of paintings because many pigments become transparent in this region of the electromagnetic spectrum. As a result, infrared

cameras can "penetrate" surface coatings and paint layers to visualize, for example, carbon-based underdrawings, faded or obscured inscriptions (see pl. 16a), and *pentimenti* (compositional changes).

The ultraviolet region of the electromagnetic spectrum lies just past the blue end of the visible spectrum, which means that ultraviolet radiation has shorter wavelengths than visible light. Some artists' materials, depending on their chemical structure and condition, will momentarily absorb ultraviolet radiation before fluorescing, or re-emitting some of this absorbed energy in visible light wavelengths. The fluorescence of different artists' materials can be captured and recorded by a camera equipped with special filters that allow only certain wavelengths of light to pass to the sensor. Ultraviolet-induced visible fluorescence is an imaging technique used to visualize and characterize surface coatings, layer structure, and select pigments (see pl. 7b). This technique can also reveal important information about the overall condition of an artwork and previous restoration campaigns. For instance, modern retouchings usually do not fluoresce and thus appear dark in ultraviolet radiation, while varnishes based on natural resins often develop a strong fluorescence as they age. Zinc oxide, a white pigment ubiquitous in the works presented here, also exhibits a strong, pinkish fluorescence (see pl. 2b).

Paint samples analyzed by microscopy in cross section can provide the most reliable information on the elemental composition and exact layer sequence of an artwork. A microscopic fragment, usually consisting of ground, paint, and varnish layers, if present, is embedded in a resin, polished, and photographed under high magnification with a camera attached to a polarizing light microscope. The unique benefit of analyzing paint samples in cross section is the possibility of characterizing individual pigment particles and inert fillers within a single paint layer using scanning electron microscopy — energy-dispersive X-ray spectroscopy (SEM/EDS). Sometimes, cross sections can also provide information as to whether a layer was brushed, sprayed, mixed by hand, or mixed industrially (see Gottschaller, fig. 17a).

ACKNOWLEDGMENTS

The work that has culminated in this publication and the exhibition *Making Art Concrete: Works from Argentina and Brazil in the Colección Patricia Phelps de Cisneros* has been made possible by the extraordinary efforts of many people. The project was initially proposed by Tom Learner and Aleca Le Blanc in an attempt to fuse art historical and technical approaches to the study of Brazilian and Argentine postwar art. The idea quickly gained support and momentum thanks to the enthusiasm of the Colección Cisneros and James Cuno, J. Paul Getty Trust president and CEO.

The technical and art historical study began as a collaborative venture of the Modern and Contemporary Art Research Initiative at the Getty Conservation Institute (GCI) and the Getty Research Institute (GRI), with a focus on Latin American art through Pacific Standard Time: LA/LA, an initiative of the Getty. The J. Paul Getty Museum has generously provided an exhibition space and expert support in the lead-up to the exhibition. We therefore offer sincere thanks to senior staff in all Getty programs for their manifold support in this truly collaborative effort: Thomas W. Gaehtgens, Deborah Marrow, Timothy Potts, Richard Rand, Jeanne Marie Teutonico, Joan Weinstein, and Timothy P. Whalen. The encouragement of the chair of the board of trustees Maria Hummer-Tuttle, is also much appreciated. A special thank-you goes to Glenn Phillips at the GRI, who initially steered the project and later offered insightful comments.

Scientific analysis is crucial to a technical study like the current one, and there are a number of colleagues in the Science Department of the GCI to whom we owe special gratitude. First and foremost, Joy Mazurek was willing to delve into new territory by analyzing more than 120 paint samples with essentially no available reference data. Joy brought her great expertise and curiosity to the interpretation of the results, informing our understanding of the artistic choices of the period in fundamental ways. Joy, along with Michael Schilling, also worked tirelessly with our partnering institutions to expand their own analysis, all of which has led to the creation of a large database that future scientific analysis can rely on. Lynn Lee and Alan Phenix have carried out meticulous elemental

analysis of cross sections, adding important insights to the growing body of knowledge about pigment choices and layering. Vincent Beltran fit a number of microfading tests into his busy schedule. We are grateful for the myriad ways in which David Carson, Angela Escobar, Anna Flavin, Cynthia Godlewski, Art Kaplan, Jeffrey Levin, Gary Mattison, Nicole Onishi, and Anna Zagorski have contributed to the project.

Without the generosity of our colleagues at the J. Paul Getty Museum, we would not have been able to carry out the study nor produce the exhibition and its catalog. In the Paintings Conservation Department, Yvonne Szafran agreed to let us impinge on her staff and space by hosting us for the examination, analysis, and storage of the works. Douglas MacLennan was involved every step of the way. His thoroughness and understanding are an invaluable contribution to this study, as is his coauthored text on documentation and analysis techniques in this catalog. Sue Ann Chui, Gene Karraker, Devi Ormond, and Laura Satterfield all assisted in countless ways small and large. Jane Bassett and Laura Rivers brought their professional acumen to the exhibition by taking care of the physical aspect of the works.

This catalog would not be the comprehensive resource it is without the flexibility and patience of the Imaging Services staff. Michael Smith was never fazed by our series of outlandish requests for additional photographs, and Stacey Rain Strickler and Rebecca Vera-Martinez are to be credited for carrying out the large number of beautiful shots that immeasurably enrich our perception of the objecthood of the works. We cannot thank them and Brenda Smith enough for their extraordinary meticulousness.

We also made great demands on the registrars at the Museum by asking them to help bring works to and fro for physical examination and study in the conservation studio, as well as in larger settings such as workshops, not to mention the exhibition itself. Sandy Choi Beacom, Jacqueline Cabrera, Cherie Chen, and Betsy Severance all accommodated our many and often unforeseen requests, and we thank them for their crucial support in the various logistical challenges. Likewise, the expert help of the preparators team led by Kevin Marshall, including Tracy DuVernet and Michael Mitchell, was indispensable.

This exhibition has been made possible by the professionalism and dedication of the J. Paul Getty Museum's Exhibitions Department. Amber Keller, in particular, has been a driving force in bringing this project to fruition, effortlessly stepping in to take a managing role when former head of exhibitions Quincy Houghton left the Getty. The Museum's Design Department has engaged us with creative and innovative solutions, and we are grateful to Irma Ramirez, Alexandra Mosher, and Merritt Price for this work. Members of the Education Department, including Maite Alvarez, Erik Bertellotti, Sarah Cooper, Laurel Kishi, Peter Tokofsky, and Karen Voss, have been valuable interlocutors and helped to make the exhibition come alive for our visitors both in the gallery and through the program of events.

We are very grateful to Alexandria Sivak, who has provided many opportunities for us to spread the word about our project, and to John Giurini for helping us to promote the exhibition to faculty across Southern California.

We would like to thank Gail Feigenbaum and Kara Kirk for supporting this publication. The preparation of the manuscript owes a huge debt to Laura Santiago's careful and assiduous editing; Janelle Gatchalian's thorough project management; and Michele Ciaccio's intelligent oversight. We appreciate the brilliant creative work of designer Catherine Lorenz as well as Michelle Woo Deemer's handling of the production.

Our colleagues at the GRI—particularly Idurre Alonso, Maristella Casciato, Marcia Reed, Kim Richter, and Rani Singh—have engaged us with rich discussions. Nancy Perloff and Christina Aube worked closely with us to explore concrete poetry's relationship with concrete art. Rebecca Peabody and Sue Kang enabled vital intellectual dialogues by helping us to plan and conceive events that brought numerous scholars to the Getty to exchange ideas with us. Lisa Forman and Melissa Huddleston contributed their expertise to help us better understand the GRI's Special Collections material displayed in the exhibition. Mahsa Hatam, Sally McKay, and Ted Walbye accommodated numerous Special Collections requests with characteristic good humor. Our graduate interns, Debora Facción and Robert Kett, contributed in manifold ways during the early days of the project. Maira Hernandez-Andrade, Samantha Gregg, Jennifer Park, Melissa Piper, and Johnny Tran provided invaluable administrative support throughout.

Over the course of our research, we have been fortunate to be able to exchange ideas and information with a great many specialists. In this respect, we are indebted to Dawn Ades, Luis Antonio de Almeida Braga, Regina Teixeira de Barros, Teodora Carneiro, Luiz Chrysostomo, Fernando Cocchiarale, Angeles Devoto, Mauro Herlitzka, Adrian Locke, Ana Gonçalves Magalhães, Jorge Mara, Edson Motta, Sylvio Nery, Luiz Carrillo Osorio, Luis Pérez-Oramas, Agustín Pérez Rubio, Ricardo Rego, Gabriela Siracusano, Megan Sullivan, Claudio Valério Teixeira, and Arianne Vanrell Vellosillo. In fall 2016, we were able to invite Alejandro Crispiani Enríquez, Heloisa Espada, Lynn Gamwell, Karen Grimson, Daniela Lucena, Maite Martinez Leal, Sergio B. Martins, Irene Small, and Barry Smith to participate in an extremely stimulating two days of discussion. The conversations greatly enriched our research perspectives.

Artists Tomás Maldonado and Judith Lauand provided firsthand recollections about their materials and processes, while Analívia Cordeiro, Fabiana de Barros (with Michel Favre), and Andréa Proença offered us deeper insights into their fathers' working methods. They, as well as Sofia Arden Quin, Lenora de Barros, Carlos Brasero, Walter de Castro, Alvaro Clark, Thadeu Duarte, Maria Lydia Fiaminghi, Gabriela Hlito, Élida Elvira Belizán Lozza, César Oiticica, and Valter Sacilotto, generously allowed us to reproduce images of the works for this catalog.

We are proud to be part of Pacific Standard Time: LA/LA and thank the formidable team that made us part of this impressive feat of organization. We are deeply grateful to the Getty Foundation for making possible the grant that enabled this research project to go forth with our incomparable partners in Argentina and Brazil, and at the Museum of Fine Arts, Houston (MFAH).

We would like to thank these partner teams headed by Fernando Marte and Luiz A. C. Souza in Argentina and Brazil: TAREA—Instituto de Investigaciones sobre el Patrimonio Cultural, Universidad Nacional de San Martín, Buenos Aires; and LACICOR (Laboratório de Ciencia da Conservação), part of CECOR (Centro de Conservação e Restauração de Bens Culturais), Escola de Belas Artes, Universidade Federal de Minas Gerais, Brazil. The members of these teams, including Florencia Castellá, Sofía Frigerio, María Amalia García, Noemi Mastrangelo, Pino Monkes, and Isabel Plante at TAREA, and Maria Alice Sanna Castelo Branco, Humberto Farías, Yacy-Ara Froner Gonçalves, Giulia Villela Giovani, Rita Lages, Eduardo Leite, Maria Angélica Melendi, María Andrés Ribeiro, João Henrique Ribeiro Barbosa, Alessandra Rosado, Patricia Schossler, and Marcos Tascon at LACICOR have made it a true pleasure to conduct research together. At the MFAH, we would like to thank Maite Martinez Leal, Corina Rogge, and Zahira Véliz.

We are indebted to Raúl Naón, who generously lent us important works from his collection that were central to this exhibition. He also welcomed us to his home to study his collection and shared his vast knowledge of the period with us.

From New York, the director and chief curator of the Colección Patricia Phelps de Cisneros, Gabriel Pérez-Barreiro, has almost felt like part of the Getty team; for his insightful contributions as a scholar of the period and collaborative and constructive embrace of our project, we thank him very much. We are also grateful to the brilliant team at the Colección: Eddy Almonte, Ileen Kohn, Sara Meadows, Skye Monson, and John Robinette. Finally, our most profound thanks must go to Patricia and Gustavo Cisneros. Patricia Phelps de Cisneros, to whom we dedicate this publication, has supported this project unwaveringly and demonstrated an enthusiasm for our research that has moved us deeply. Her commitment and contribution to research in the field of Latin American art is unparalleled and will be a gift to future generations of scholars.

Pia Gottschaller, Aleca Le Blanc, Zanna Gilbert, Tom Learner,
and Andrew Perchuk

CONTRIBUTORS

ZANNA GILBERT is a research specialist at the Getty Research Institute. She completed her PhD at the School of Philosophy and Art History at the University of Essex, UK, in collaboration with Tate Research. From 2012 to 2015, Gilbert was Andrew W. Mellon postdoctoral fellow in the Department of Drawings and Prints at the Museum of Modern Art (MoMA) in New York, where she was responsible for C-MAP research focusing on modern and contemporary art in Latin America and was coeditor of the online publication *post.* She has curated a number of exhibitions, including *Daniel Santiago: Brazil Is My Abyss* (Museu de Arte Moderna Aloisio Magalhães, Recife, 2010; and Museu de Arte Contemporânea de Niterói, 2012); *The Unmaker of Objects: Edgardo Antonio Vigo's Marginal Media* (MoMA, 2014); and *Home Archives: Paulo Bruscky and Robert Rehfeldt's Mail Exchanges* (Chert, Berlin, 2015). She has contributed a section on artistic exchange for the exhibition *Transmissions: Art in Eastern Europe and Latin America, 1960–1980* (MoMA, 2015). Gilbert's texts have appeared in *Art in America, Art Margins, Fillip, OEI, Arte y Parte, Caiana, Blanco sobre Blanco,* and *Art in Print,* as well as in a number of exhibition catalogs and books.

PIA GOTTSCHALLER is a senior research specialist at the Getty Conservation Institute. She came to the GCI in 2015 from Tate, London, and has held positions at the Harvard Art Museums, Cambridge; The Menil Collection, Houston; the Whitney Museum of American Art, New York; and Villa Massimo, Rome; as well as research fellowships at Bibliotheca Hertziana, Max Planck Institute for Art History, Rome; and the Courtauld Institute of Art, London. Gottschaller has a BA in art history from Ludwig-Maximilians-Universität, Munich, a diploma in painting conservation from the Courtauld Institute of Art, London, and a PhD from Technische Universität München. Her research focuses on issues of technical art history in modern and contemporary art. She is the author of books and essays on Blinky Palermo, Mark Rothko, Lucio Fontana, as well as various minimalist and conceptual artists.

TOM LEARNER is head of the Getty Conservation Institute's Science Department; he oversees all the Institute's scientific research, developing and implementing projects that advance conservation practice in the visual arts. Learner was a GCI senior scientist from 2007 to 2013, overseeing the Modern and Contemporary Art Research initiative, during which time he developed an international research agenda related to the conservation of modern paints, plastics, and contemporary outdoor sculpture. He has curated two exhibitions at the Getty: *From Start to Finish: De Wain Valentine's* Gray Column (2011) and *Jackson Pollock's* Mural (2014). Prior to his arrival at the GCI, Learner served as a senior conservation scientist at Tate, London, where he developed Tate's analytical and research strategies for modern materials and led the Modern Paints project in collaboration with the GCI and the National Gallery of Art in Washington, DC. He was a GCI Conservation Guest Scholar in 2001. Learner is both a chemist and a conservator, with a PhD in chemistry from Birkbeck College, University of London, and a diploma in the conservation of easel paintings from the Courtauld Institute of Art, London.

ALECA LE BLANC is an assistant professor of art history at the University of California, Riverside. She is a scholar of modernism, specializing in Latin American art and architecture with a focus on Brazil. Le Blanc's scholarship addresses paradigms of abstraction, institutional histories, and global modernisms. She has published and lectured widely on these topics. Before joining the faculty at UC Riverside, she was managing editor of the *Getty Research Journal,* a peer-reviewed scholarly publication. Le Blanc has degrees in art history from the University of Southern California (PhD), Columbia University (MA), and the University of California, Santa Barbara (BA).

DOUGLAS MACLENNAN is a research lab associate at the Getty Conservation Institute. He joined the Technical Studies research laboratory in 2016 and focuses on the technical examination of works of art in collaboration with conservators and curators. MacLennan's research interests include the use of XRF and multispectral reflectance imaging spectroscopy for the noninvasive study of works of art. Prior to joining the GCI, he worked as an assistant paintings conservator in the J. Paul Getty Museum and, from 2014 to 2015, was a Getty graduate intern in paintings conservation. MacLennan received a postgraduate diploma in the conservation of easel paintings from the Courtauld Institute of Art, London, and a double BA in history and German from the University of Michigan, Ann Arbor.

ANDREW PERCHUK is deputy director of the Getty Research Institute. A specialist in modern and contemporary art, Perchuk holds a PhD in art history from Yale University. His publications include *The Masculine Masquerade* (1995); *Allan Kaprow—Art as Life* (2008); *Harry Smith: The Avant-Garde in the American Vernacular* (2010); *Pacific Standard Time: Los Angeles Art, 1945–1980* (2011), which received the 2011 award for outstanding exhibition catalog from the Association of Art Museum Curators; and *Voulkos: The Breakthrough Years* (2016). Perchuk served as codirector of Pacific Standard Time, which comprised more than sixty museum exhibitions on postwar art in Los Angeles, for which he received a special award from AICA USA. He has been coleading a project on Jackson Pollock's *Mural* with a publication in press, and has been working extensively with colleagues at the GCI on issues related to technical analysis, materiality, and art history.

ILLUSTRATION CREDITS

Every effort has been made to identify and contact the copyright holders of images published in this book. If you are able to identify the artist of an unattributed work, please contact the publisher.

The following sources have provided photographs or granted permission to reproduce the illustrations in this book:

LE BLANC ESSAY

Page viii, Fig. 1. Images: Museu de Arte Moderna do Rio de Janeiro.

Fig. 2. Image: Library and Documentation Center of MASP.

Fig. 3. Permission generously granted by Tomás Maldonado and by Gabriela Hlito.

Fig. 4. Image: Los Angeles, Getty Research Institute.

Fig. 5. Élida Elvira Belizán Lozza. Image: Archivo Raúl Naón.

Fig. 6. Property of the Clark Family; Courtesy of "The World of Lygia Clark" Cultural Association.

GOTTSCHALLER ESSAY

Page 24. Permission generously granted by Estate of Vardanega. © Estate of Gregorio Vardanega. Photo: J. Paul Getty Museum.

Fig. 1. © CNAC/MNAM/Dis. RMN-Grand Palais/Art Resource, NY.

Figs. 2, 4. Permission generously granted by Fundación Juan Melé. Photo: Pia Gottschaller/Getty Conservation Institute.

Fig. 3. Permission generously granted by Fundación Juan Melé. Photo: Otilio Moralejo.

Fig. 5. Photo: Pia Gottschaller/Getty Conservation Institute.

Fig. 6. Élida Elvira Belizán Lozza. Photo: Pia Gottschaller/Getty Conservation Institute.

Figs. 7, 8. Permission generously granted by Gabriela Hlito. Photo: Pia Gottschaller/Getty Conservation Institute.

Fig. 9. Photo: Pia Gottschaller/Getty Conservation Institute.

Fig. 10. Permission generously granted by Fabiana and Lenora de Barros. © Fabiana and Lenora de Barros. Photo: Pia Gottschaller/Getty Conservation Institute.

Fig. 11. Courtesy Analívia Cordeiro. Photo: Pia Gottschaller/Getty Conservation Institute.

Fig. 12. Courtesy Analívia Cordeiro. Photo: Unknown photographer.

Fig. 13. Photo: Unknown photographer.

Figs. 14, 15. Permission generously granted by Estate of Hermelindo Fiaminghi. Photo: Pia Gottschaller/Getty Conservation Institute.

Fig. 16. Permission generously granted by Andréa Proença. Photo: Pia Gottschaller/Getty Conservation Institute.

Figs. 17a, 17b. Courtesy of "The World of Lygia Clark" Cultural Association. Photo: Pia Gottschaller and Alan Phenix/Getty Conservation Institute.

Fig. 18. Courtesy of "The World of Lygia Clark" Cultural Association. Photo: Pia Gottschaller/Getty Conservation Institute.

Figs. 19, 20. Permission generously granted by Estate of Willys de Castro. Photo: Pia Gottschaller/Getty Conservation Institute.

PLATES

The photographs of works from the Colección Patricia Phelps de Cisneros are courtesy the J. Paul Getty Museum, except for plates 3a, 4c, 6a, 6b, 8b, 10b, 11c, 15c, 18a, 18b, 19b, 21a, 22a, 24a, 27b, 32b, 34a, and 34b, which are courtesy Pia Gottschaller/Getty Conservation Institute; and 33a, which is courtesy Valter Sacilotto.

Pls. 1, 1a, 1b. Permission generously granted by Estate of Carmelo Arden Quin.

Pls. 2, 2a, 2b, 2c, 3, 3a, 3b, 4, 4a, 4b, 4c, 5. Permission generously granted by Andréa Proença.

Pls. 6, 6a, 6b, 6c, 7, 7a, 7b, 7c, 7d, 8, 8a, 8b. Courtesy of "The World of Lygia Clark" Cultural Association.

Pls. 9, 9a, 9b. Courtesy Analívia Cordeiro.

Pls. 10, 10a, 10b, 10c, 11, 11a, 11b, 11c, 11d. Permission generously granted by Fabiana and Lenora de Barros. © Fabiana and Lenora de Barros.

Pls. 12, 12a, 12b, 13, 13a, 13b, 14, 14a, 14b, 14c, 14d, 15, 15a, 15b, 15c. Permission generously granted by Estate of Willys de Castro.

Pls. 16, 16a, 16b, 16c, 17, 17a, 17b, 17c, 17d. Permission generously granted by Estate of Hermelindo Fiaminghi.

Pls. 18, 18a, 18b, 19, 19a, 19b, 20, 20a, 20b. Permission generously granted by Gabriela Hlito.

Pls. 21, 21a, 21b, 22, 22a, 22b, 22c, 23, 23a, 23b, 23c, 23d, 24, 24a, 24b, 24c. © Artists Rights Society (ARS), New York/AUTVIS, São Paulo.

Pls. 25, 25a. Élida Elvira Belizán Lozza.

Pls. 26, 26a, 26b, 27, 27a, 27b. Permission generously granted by Tomás Maldonado.

Pls. 28, 28a, 28b, 29, 29a, 29b. Permission generously granted by Fundación Juan Melé.

Pls. 30, 30a, 30b, 31, 31a. Permission generously granted by Projeto Hélio Oiticica. © César and Claudio Oiticica.

Pl. 33. Permission generously granted by © Valter Sacilotto.

Pl. 33a. Permission generously granted by © Valter Sacilotto. Photo: Unknown.

Pls. 34, 34a, 34b. Permission generously granted by Estate of Vardanega. © Estate of Gregorio Vardanega.

INDEX

Note: page numbers in italics refer to figures; those followed by n refer to notes, with note number.

experimentation with, 42–43, 48

and industrial surface finish, 41–47, 54

as inexpensive alternative, 12

nitrocellulose paints, 17, 29, 37–38, 50–51

types of, 29

use of, 10, 11, 29, 32, 34–35, 37–38, 40, 41, 44, 45, 46, 47, 48, 50–51, 56n18

paint samples, microscopic analysis of, 131

Palatnik, Abraham

and Grupo Frente, 19n2

and MAM Rio exhibition of 1956, 19n4

Pape, Lygia

and Grupo Frente, 19n2, 40

influences on, 36

and MAM Rio exhibition of 1956, 19n4

Pedrosa, Mário, 40, 48

Pedrosa, Vera, 48

Perceptismo

and destruction of illusion of space, 33

emergence of, 26

founding of, 28

and scholarship on concrete art, 20n10

Pérez-Barreiro, Gabriel, 28, 32, 56n36

Péri, Lázló

as precursor of concretism, 27

Raumkonstruktion 3, 27, 27

Perón, Juan, 3

photographic documentation techniques, 130–31

photomicrographs, 130

Picabia, Francis, 40

Picasso, Pablo, 2, 40

Pollock, Jackson, 38

Portinari, Cândido, 15

Prati, Lidy

and *Arturo* magazine, 26

associates among concrete artists, 30

marriage to Maldonado, 21n14

Proença, Andréa, 48

Purism, and industrialization, 20n6

Rio de Janeiro

concrete artists in, 17, 40–41, 48–51

establishment of concrete art in, 5–6

as focus of *Making Art Concrete* exhibition, 3

as government center, 19n3

history of modern art in, 4

industrialization in, 2

museums in, educational mission of, 6

rivalry with São Paulo, 40

See also Museu de Arte Moderna do Rio de Janeiro (MAM Rio)

Río de la Plata region

concrete artists in, 26–28

and concrete depersonalization of artworks, 26

Rodchenko, Alexander, 54

Rothfuss, Rhod

and *Arturo* magazine, 26

associates among concrete artists, 30

background of, 30

Cuadrilongo amarillo, 30–33, 32, 56n23, *124–25*

influences on, 32

and Madí group, 28

"El marco: Un problema de plástica actual," 15, 26

materials used by, 32, 56n20

and rectangular frame, rejection of, 21n16

ruling pens, as tool in artworks, 35–36, *37,* 43, 44, 45, 47, 51

vs. tape, 36, 44, 47, 57n45

Russian constructivism

concrete artists and, 37, 54

as response to industrialization, 20n6

Sacilotto, Luiz

Concreção 58, 126–27

and Grupo Ruptura, 39

Sagradini, Mario, 56n20

Salão Nacional de Arte Moderna, 20n9

São Paulo

concrete artists in, 6, 9, 11, 12, 14, 16, 22n26, 39–40, 41–48, 51–53

as focus of *Making Art Concrete* exhibition, 3

history of modern art in, 4

as industrial center, 19n3

industrialization in, 2

museums in, educational mission of, 6

rivalry with Rio de Janeiro, 40

See also Museu de Arte de São Paulo (MASP); Museu de Arte Moderna de São Paulo (MAM-SP)

SEM/EDS (scanning electron microscopy—energy-dispersive X-ray spectroscopy), 56n23, 131

seriality

as compositional scheme, 8–9

concrete artists' embrace of, 8

and depersonalization of art, 8

Gestalt psychology and, 47

group installations and, 8

as industrial-style model, 8, 13–14

and multiple versions of works in series, 13, 17, 22n32, 47

and nature of art, 8, 13

Serpa, Ivan

Cordeiro on, 40

and Grupo Frente, 19n2, 40

as instructor at MAM Rio, 6, 48

and MAM Rio exhibition of 1956, 19n4

Sheeler, Charles, 20n6

sides and back of works, as part of artwork, 5, 11, 17, 29, 51

Silveira, Elisa Martins da, 19n4

Siqueiros, David Alfaro, 38

Small, Irene, 41

socialist values of concrete artists

commodity culture and, 12

and depersonalization of artworks, 11–12

Grupo Ruptura and, 39

and Russian constructivism, 37

Sociedad Argentina de Artistas Plásticos, 28

supports

artists' identification by brand name, 12

and *marcos recortados,* 15–16, 26–27, 28, 29, 32

as part of artistic choice, 5, 28, 50

See also hardboard panels; *marco recortado* ("cutout frame")

tape, as tool in artworks, 10, 11, 36, 38, 41–42, 44, 47, 51, 57n45

technique in concrete art, emphasis on impersonal mechanical precision in, 10, 11, 25, 26, 27–28, 39, 42, 44, 47, 54

"Teoria do não-objeto" (Gullar), 16–17, 40

Torres-García, Joaquín

and black grids in *marcos recortados,* 33

and Hlito, 34

influence on Latin American artists, 26, 32, 36–37

and introduction of concrete art to Latin America, 27

Maldonado on, 37, 38

Ulm School. *See* Hochschule für Gestaltung (Ulm)

ultraviolet radiation, in painting analysis, *24,* 48, *50, 51, 64, 74,* 131

Unilabor, 41, 22n26

utopianism, in concrete art, 25

Van Doesburg, Theo

"Art Concret: The Basis of Concrete Painting," 27

"Comments on the Basis of Concrete Painting," 27

influence on Latin American concrete artists, 27

and introduction of concrete art, vi, 4

Vantongerloo, Georges

and dematerialization of matter, as goal, 54

influence on Latin American artists, 54

Maldonado and, 36

Pérez-Barreiro on, 56n36

Vardanega, Gregorio

and AACI, 28

and art schools, concrete artists met at, 28

and origins of concrete art, 27

signing of works by, *128*

Sin título, 24, 54, *128–29*

Vantongerloo and, 54

working method of, 54

Vargas, Getúlio

commitment to modernization, 3, 39

and Companhia Siderúrgica Nacional, building of, 19n3

Vieira, Décio, 19n4

Villalba, Virgilio, 54

Weissmann, Franz, 19n4

Wollner, Alexandre

on Hochschule für Gestaltung (Ulm), 38–39

and IAC, 6

studios shared by, 43

wood panels. *See* hardboard panels

World War II

and Latin America focus on education, 6

and modernism in Latin America, 3

INDEX

143

Recent Titles on Latin American Art Published by the Getty

Golden Kingdoms: Luxury Arts in the Ancient Americas
Joanne Pillsbury, Timothy Potts, and Kim N. Richter
ISBN 978-1-60606-548-8 (hardcover)

Photography in Argentina: Contradiction and Continuity
Idurre Alonso and Judith Keller
ISBN 978-1-60606-532-7 (hardcover)